ART AND EMOTION

Art and Emotion

DEREK MATRAVERS

CLARENDON PRESS · OXFORD
1998

Oxford University Press, Great Clarendon Street, Oxford OX2 6DP

Oxford New York
Athens Auckland Bangkok Bogota Bombay
Buenos Aires Calcutta Cape Town Dar es Salaam
Delhi Florence Hong Kong Istanbul Karachi
Kuala Lumpur Madras Madrid Melbourne
Mexico City Nairobi Paris Singapore
Taipei Tokyo Toronto Warsaw
and associated companies in
Berlin Ibadan

Oxford is a trade mark of Oxford University Press

Published in the United States by
Oxford University Press Inc., New York

© Derek Matravers 1998

British Library Cataloguing in Publication Data
Data available

Library of Congress Cataloging in Publication Data
Data available
ISBN 0–19–823638–7

1 3 5 7 9 10 8 6 4 2

Typeset by Invisible Ink
Printed in Great Britain
on acid-free paper by
Biddles Ltd, Guildford and King's Lynn

To
Hugh Mellor

PREFACE

My intention in this book is to rehabilitate an approach to the connection between art and the emotions long regarded as heretical. I have been mulling over some of the ideas expressed in this book for a number of years. Some of them were worked out during my period at Cambridge University, first as a graduate student and then as a Research Fellow. I am grateful to Darwin College for a Research Fellowship and to the British Academy for awarding me a Post-Doctoral Fellowship.

Robert Hopkins read some and Berys Gaut all of the manuscript and I have profited greatly from their comments. I have been saved from error on several occasions by the patient and intelligent criticism of Jerrold Levinson. His comments on my text not only sharpened my thoughts considerably, but turned the process of redrafting material from a chore to a pleasure. Angela Blackburn's editing added polish to the book, and her philosophical acumen saved me from error on more than one occasion. I have also benefited from the conversation and company of the Cambridge Faculty, my many graduate contemporaries, and my new colleagues at the Open University. Nigel Warburton falls into both the second and third of these categories. My Ph.D. examiners, Sebastian Gardner and Edward Craig, made it clear to me how much more work I needed to do. Hugh Mellor agreed to supervise a thesis in a topic remote from his own interests. I benefited greatly from his generosity of spirit, and my thoughts on aesthetics were much influenced by his discussions of such matters as colour perception and properties and predicates. I have dedicated this book to him in gratitude not only for that early help, but for his continued friendship and support.

My family has been a source of financial and moral support. In particular, I must thank my brother Matt (now also a philosopher) for not objecting when I took over the family house. Friends, particularly those well-read in literature, music, and the visual arts, have been a helpful source of primary material.

My wife, Amanda, read the final manuscript and did what she

could with my writing style; an ordeal undertaken with the customary good humour which has brought both of us through the final stages of preparing this book.

Material from three previously published articles appear in this book. They are 'Art and the Feelings and Emotions', *British Journal of Aesthetics* 31 (1991): 322–31; 'Unsound Sentiment: A Critique of Kivy's "Emotive Formalism"', *Philosophical Papers* 22 (1993): 135–47; and 'The Paradox of Fiction: The Report versus the Perceptual Model', in Mette Hjort and Sue Laver, eds., *Emotion and the Arts* (New York: Oxford University Press, 1997), 78–92. These appear by permission of Oxford University Press and Philosophical Papers.

Cambridge D.C.M.
April 1997

CONTENTS

1 INTRODUCTION 1

2 THE EMOTIONS 14

3 'FEARING FICTIONS' 29

4 ENGAGING FICTIONS 57

5 CAUSAL STORIES 83

6 EXPRESSION AS METAPHOR 102

7 THE COGNITIVE THEORY 114

8 DEFENDING THE AROUSAL THEORY 145

9 THE MUSICAL EXPERIENCE 165

10 BELIEF AND EXPERIENCE 188

11 CREATION AND CRITICISM 204

12 AFTERWORD 225

Bibliography 227
Index 233

I

Introduction

1. Great art provides some of the most valuable experiences it is possible for us to have. Such experiences engage many aspects of our mental life simultaneously: filling our senses whilst at the same time making demands on our intelligence, our sympathies, and our emotions. These links give the experience of great art an importance and complexity that, for example, the experience of good food, however enjoyable, lacks. In this book I explore one of these links: the relation—or rather, the relations—between art and the emotions.

Two problems concerning art and the emotions have been particularly prominent in recent analytic aesthetics. The first concerns what are apparently emotional reactions to fictional characters and events. Engaging with a fiction, whether a James Bond film or *Pride and Prejudice*, frequently prompts a response which seems to be an emotion for a particular character: we feel sorry for James Bond as he is (once again) left in chains to face an appalling death, or sympathy for Elizabeth Bennett when she has to break the news of her sister's elopement to Mr Darcy. Whatever the work, our reactions to it are bound to be influenced by the fact that the content presented is in the work, not in the world. When watching a Bond film, the viewer is not faced with Bond chained and awaiting an appalling death but with a representation in which Bond is chained and awaiting an appalling death. Furthermore, the viewer presumably believes that there never was a secret agent called James Bond who found himself in this particular dangerous situation. These considerations are bound to make the states of mind engendered by perceiving fictions differ from those engendered by perceiving the world around us. A representation is removed from reality; which is why it is more appropriate to contemplate it than to react to it; we do not try to tell James Bond that it is S.M.E.R.S.H. that is trying to kill him. The content of fictions occupy a different

'space' to that occupied by objects around us—the relevance to us of events in fiction is different from that of similar events in the real world.

It is strange that although we do not have any physical inter-action with the characters in a fiction, we do interact with them in other ways: in particular, we react emotionally to their plight. If the world of a work of fiction is not a world we inhabit and with which we can interact, what justifies our getting emotion-ally involved in it? For some people nothing does; consider, for example, the view expressed by Mr Keith in Norman Douglas's novel, *South Wind*:

It saddens me to see grown-up men and women stalking about in funny dressing gowns and pretending to be Kings and Queens. When I watch *Hamlet* or *Othello*, I say to myself: 'This stuff is nicely riveted together. But, in the first place, the story is not true. And secondly, it is no affair of mine. Why cry about it?'

The same thought occurs to Hamlet in the famous soliloquy prompted by the Player King's tears: 'What's Hecuba to him, or he to Hecuba, That he should weep for her?' (II. ii. 543–4). What is in question here is the sense of wasting our emotional energies on people who never suffered; indeed, never even existed. There is, however, a prior question of whether what we would feel for fictional characters were we to engage with them could ever be correctly classified as an *emotion*. My argument that what we feel should be so classified will occupy most of Chapters 3, 4, and 5. It may not be thought to require much argu-ment—to react with emotion to fictional characters seems a com-mon, even typical, experience. The problem is rooted, once more, in the gulf between the real world and the world of a work of fic-tion. We believe things about the real world: that we are read-ing a book, that we are watching a film, and so on. We do not have the equivalent kind of beliefs about the fictional world. We do not *believe* James Bond averted nuclear catastrophe or that Mr Darcy proposed to Elizabeth Bennett. It is argued by some that emotions are so much part of the real world that they necessarily involve beliefs. If the viewer does not have the requisite belief, then whatever he feels, it is not an emotion. On this view, however like emotions our reaction to fictional char-acters are, they cannot properly be emotions. This is what I shall

call the 'definitional problem': how should our apparently emotional responses to fictional characters be classified?

The answer to this is bound to be connected to the representational content of the fiction. Whether it is his affair or not, even Mr Keith realizes that is more appropriate to *cry* about *Hamlet* and *Othello* than laugh about them, and this must be because of what they are represented as doing and enduring. This information is analogous in the fictional world to belief in the real world. We can be sure therefore that the solution to the problem of explaining the nature of our reaction to fiction will have something to do with what is represented.

It is in this that the definitional problem differs from the second of the two problems of art and emotion I shall consider: namely, the rationale for characterizing works of art themselves with terms which name the emotions (which I shall call 'emotion terms'), when such a characterization is not explained—or not solely explained—by the representational content of the work. The problem of our describing instrumental music using emotion terms is a particular case of this. Although it is not particularly unusual for us to describe music in this way, not only is instrumental music discontinuous with the rest of our lives, it is not *about* anything which could—were it real—justify the emotion term being applied to it. The problem can be put another way. Certain pieces of music (not to mention poems or other works of art) seem to express human emotions. It is not obvious, however, that there is any link between such works and the expression of emotion by people. From where, then, do we get the idea that the works are expressing emotions? As recent work demonstrates, giving an account which shows how and why the expression of emotion 'enters into' the experience of such works has proved particularly difficult.

However different these two problems are from each other, they will both be solved by showing that the concept of the emotions can be extended from the central to the problematic cases. Unless we are going to say the use of emotion terms is ambiguous, the unity of the concept will need to be preserved. I shall argue that in both problematic cases there is an overlap between the mental states provoked by the works of art and the complex mental state that is an experience of an emotion in the central case. Understanding this overlap is essential to solving the

two problems. An emotion is a complex state; it has both cognitive and affective components. I shall argue that it is in the affective components that the overlaps which are crucial to understanding occur. This will mean, in answer to the second of the two problems (that concerning expression), defending a version of the so-called 'arousal theory'.

This approach is unlikely to find immediate favour. It has been my experience that people who work in the field are unwilling even to consider the arousal theory. One philosopher in particular, Peter Kivy, has attacked the arousal theory wherever it has appeared and even in some places where it has not.[1] I shall consider these attacks later in the book. Kivy is not alone in his antipathy to the theory, however. The current orthodoxy is that the arousal theory is certainly false and that all that remains to be settled is which 'cognitivist' view is correct. I shall argue that cognitivism itself is silent at precisely the moment it needs to say something interesting. Furthermore, few of the arguments against the arousal theory need to be taken seriously and none are conclusive. Not only does the arousal theory provide a satisfying solution to the problem of expression, it forms part of a unified account of our emotional reactions to each other, the world, and works of art.

2. There are some who would argue, even from the little I have said so far, that my approach is misguided. They would say that the problem I claim to see in the relation between art and the emotions is chimerical; a product of dividing our uses of terms for emotions into groups and claiming that some of these uses need justifying by reference to others. If we think of the emotions as a 'family resemblance' concept which is sometimes used to refer to people's mental states ('he is upset'), sometimes to describe the behaviour of groups ('terror gripped the population'), and sometimes in other ways, that appearance vanishes. That emotion terms appear in our talk about art and our experience of art may be worth noting, but only as an interesting fact about our concept of an emotion. The appearance of a problem only arises if we take certain uses of emotion words to be privileged—for example, their application to people—and claim that other

[1] See his attack on Jerrold Levinson in Kivy 1989: ch. 16.

uses—their application to works of art—require justification in terms of the privileged group. This, some might argue, is a philosophical distortion. No such justification is needed.

I disagree. Far from being a philosophical distortion, the problematic nature of the relation between art and the emotions follows directly from facts about the meaning of our emotion terms. (At least, I shall put the argument in terms of meaning, although as we shall see later it can be put in other ways.) For the fact is that, in learning to understand a word, we first pick out the central cases of its use and these, in the case of emotion words, can be shown to be those in which they are applied to people. Those are the cases via which the use of these words must first be learned, and to which their other uses must somehow be related.

That meaning derives from central uses of words holds not just for emotion terms but for words generally. Take 'slow', for example. If we had to define it for somebody, we would probably start with the idea of something that took a long time to move uniformly between two fixed points. All our uses of the word link back to this paradigm situation in one way or another. A slow train is a train that moves slowly, a slow journey is a journey that takes a long time. A slow thinker also takes a long time to complete a 'journey'; from the beginning to the end of a problem. Now consider a peculiar use of 'slow'; one which has no such link with its paradigm use. Suppose, for instance, I call a piece of driftwood slow. In order to explain what I mean, I must draw some link with its central uses. But suppose I do not: suppose I justify my use by saying, not that driftwood is wood that drifts—a slow process—but that driftwood is brown. This leaves a problem. If the link is not apparent, an explanation is required because, without it, the meaning of my original remark is not clear: the suspicion must remain that I do not know what 'slow' means.

Compare this to our uses of emotion terms. Ronald de Sousa has suggested that we learn terms which refer to emotions through what he calls 'paradigm scenarios' in which the terms and the characteristic contexts of the terms are closely linked: 'Paradigm scenarios involve two aspects: first a paradigm situation providing the characteristic objects of the emotion (where objects can be of various sorts, sometimes more suitably labelled "target" or "situation") and second, a set of characteristic or nor-

mal responses to the situation' (de Sousa 1979: 42). This paradigm scenario would establish a connection between the cause of an emotion, feeling the emotion, and the behaviour the emotion causes. Learning the emotion term in this way establishes a connection between *having* an emotion and *feeling* an emotion, precisely because, in the central cases, only those things which have the appropriate experiences could properly be said to have an emotion. The paradigm scenario of (for instance) 'sad' would, of course, be fairly limited in scope; and de Sousa acknowledges that it would be absurd to claim that our use of such a concept, once grasped, is forever constrained within those limits. Our mature use of 'sad' may be broader than that; but we still need to see how its broader uses link back to its paradigm. Hence, one way to understand the role the emotions play in art is to understand how our experience of them in aesthetic contexts is related to the central, defining, cases. The principle is the same as in the driftwood example; any use of a word which is not obviously linked to the central case needs a justification. Without a justification, it is unclear whether this usage is a mistake, a simple ambiguity, an obscure witticism, or whatever.

How do we know whether or not a use is 'obviously linked' to the central case? It is relatively easy to plant a seed of doubt in the mind of someone who thinks, on first reflection, that the apparently emotional reaction he has to fictional characters is just what it seems: an emotion. How can what one feels be *fear* of Count Dracula, if it has none of its characteristic effects (a disposition to flee, for example)? How can what one feels be pity if one does not believe the object of one's pity ever suffered—or existed, for that matter? These claims are unsettling and deserve an answer. Similarly, our confidence in the practice of applying emotion terms to instrumental music is shaken by reflecting on how different the application of emotion terms to music is to the central cases of the application of these terms. The first task, then, is to map the boundaries of the central case and explore its connotations. Once this is done we will know whether a particular use of a word falls within or without those boundaries, or is perhaps incompatible with the central use altogether. Hence, in Chapter 2, I will give a brief account of the central cases of the emotions, to which the aesthetic use of emotion terms can be compared.

3. Solutions to the definitional problem are defined largely in relation to Kendall Walton's view on the subject. His book, *Mimesis as Make-Believe*, presents a general theory of representation of which a solution to the definitional problem forms a part. In Chapter 3 I take a critical look at Walton's work. Walton's basic insight may be expressed as follows: children 'feel emotions' as part of their games of make-believe. However, they are not *really* feeling emotions, they are merely in some state which makes it true that *in the game* they are feeling emotions. Walton argues that our reaction to fiction can be explained by construing it as a sophisticated game of make-believe. According to Walton, one of the games of make-believe we play with fiction is to imagine that the novel is a true report of the activities of a person (or a thing, or whatever). Reading this report arouses states which have the phenomenological and physiological appearances of emotions, but which are not emotions because they do not include the requisite beliefs. Hence, in the real world they are only 'quasi emotions', although in the game of make-believe they are really emotions.

Modifying Walton's theory and explaining communication by a fictional narrator is the task of Chapter 4. I argue that such an explanation is little different from an explanation of how a narrator would communicate via *any* representation, fictional or not. The argument that beliefs are an *essential* component of emotions (a position I call 'narrow cognitivism') relies on the claim that emotions must have certain properties which only a belief could give them: in particular, a connection to action. Against this, I argue that some unproblematic cases of emotion (those we feel in response to a documentary of past events, for example) lack a connection to action. This undermines narrow cognitivism and opens the way to the claim that the emotion-like states aroused by fictions are really emotions.

Even with the definitional problem solved, Mr Keith's question remains unanswered. Is it rational to engage with a representation (and have an emotion aroused by it) when there is no possibility of encountering or influencing the objects which such a representation is about? What is the point of becoming emotionally bound up in something which is merely a fiction? An analogous question may be asked of becoming involved in an historical narrative; neither fiction nor history is of any

immediate use. It is obvious that the answer to this could appeal to any of a wide range of values and interests. Perhaps people read history because they desire an accurate picture of how the world was. If there were no satisfactory reason for our troubling to engage with fiction then reactions to fiction—including emotional reactions—would not be justified. Presumably there is a satisfactory reason, although this is not the place to give it: it would be given by a theory of the value of fiction.

The arguments of Chapter 4 concern beliefs and other cognitive aspects of our interaction with representations. Explaining these cognitive states, however, does not provide a full account of our emotional reaction to fiction. Two versions of the same story (narratives which express the same propositions) might provoke very different emotional reactions in the same observer; a fact accounted for by the non-propositional properties of the representation. In Chapter 5 I argue that the non-propositional properties have two relevant functions: first, they can present the propositions in such a way that the observer is 'struck' by them, and second, they can act directly on the observer's feelings. The first is necessary for an emotion to be caused at all, and the second partially causes, and hence influences the identity of, the resultant emotion. In influencing the identity of the emotion, the non-propositional properties can also influence the beliefs the observer forms about fictional characters. For example, the eponymous Count in the Dracula films might arouse disgust (as opposed, for example, to fear) which might then cause the belief that he is revolting (rather than the belief that he is frightening).

Emotions do not enter only our experience of fiction in our reaction to particular characters and events. Some works of fiction (it may be more useful here to think of poetry) seem to *express* emotions. This is a particular case of the second of the two problems I mentioned above. The role of aroused feelings, which I have just considered, might prompt the thought that they have an explanatory role here. That is, the work arouses feelings which do not form part of any emotion directed at a character or situation within the work. As a consequence, the beliefs characteristically caused by such feelings will not be beliefs about characters, but what I call 'expressive beliefs': that is, beliefs that the work itself expresses a particular emotion. I consider various other possibilities, for example, that a work of fiction which

expresses sadness is a work that seems as if it were written by a sad person. I argue that, even at this early stage, it is apparent that a cognitivist account such as this (cognitivist, because it relies on *recognizing* some property of the work) has difficulties. A full defence of the arousal theory, however, must wait for the development of the theory later in the book.

There is a host of objections to any account which finds the ground for expressive judgements in aroused feeling. Part of the support I offer for such a theory is that it alone provides hope of a solution. To this end, in Chapters 6 and 7 I reinforce my argument that contemporary cognitivist attempts to solve the problem end in failure. The first such attempt I consider argues that expressive judgements are problematic only because they are an instance of a more general philosophical problem: that of metaphor. This assimilation is prima facie plausible; in both a metaphor and an expressive judgement a word is used in a way that is parasitic upon, but different from, its central use. The attempt at solution is undermined, however, by the fact that there is no general justification for all metaphorical uses of terms. Instead, particular metaphors are justified by specifying, in other terms, the similarity they indicate. Hence, even if expressive judgements are classified as metaphors, it would still be necessary to find the similarity between the aesthetic and central cases which justifies them. As this is the problem with which we started—the problem that appealing to metaphor was intended to solve—assimilating expressive judgements to metaphor is 'an unnecessary shuffle'.

A lesson to be learned from the failure of metaphor to account for expressive judgements is that the problem of expression is not merely semantic. To explain a metaphor is to explain why it makes sense to use a word in a context apparently precluded by its definition. Expressive judgements are, however, paradigmatically made on the basis of *experiencing the work as expressive*. An account of expressive judgements must explain the relation between the experience and the judgement. Such an account will, inevitably, also be an account of the experience itself.

What is distinctive about cognitivism is the claim that expression is a property of a work which is describable as such independently of an individual reaction to it. Characteristically, the move from the experience of expressive music to the expressive

judgement is made by the listener's recognition of this property. Peter Kivy argues that music which expresses a certain emotion resembles the appearance and behaviour of a person expressing that emotion (Kivy 1989). Against this, I argue that we cannot make sense of a listener's experience on this basis. Other cognitivists have avoided the pitfalls of Kivy's account by abandoning it as an *analysis* of expression—although they retain it as a supplement to such an analysis. Bruce Vermazen argues that expressive music is heard *as if it were* the expression of person (Vermazen 1986); Jerrold Levinson argues that it is heard as a *sui generis* mode of expression (Levinson 1996); and Malcolm Budd argues that expressive music prompts us to 'make-believe' certain facts about the central case (Budd 1989). Interesting as these proposals are, they do not, I argue, connect the experience of expressive music and the expressive judgement in a way that reveals the link between music and the emotions.

The alternative is to abandon the attempt to understand the experience of expressive music as being in some way the experience of an expressive person and return to the account suggested earlier: the music is expressive in virtue of the feelings it arouses in the appropriate listener. Two recent accounts by Kendall Walton and Aaron Ridley are sophisticated variations of the standard arousal theory; I discuss both in Chapter 7 (Walton 1994; Ridley 1995b).

In Chapter 8 I consider five well-known objections to the arousal theory: that listeners do not, as a matter of fact, react to expressive music with a feeling; that if they did, this would have the unacceptable consequence that listeners would have a good reason to shun music expressive of the 'negative emotions'; that emotions have an essential cognitive component which non-representational art (in particular, music) could not arouse; that any emotion aroused by music would be inexplicable and therefore mysterious; and that the type of emotion aroused by music is not necessarily the type expressed by it. The target of these objections is an implausibly naïve version of the arousal theory; a more plausible and more sophisticated version has nothing to fear from them.

In Chapter 9 I consider a more serious objection. The arousal theory maintains that the relevant property of an expressive work is a capacity to cause a non-cognitive and non-representational

state in the mind of the listener. The experience of expressive music suggests, however, that the cognitivists are right to take expression to be a perceivable property of the work. How can something's capacity to arouse a feeling be a perceivable property of it? This opens the gates and problems flood in. Might Wittgenstein be right in holding that expression is an intentional rather than a causal notion? If this were true, the arousal theory (which is explicitly causal) would miss the point. To answer this objection it is enough to show that expression has a causal element. That much is easily done; but it is more difficult to maintain the arousal theorist's claim that expression is exclusively causal. Many things arouse our feelings—drugs, for instance—without thereby being expressive. From such considerations cognitivists conclude that arousal of feelings is at most a necessary condition for expression—there needs to be a fact about the work (that it has an expressive property) and it is *this* that needs to be causing the reaction. Against this I argue that the explanation *can* be found within the causal picture: the arousal theory can explain why the experience of the arousal of feelings by drugs and the like is sufficiently different from the experience of the arousal of feelings by art to explain why the latter is expressive and the former is not.

It is necessary to do more than mount a piecemeal defence in the face of any attack that happens along. The arousal theory needs to deal with the root of such attacks—the claim that it cannot account for expression as a property of the work. I argue that this claim is flawed to the extent that it claims that whether an analysis is correct or not can be deduced from phenomenological premisses. I argue that the mental state with which the arousal theory needs to work, a particular sort of mental state aroused in a particular way, *does* justify the claim that expressive properties are properties of the music. The claim that an aroused qualitative state can be tied to the object that caused it takes us closer to talk of secondary properties. In the final two chapters I explore the arousal theory through the analogy with secondary properties; in particular, with colour. Chapter 10 deals with the analogy between the experience of art and the experience of colour and Chapter 11 with the analogy between the expressive work itself and the primary properties which cause the colour experience. Much of Chapter 10 is taken up with a discussion of what

it is to be a 'qualified observer' of expressive art, and what counts
as 'normal perceptual conditions'. I also discuss the phenome-
non of 'dry-eyed' criticism: that is, cases in which an expressive
judgement is made but in which it is explicitly disavowed that an
emotion is felt. This objection certainly tells against a strong ver-
sion of the arousal theory, although I argue that my weaker and
more plausible version escapes refutation.

Chapter 11 continues the discussion of criticism. Although
expressive judgements are grounded in feelings aroused by works
of art, they are no more about those feelings than colour judge-
ments are about the visual sensation of colour. The judgements
are about the works themselves; specifically, about their capacity
to cause certain sorts of experiences. I discuss Mary Mothersill's
influential claim that nothing systematic can be said about the
relation between the causally efficacious properties of a work and
the experience they arouse. In response, I argue that putting
expression on a causal basis enables us to accommodate
Mothersill's intuitions without such a radical reappraisal of the
basis for criticism. Furthermore, it enables us to make better
sense of actual critical practice. The conclusion I draw is that the
arousal theory is not refuted by any of the many arguments
currently ranged against it. In addition, it has the advantage over
contemporary cognitivism of providing a philosophically satis-
factory solution to the problem under consideration.

4. Finally, I would like to say a word about my use of exam-
ples. There are dangers both in using too many examples and in
using too few. Too many examples may intimidate the reader,
especially if the author is prone to advertising his wide-ranging
intellect and cultural acumen. There is a greater danger, however,
in using too few: namely, the danger of a priori theorizing uncon-
strained by the facts of our experience of works of art. It is
important to be reminded, while thinking about these problems
philosophically, that the problems spring from our experience of
art and have not been invented as a technical challenge. I have,
therefore, not stinted from using examples where I felt they were
appropriate, whilst at the same time endeavouring to keep the
examples within a range of works that readers will either have
experienced or be able to experience with a minimum of effort.
I have persisted, in discussing music, with the standard example

of 'the music is sad', assuming that readers will take this for what it is; a dummy sentence, not a piece of serious music criticism (for a sterling defence of this, see Kivy 1989: 181). There are no examples in musical notation nor, given that my interest lies in the common experience of music, are there examples of technical musical criticism.

2

The Emotions

1. There are several different accounts of how the emotions ought to be understood. I shall join the consensus which holds that, whatever the details, when talking about and defining emotions it is explanatory to interpret an emotion as a complex of components central among which is some representational state.[1] A narrower version, which I shall refer to as the 'narrow cognitive theory of the emotions' (not to be confused with what I have called the cognitivist theory of how emotion terms come to be applied to art) claims that the representational state is necessarily a belief. The roots of this can be found in Aristotle (*Rhetoric*: Bk. II, ch. 2); it has also been endorsed in the work of a number of contemporary philosophers.[2] I shall discuss the narrow cognitive theory in section 3. For the remainder of this section, I shall consider the arguments for the broader account.

Within the broad cognitive view of the emotions, there is much disagreement as to the nature of both the cognitive component and the additional components of the emotion. I do not propose to discuss any specific account in detail; rather I shall outline my views on the emotions and support them with arguments which are commonly encountered in the literature. I shall then indicate why I have not helped myself to various claims that are on offer and which would appear to make it easier to solve the two problems described in Chapter 1.

Consider a plausible scenario in which someone might come to feel an emotion. Fred sees a large dog bounding towards him. This perception causes Fred to believe he is in danger. This belief causes other cognitive states in Fred (for example, the

[1] Recent work on the emotions includes Lyons 1980, de Sousa 1987, Greenspan 1988, Roberts 1988, and Gordon 1990.

[2] A classic defence of the cognitive theory of the emotions is Bedford 1956. More recent defences can be found in Budd 1985a: ch. 1, Currie 1990: ch. 5, Lyons 1980, Rey 1980, and Ridley 1995b: ch. 1.

desire to flee) as well as various physiological and phenomeno-
logical effects. The emotion—fear—is a compound of this belief
and these other effects.

This is the simple paradigm case, and I see no reason to stray
very far from it. A full description of our emotional reaction
might well be more complicated than this simple case implies.
In some cases, for example, it might be necessary to discriminate
between the cause and the 'trigger' of the emotion. Perhaps Fred,
who is not usually frightened of dogs, has taken a drug which
induces fear whenever Fred sees a dog's ears. I have no preten-
sion to the production of a full account of the emotions, although
I hope my simple model is compatible with one (such as that pro-
vided in de Sousa 1987: 116–22). I shall restrict my discussion here
to the typical cognitive and affective components of at least the
central class of emotions.

In order to be afraid of the dog, Fred must realize that he is
threatened by it. If he does not realize this, the fact that he is
threatened will not effect him. That is, there must be some men-
tal analogue, some inner state, to represent what it is in the world
that is the cause of the emotion. More specifically, there must
be some propositional attitude which is caused by a perception
and which causes the other aspects of the emotion (which I will
come to presently). This propositional attitude is the cognitive
aspect of the emotion. In the example above, Fred's perception
of the dog causes his belief that he is threatened by it, and this
belief becomes a component of his subsequent fear.

The presence of this propositional attitude explains many
significant facts about the emotions. Perhaps the most significant
of these stems from such propositions (typically constituents of
beliefs—but I do not want to beg the question in favour of nar-
row cognitivism) being states which are 'object-directed'. That
is, there is something that such propositions are *about*. In the
example it is Fred's belief *that* the dog is threatening him. If emo-
tions involve propositions, as I am claiming, we should expect
an emotion to be about something as well; and indeed, this is
generally the case. It is natural to claim that what the belief
involved in the emotion is about is also what the emotion itself
is about. Fred fears that which he believes is threatening him.

In addition, the fact that emotions involve propositional atti-
tudes also explains how emotions can be caused without reason.

It could be that Fred mistakes a shrub for a dog, believes he is threatened, and feels fear as a result. Beliefs, like all propositional attitudes, do not have to be directed towards existent objects. In consequence, the falsity, groundlessness, or irrationality of a propositional attitude does not justify the denial that someone can have it. A belief remains a belief which someone holds, however false, groundless, or irrational it may be. Of course, if the propositional attitude which is a component of the emotion is inappropriate in one or more of these ways, then the emotion it causes will also be inappropriate.

The propositional component of an emotion does not by itself provide that emotion with adequate identity conditions. Returning to the example of Fred and the dog, the belief that he is threatened is not sufficient to discriminate between (for example) an emotion of fear that Fred feels in the circumstances and an emotion of pleasurable excitement. Furthermore, nothing has yet been said about what is arguably most characteristic about emotions: their psychological and physiological aspects.

Each emotion has a 'phenomenological profile' which, together with the propositional content, is sufficient to provide the requisite identity conditions for the emotions. When I introduced my example, I said that Fred's belief that there is a dog running towards him causes various physiological and phenomenological changes. Such a belief may cause such involuntary occurrences as, for example, fluctuations in the pulse-rate, adrenalin flow, and rate of sweating. The subject may be conscious of some of these changes (such as a thumping heart) and not of others (such as changes in the rate of sweating). Although Fred will be conscious of a thumping heart *as* a thumping heart, he will not be conscious of (for instance) an increase in adrenalin flow as an increase in adrenalin flow. Instead it might appear as excitement, tenseness, or both. In addition, there will be what Malcolm Budd has called the emotion's 'hedonic tone' (Budd 1985*a*: 129). It is characteristic of emotions to be pleasant or unpleasant. Fear, for example, involves feelings of distress and unease, while joy involves feelings of pleasure.

We are now in a better position to appreciate de Sousa's notion of 'paradigm scenarios' introduced in the previous chapter. These involve two aspects: 'a situation type providing the characteristic *objects* of the specific emotion type' and second 'a set of char-

acteristic or "normal" *responses* to the situation, where nor-
mality is first a biological matter and then quickly becomes a cul-
tural one' (de Sousa 1987: 182). In other words, we build up our
stock of emotion concepts by bracketing together propositional
attitudes of a certain sort with the responses they character-
istically cause: those which constitute the emotion's phenomeno-
logical profile. An emotion is a compound of some proposition
to which the subject assents (putting aside, for the moment, the
question of whether this assent need be a belief) and various
other states, possibly including other cognitive states (such as
desires) and physiological and phenomenological states. The
usual pattern of causation is as follows. The subject is caused to
adopt a certain proposition attitude, usually as a result of some
sensory information. This propositional attitude causes various
other states and together these constitute the emotion.

2. In a recent book Patricia Greenspan agrees that an emotion is
a compound of the elements I have described; as she puts it,
'affective states of comfort or discomfort and evaluative propo-
sitions spelling out their intentional content' (Greenspan 1988:
4). She disagrees, however, with the characterization of the non-
cognitive aspects of the emotion. I have claimed that these are
physiological and phenomenological states which, because they
are devoid of cognitive content, are not 'object-directed'.
Greenspan argues that it is a 'brute fact' that the affective states
are 'object-directed': in fact, their object is the cognitive content
of the emotion (Greenspan 1988: 3). I would like to explain why
I am not going to help myself to this view.

Greenspan draws a contrast between having an affective
state towards a belief and having an affective state as well as a
belief. In the first instance, to use her example, I might have
feelings of unease towards the thought that a salesman is dis-
honest. This is a case of suspicion, and 'is not just like chills or
shudders, or even general discomfort, accompanying an evalu-
ative thought in the way that a headache might accompany the
thought that I am losing out in a business transaction'
(Greenspan 1988: 5). Greenspan is contrasting having a belief *as
well as* some affective states with having the phenomenologically
more unified experience of an emotion. To account for this con-
trast she claims that the affective states of the latter are object-

directed. One must, of course, grant the contrast Greenspan draws. In Chapter 9 I argue that this same contrast appears to pose a major problem for the view of art and emotions I shall be advocating. Greenspan's view of the emotions would solve this problem at a stroke. Such help—that which comes at such little cost—poses a problem. For Greenspan's account does not have sufficient independent motivation, and would, therefore, be an *ad hoc* solution to the most serious problem which has been posed for the view which I advance. Against Greenspan's assumption of the object-directedness of affective states is the powerful consideration that the object-directedness of cognitive states is explained in terms of the object-directedness of the propositions that are their content. As affective states do not have such propositional contents, their object-directedness would be a mystery. Rather than fly in the face of this orthodoxy, I shall present an alternative account of the contrast drawn by Greenspan.

This contrast is also employed by Robert C. Roberts as an argument against any account of the emotions as a complex of simpler mental states. The following, he says is 'a fact that an account of emotions must accommodate': 'Emotions are typic-ally experienced as unified states of mind, rather than as sets of components (for example, a belief + a desire + a physiological perturbation + some behaviour)' (Roberts 1988: 184). I am happy to admit this phenomenological claim without, however, admit-ting that it necessarily has anything to do with the analysis of the emotion. For example, it might be that of the components described by Roberts, only the physiological perturbation has any phenomenological presence. If this were the case, the phe-nomenological unity of the emotion would not imply that it could not be analysed into simpler states. I will explore this in greater detail in Chapter 9.

3. In this section I will examine the narrow cognitive theory of the emotions: the thesis that the propositional ground of an emo-tion must be a belief. This is a strong, constitutive claim: namely, anything that does not include a belief is not an emotion. Narrow cognitivism, as I describe it, rests on two powerful arguments: that we acknowledge a logical connection between emotion

and belief, and that there is an intimate connection between emotions and actions.

Before considering these two arguments, I want to consider a slight complication. It is difficult to see that any belief is essentially involved in the thrill of downhill skiing, and yet such a thrill can plausibly be called an emotion (Mothersill 1986: 514). What this shows is that not all kinds of what we might call psychological experience are object-directed. This property of propositional attitudes, and therefore of the emotions which involve them, serves to distinguish these states in particular from experiences which fall under another psychological category: those which I shall call 'feelings'.[3] In distinguishing these two categories of psychological experience, I do not want to claim that there must be a very clear distinction in the experiences themselves, nor that an emotion term cannot also rightly be used for a feeling which differs from the emotion only in lacking its cognitive component. Thus on one occasion we might want to call an instance of fear an emotion, because it had an object (fear of something), and on another a feeling because it did not; that is, because it was objectless.[4] Any psychological taxonomy contains a whiff of stipulation (or at least of regimentation of usage) and mine is no different. The distinction between mental states which are and those which are not about something is, however, reasonably obvious and marking it contributes much to clarity. For instance, the example presented above of an apparently objectless emotion, the thrill which people experience during downhill skiing, I will henceforth call a feeling; and similarly with other objectless states, such as lethargy and excitement.

This distinction is not between states which have typical causes and those which do not. The fact that feelings are not object-directed does not preclude them from having typical causes. We may feel excited because of some exciting event we are witnessing without a belief about that event being a component of our subsequent state. An event can be a typical cause of

[3] It is not part of my claim that this twofold classification will be sufficient for all purposes. It might, for some purposes, be useful to distinguish other categories (moods, for example).

[4] In this particular case we might well mark the difference by using different words. Fear, we might say, is the emotion of which, perhaps, anxiety is the corresponding feeling.

excitement in the same way that a poor night's sleep can be a typ-
ical cause of lethargy, without being in any sense the object of
that psychological state. It is the presence or absence of the rel-
evant propositional attitudes, notably belief, which I shall take
to distinguish emotions from feelings. The other two components
of these two kinds of psychological states, the phenomenologi-
cal and the physiological, I shall take to be characteristic of both.

An emotion is distinct from a feeling, then, in having a cog-
nitive aspect. But must this cognitive aspect necessarily be a
belief? Above I mentioned that there are two arguments to this
conclusion. For the first, let us return to Fred and his fear of the
dog. The argument is that unless Fred believes he is threatened
by the dog, he cannot be afraid of it. Whatever he feels just would
not be fear unless it was accompanied by a belief that, at some
level, he was threatened. The point has been made by Robert
Solomon: 'A change in my beliefs (for example, the refutation
of my belief that John stole my car) entails (not causes) a change
in my emotion that John stole my car. I cannot be angry if I do
not believe that someone has wronged or offended me' (Solomon
1976: 185). Changing this to my example, if Fred became con-
vinced that what he thought was a large dog was in fact an ex-
ample of topiary, his feeling—if, indeed, he continued to feel
anything—could not be fear. The emotion does not make sense
without the belief, so the belief must be (at least partly) consti-
tutive of the emotion.

The second argument concerns the connection with action. I
have assumed that belief is one of a sort of psychological state
known as a propositional attitude; that is, an attitude to a pro-
position which is the content of the state. I shall further assume
that the so-called functionalist account of such attitudes is cor-
rect; that is, that they can be defined in terms of their place in a
causal network of inputs, outputs, and connections with other
mental states.[5] A belief, for example, is caused by some charac-
teristic input and will, in combination with the requisite desire,
combine to cause behaviour or dispositions to behaviour.

It is also characteristic of emotions that they cause behav-

[5] See Armstrong 1968: ch. 16 and Putnam 1975: ch. 21. For an introductory
account, see Smith and Jones 1986: Pt. 2.

iour. It is, to take William Lyons's example, 'not uncommon for someone to say something like "Jealousy caused Jones to stab his wife outside the bar"'. This he takes as a decisive argument for identifying emotions with cognitive rather than non-cognitive states.

if we substitute the phrase 'a particular feeling' for 'jealousy' in the sentence . . . we get, 'A particular feeling caused Jones to stab his wife outside the bar', which begins to look odd. This oddity is compounded if we now substitute for the phrase 'a particular feeling' the phrase 'a feeling of throbbing and constriction about the heart'. For if we now transcribe the sentence as 'A feeling of throbbing and constriction around the heart caused Jones to stab his wife outside the bar' it becomes more or less absurd. For feelings themselves don't lead to behaviour. They only do so if they are connected to wants and desires of some sort. (Lyons 1980: 7)

On Lyons's account the cognitive element of emotions is an evaluation: a belief as to the worth of something. This account has no problem in rationalizing the link with action.

The evaluation of the object, event or situation, which the subject of the emotion makes, leads one both rationally and causally to certain specific desires, which in turn lead to behaviour in suitable circumstances. For example, the fearful person's evaluation of the object as dangerous gives that person a good reason for wanting to avoid or be rid of the object. A feeling does not provide one with a good reason for wanting to do anything and so for action. An evaluation does, particularly the evaluation involved in emotion, for such an evaluation, being of the world or some aspect of it in relation to the agent's needs, interests or values, generates desires to change the situation vis-à-vis the subject, or else to prolong it. (Lyons 1980: 65)

In summary, it is particularly plausible to explain the connection between emotions and action as another instance of the well-attested connection between beliefs, desires, and action. Taken together with the earlier claim that some emotions do not make sense in the absence of the corresponding beliefs, we have a strong case for narrow cognitivism.

It should not be thought that the combination of the belief and desire constituents of the emotion are *sufficient* to cause action, however. Fred may believe John's pain will be alleviated by the administration of his insulin; he may desire to alleviate his pain and yet not act because he does not know how to administer

insulin. Action would only be caused if among Fred's background beliefs is one about how to administer insulin. I shall call these beliefs—that is, beliefs necessary for appropriate belief/desire pairs to result in action—'instrumental beliefs'. Such beliefs are not themselves constituents of the emotion; they are there before the emotion is caused, and remain after the emotion has ceased. They are part of the acquired background we might use to get around the world. Of course, the need for such instrumental beliefs does not, on its own, undermine narrow cognitivism.

4. Against narrow cognitivism is the thought—stressed in much recent literature—that it does not do justice to the complexity of emotional reaction.[6] Patricia Greenspan is one such critic. Her argument begins with a simple example of 'phobic response' (Greenspan 1988: 17–20). She imagines an agent who, since being bitten by a rabid dog, has felt fear in the presence of all dogs. This includes Fido, a harmless old hound, well-known to the agent. In Fido's presence, the agent feels fear. This is not merely the physiological and phenomenological aspects of fear, but includes a cognitive content. The agent does not, however, *believe* the cognitive content. Instead, he might 'feel as though' Fido is likely to injure him. The absence of belief is clear from the fact that the agent feels no inclination to perform such actions as warning others against Fido. Greenspan concludes that

Instead of supposing that his beliefs come into momentary conflict whenever Fido comes near, it seems simpler, and preferable from the standpoint of rational explanation, to take this as a case where emotion parts from judgment. It exhibits the tendency of emotions, in contrast to a rational agent's beliefs, to spill over to and to fix on objects resembling their appropriate objects in incidental ways. (Greenspan 1988: 18)

It is not clear how best to construe phobias psychologically, although Greenspan's account seems as plausible as any. Once the moral of Greenspan's example has been grasped, it is not difficult to find other examples to encourage scepticism about narrow cognitivism. Robert C. Roberts describes a scenario in which a person's long-rejected belief that black people are sub-human

[6] Places where this view is expressed (apart from those cited here) include Calhoun 1984 and Leighton 1984.

is the cognitive component of an emotion that comes over that person when his sister brings home a black boyfriend: 'an emotion is no less an emotion for being irrational' (Roberts 1988: 195). Of course, there are ways of construing this which preserve narrow cognitivism. The person in question could have beliefs about black people being sub-human (as evidenced by his emotion) but not believe he has such beliefs (as evidenced by his disavowals of racism). To sort this out we shall have to return from intuitive to more philosophical argument. Before doing that, however, I want to show why this is directly relevant to my current concerns.

If narrow cognitivism were true, it would confirm the view discussed in the introduction: that occasions in which emotions are experienced (or emotion terms applied) in the absence of a belief will be philosophically problematic. The relevant cases in which there is a strong prima facie case for emotions that *do* involve cognitive states other than beliefs are those which arise in response to fiction. For example, the passage describing the walk during which Mr Darcy proposes to Elizabeth Bennett leaves the reader with what appears to be compassion for the two lovers. However, the reader does not take *Pride and Prejudice* to report events which actually happened; he does not believe there to have been such a walk taken by such people. Hence, if the mental state which is aroused is compassion, it is, contrary to narrow cognitivism, compassion which does not involve a belief.

The simple considerations Greenspan and Roberts present against narrow cognitivism do not engage directly with the arguments in its favour. We are therefore left both with arguments for the theory *and* reason to be sceptical of it. As a first step towards resolving this unsatisfactory state of affairs, I shall return to de Sousa's claims about paradigm scenarios.

5. Recall that paradigm scenarios involve two aspects: first, a situation type providing the characteristic cognitive components of an emotion type, and second, a set of characteristic or 'normal' responses. As stated in the previous chapter, de Sousa does not believe that the concept grasped initially in the paradigm scenario is forever linked to that narrow circumstance. Paradigm scenarios

are drawn first from our daily life as small children and later reinforced by the stories, art, and culture to which we are exposed. Later still, in literate cultures, they are supplemented and refined by literature . . . That is why, as Iris Murdoch has put it, 'The most essential and fundamental aspect of culture is the study of literature, since this is an education in how to picture and understand human situations'. (de Sousa 1987: 182–4)

This suggests a way of making sense of the tensions between the two views given above. On de Sousa's view, our grasp of an emotion develops from the paradigm scenario in a number of ways. One key way is the appreciation of literature. What we need to ponder is the extent to which the connections grasped in the paradigm scenario can be added to or abandoned without changing the type of emotion for which it is the scenario. In particular, supposing that in the initial paradigm scenario the emotion involves a belief, can the person's grasp of that emotion extend so that he can apply the emotion term correctly to occurrences *not* involving belief?

Consider, once again, the example of fear for oneself. The paradigm scenario will link the proposition specifying the ground of the fear with the characteristic fearful response. The question is whether the subject would be right to include as examples of fear for himself situations in which he does not believe he is threatened. One could say, in the spirit of narrow cognitivism, that a diver who has complete faith in his shark-cage could not frightened for himself when watching an approaching Great White. To be in such a state, he must believe that he is in danger, and he could not have this belief if he believes he is safe. It would be better to describe his condition differently; as shock, for instance. On the other hand, the feelings the diver is experiencing are characteristic of the paradigm scenario in which the emotion of 'fear for oneself' is grasped. Is this not a good ground for describing his condition as 'fear for himself'?

I am not going to attempt an answer to that question just yet, but instead I will look at other emotions which seem less amenable to a narrow cognitivist construal: namely, emotions felt for other people. These include fear, compassion, pity, joy, and so on. Let us concede to the narrow cognitivist that the paradigm scenario for each of these emotions would involve a belief. Characteristically, the beliefs which are part of the para-

digm scenarios for emotions felt for oneself concern relations between the person holding the belief and the immediate environment. For example, the paradigm scenario for fear for oneself will involve the belief that, here and now, one is threatened. By contrast, the characteristic beliefs which are part of the paradigm scenarios of emotions felt for other people need not concern the relation between the person holding the belief and the immediate environment. Emotions felt for other people characteristically involve beliefs about how the world may affect *those* people. There need be no possibility of interaction between the situation and the person holding the belief. To anticipate future discussion, it would be quite in order to feel an emotion for someone else as the result of encountering a representation, even when that representation described events with which the reader did not, or could not, interact. Hence, we can begin to see what de Sousa means by developing our emotions through reading literature. Literature does not concern the relation between us and our environment, but the relation (albeit fictional) between various characters and their environment. So it looks as if there is at least a possibility of our feeling emotions for them. I shall argue in Chapter 4 that this is important in sorting out our emotional reaction to fiction.

6. Finally in this chapter I want to consider the appropriate reaction to the expression of emotion by other people. On encountering a person who is expressing sadness (for instance), how is it appropriate to react? One way, of course, is to form the belief that they are sad. In this, reacting to the expression of sadness does not differ from reacting to many other things. The bare formation of a belief is not really an adequate response: the expression of an emotion is itself an appropriate cause of an emotional reaction. As an appropriate cause, it is not surprising to find that a proposition such that a person is expressing sadness, joy, or some other emotion is itself a characteristic cognitive component of an emotion.

What sort of reaction, for example, do we usually have to the sadness of others? Typically, perceiving their sadness makes us sad too, because we are able to sympathize with their situation. That is, we use our imagination to appreciate what it is like for

them; we imagine what it is like to feel bereaved or injured. But there is more to it than that. The emotion of the other stems from their awareness of—for instance—the death of their cat, while our emotion stems from our awareness of their sadness (at the death of their cat). So although our imaginative identification with a sad person will result in a sympathetic feeling of sadness in us, the emotion of which this feeling is a component will not be the same. The propositional content of our emotion (that they are sad because their cat has died) will be different from the propositional content of theirs (that their cat has died). This difference in what the emotion is about turns it into a different emotion: not just sadness, but *pity*.

Our pity does not of course differ from the sadness to which it is the response only in the proposition it involves; for that difference itself generates others. For example, while pity shares many of the phenomenological and physiological components of sadness, these will not usually be as intense as those of the sadness that prompts it. There is a good adaptive reason for this. The difference in the propositional content involved in pity and sadness naturally leads to different dispositions to action. Part of our normal reaction to somebody in distress is to try to alleviate that distress; we want to help, and our being less distressed than they are may render us better able to do this. Pity, then, is really a quite different emotion from sadness. It is usually less intense; it takes different objects and is characterized by different dispositions to action. What the sad person we pity is disposed to do, faced with what is distressing them, will usually be quite different from what our pity for them will dispose us to do.

In other cases, the emotion with which we react will not be of a different type to the one being expressed. I might react to the expression of a friend's joy with joy; I like to see him happy. The two emotions may still embody different propositions: my friend is joyful about his exam results, I am joyful at the fact that he is happy. In both cases, however, it is joy which is being felt. Whether or not such 'reactive emotions' (as I shall call them) are of the same type as the emotions to which they are a reaction, the point remains that we do not characteristically react to the expression of emotion with the bare formation of a belief. As a general rule, such a reaction would be inappropriate; the char-

acteristic response to such situations is another emotion, whether of the same or of a different type.

The belief that someone is sad is (characteristically) a propositional content for a different emotion to that which has as a propositional content the belief that someone is happy. Such differences are not particular to reactive emotions—the belief that I have won the race is (characteristically) a propositional content for a different emotion from that which has as a content the belief that I have lost the race. At a later stage of my argument I shall utilize the claim that, for a range of emotions, the belief that a particular emotion is being expressed is (characteristically) the cognitive component of a specific and distinct emotion or set of emotions. That is, each of those beliefs has a distinct emotion or set of emotions of which it (characteristically) is a cognitive component.

The view that it is possible to match reactive emotions with expressed emotions in a context-independent way has been criticized by Stephen Davies (Davies 1994: 197). He is right to the extent that it would be absurd to claim that there is a single emotion which is an appropriate reaction to (for instance) the expression of joy in each and every case. Joy would be an appropriate reaction to a friend's joy at hearing some good news. It would not, by contrast, be an appropriate reaction to a thief's joy at stealing my car. In order to produce a context-independent match of reactive emotions with emotions, I will need an idealized background. I do not mean a background beyond all experience; I mean one in which the identity of the reactive emotion is determined simply by the identity of the emotion being expressed, rather than the reasons for its being expressed at that particular time and place.

Consider a 'reasonably sympathetic person': someone who is emotionally affected in some measure by the expression of emotion in others. Also consider a 'reasonable expressor of emotion'; someone who can express an emotion in a way that is neither too indulgent nor too reserved. If the former met the latter, and all he knew was that the latter was in a particular emotional state, would it be possible to predict how the former would react? Given the provisos below, I claim that it would indeed be possible. Our predictions would rely on our beliefs as to what would

be the 'default option' when reacting to someone expressing an emotion. We are not at a loss if asked what would, all things being equal, be the appropriate reaction to joy, sadness, grief, or whatever.

My claim, then, is that it would be possible, against this idealized background, to correlate a reactive emotion or group of emotions to the expression of each of a range of emotions. The claim is more plausible the broader the level of description: joy is an appropriate reaction to joy, sadness an appropriate reaction to sadness. It also seems plausible with respect to slightly more specific emotions: pity is an appropriate reaction to pain and sympathy an appropriate reaction to grief. Obviously, it becomes less plausible as the descriptions of the emotions become more specific. In Chapter 8 I will use this contingent psychological fact to explain some general characteristics of music criticism.

To return to the general point, I hope, in what follows, to use the fact that the appropriate reaction to the expression of emotion is itself an emotion to provide a unified account of the emotions in the central case; in our reaction to fiction and our use of expressive judgements. How this happens will, I hope, become clear as the argument unfolds.

3

'Fearing Fictions'

1. I have argued that fictions appear to cause emotions which do not involve beliefs. Reading the passage in *Pride and Prejudice* in which Mr Darcy proposes to Elizabeth Bennett causes a state which seems, to the reader, very like compassion. To claim that it *is* compassion would contradict narrow cognitivism, for it would allow the existence of an emotion the cognitive content of which was other than a belief. But if this state is not compassion, what is it? This is, you will recall, what I have called the 'definitional problem' of our emotional reaction to fictional characters and situations. If narrow cognitivism is true and emotions essentially involve beliefs, what is it we feel towards fictional characters and situations which do not involve beliefs?

In the previous chapter I provided two arguments for narrow cognitivism: that it seems impossible to feel some emotions in the absence of the relevant beliefs, and that beliefs are needed to provide the connection between emotion and action. Given that we do not believe the contents of works we know to be fictional, whatever is an argument for narrow cognitivism is also an argument for the existence of the definitional problem. In this chapter I will look at the first argument; in the following chapter I shall look at both together. The underlying claim of the first argument is that it is simply not possible to feel (for instance) compassion for someone without the belief that they have done something to deserve it. As informed readers do not believe that Mr Darcy proposed to Elizabeth Bennett, what they feel cannot be compassion. Colin Radford makes this point, in the paper that introduced the definitional problem to contemporary philosophy. Imagine, he says, that

you have a drink with a man who proceeds to tell you a harrowing story about his sister and you are harrowed. After enjoying your reaction he then tells you that he doesn't have a sister, that he has invented the story . . . once you have been told this you can no longer

feel harrowed . . . the possibility of being harrowed again seems to require that you believe that someone suffered. (Radford 1975: 69)

We can agree with Radford that, in this instance, it would border on incoherence to continue to feel harrowed in the absence of the relevant belief. This is not, however, to concede all to the narrow cognitivist. For, as we saw in the last chapter, there are other circumstances in which our intuition would surely be that we *can* feel harrowed without the relevant belief. For example, if the man with whom you have the drink is Leo Tolstoy, the tale he is spinning might be affecting independently of whether or not you believe it. Someone opposed to narrow cognitivism could argue that, far from being a problem case, the fact that we feel emotions towards characters we know to be fictional demonstrates that narrow cognitivism is false.

One philosopher who takes this approach is Noël Carroll.[1] Carroll uses an example made famous by Kendall Walton, that of fear of a carnivorous, but fictional, 'Green Slime':

what we might wish to reject is the presumption that we are only moved emotionally where we believe that the object of our emotion exists. The possibility of denying this premise of the paradox opens [another] avenue of theorizing, one that is based on the conjecture that it is the thought of the Green Slime that generates our state of [horror], rather than our belief that the green slime exists. (Carroll 1990: 80)

As I indicated in the last chapter, this seems a promising line of thought. The argument, however, is unlikely to convince the narrow cognitivist. There is, he will retort, an obvious difference between the thought that one is threatened and the belief that one is threatened. It is only if one has the latter that it makes sense to feel fear for oneself. If Charles believes he is perfectly safe (as presumably he does) it does not matter what thoughts he has, what he feels cannot be fear for himself.

In order to substantiate his account, Carroll would need to answer the two arguments given for narrow cognitivism and show why, in the case of fiction, the mere thought that something has happened, rather than the belief, can be a constituent of an emotion. I shall try to do this in the next chapter. In this chap-

[1] Similar solutions can be found in Weston 1975, Rosebury 1979, and Lamarque 1981. For criticism, see Damman 1992.

ter I will look at the best-known account of our emotional reaction to fictional characters; an account which needs to do none of these things as it is compatible with the narrow cognitive theory.

2. The account is by Walton himself, who, over the years, has argued that a solution to the definitional problem can be wrung from the concept of make-believe. Here is his example in more detail:

Charles is watching a horror movie about a terrible green slime. He cringes in his seat as the slime oozes slowly but relentlessly over the earth, destroying everything in its path. Soon a greasy head emerges from the undulating mass, and two beady eyes fix on the camera. The slime, picking up speed, oozes on a new course straight towards the viewers. Charles emits a shriek and clutches desperately at his chair. Afterwards, still shaken, he confesses he was 'terrified' of the slime. (Walton 1990: 196)

Before we can understand Walton's assessment of Charles's confession, we need to clarify the concept of make-believe. Walton takes children's games as his paradigm; his example is one in which tree stumps count as bears. Such games are based on a set of conventions: in this case, that tree stumps are to be bears. The stumps become a *prop* in the game and generate fictional truths (Walton 1990: 37). If there is a tree stump in the undergrowth, it is fictional that there is a bear in the undergrowth. The other important point is that the participants in the game of make-believe are themselves props (reflexive props) who therefore also generate fictional truths (Walton 1990: 209). If Gregory strikes a tree stump, it is fictional that Gregory strikes a bear. As will become apparent, Walton's intricate account defies easy simplification, but this brief comment is enough for my purposes at the moment.

What of Charles? Walton concedes immediately that 'Charles' condition is similar in certain obvious respects to that of a person frightened of a pending real-world disaster. His muscles are tensed, he clutches his chair, his pulse quickens, his adrenaline flows' (Walton 1990: 196). But Walton does not think that this 'physiological–psychological' state (which he calls 'quasi fear') constitutes fear because 'to fear something is in part to think one

is endangered by it' (Walton 1990: 197). Charles, knowing he is in the cinema, has no such thought. So how are we to understand Charles's state? If quasi fear is not fear, what is it?

Walton's answer is that Charles is participating in a game of make-believe. In this game there are at least two props; the shape on the screen is a prop for the dangerous slime and Charles is a prop for himself. It is clear from Walton's description of what is happening in the cinema that it is fictional that the slime is threatening Charles. As a result of this fictional truth Charles goes into the state he does. But Charles's state is part of the game of make-believe which itself generates a fictional truth: namely, that Charles is feeling fear. As Walton puts it: 'He experiences quasi fear as a result of realizing that fictionally the slime threatens him. This makes it fictional that his quasi fear is caused by a belief that the slime poses a danger, and hence that he fears the slime' (Walton 1990: 45). It is make-believe that Charles is afraid in as much as his experience of quasi fear is caused by his belief that it is make-believedly the case that he is in danger. In the introduction I asked what could justify the 'real world' response of emotion to the 'other world' content of fiction. Walton's reply is that the viewer's response is itself of the 'other world'; it is not emotion, but make-believe emotion. It is on the same level as, part of the same game as, the fiction. As Charles's reaction is not an emotion, it is not a counter-example to the narrow cognitive theory.

3. Walton's account is often dismissed on the grounds of a criticism which, on the face of it, simply does not apply.[2] This is the claim that the account is not true to the phenomenology of our emotional reaction to fiction. As Noël Carroll puts it:

Purportedly, when we recoil with apparent emotion to *The Exorcist*, we are only pretending to be horrified. But I, at least, recall being genuinely horrified by the film. I don't think I was pretending; and the degree to which I was shaken by the film was visibly apparent to the person with whom I saw the film. Walton's theory . . . does not seem to square with the phenomenology of [horror]. (Carroll 1990: 73–4)

[2] See, for example, Carroll 1990: 73–4, Novitz 1987: 84, Boruah 1988: 66. A defence of Walton against this criticism can be found in Neill 1991: 49 and Matravers 1991a. The defence is implicit in Budd 1985a: 129.

Of course, a viewer could be *genuinely* horrified by a film, in the sense that they think it is disgusting or amoral that such a film should ever come on public display. This is not what Carroll means. Such a reaction is not relevant to aesthetics; its object would not be parts of the content of the film (the slime, for example) but the film itself. To change the example, there is a difference between a viewer being 'scared' in the cinema because the slime is coming to get him, and being scared because he thinks the film might bring on an epileptic attack. The latter sort of reaction is philosophically unproblematic; it is a case of fear which is caused by, and has as a part, a belief. It is the former sort of reaction which concerns us here. Given, then, that Carroll is talking about the former, he could mean one of two things. He could mean that the qualitative character of the experience of reacting to *The Exorcist* is incompatible with its being make-believe, or he could mean that he was not aware, when reacting to *The Exorcist*, that he was indulging in make-believe.

In what way could the qualitative character of the emotional experience be incompatible with make-believe? Carroll's thought must be that Walton implies that what is felt is somehow a pretend emotion; something that we do not really feel but only pretend to feel. But Walton claims no such thing: according to him Charles does experience every aspect of fear apart from the belief that he is in fact threatened. There is, in principle, nothing to prevent this experience being as intense as the real experience of fear, as Carroll himself appears to admit (Carroll 1990: 71). The sole ground for this objection seems to be an inference from Walton's claim that it is make-believedly the case that Charles feels fear to it being the case that Charles feels make-believe fear (where 'make-believe fear' is not a real experience, but an experience Charles pretends to have). As this inference is not valid, the objection fails.

Carroll's worry might be that if Charles is playing make-believe, he ought at least to be aware he is doing it. But of what ought he to be aware? According to Walton, Charles feels quasi fear when he believes it is make-believe that he is in danger. During which part of the process will he also have the belief that he is playing a game of make-believe? Not in what he actually feels, because quasi fear is, as we have seen, simply a collection of physiological and phenomenological states. Hence, Charles

does not need to be conscious of participating in a make-believe in order to feel those states. Furthermore, the link between the quasi fear and the belief is simply causal, so Charles is not even aware of that (see the footnote to Walton 1990: 245). Hence, if Charles is conscious of the make-believe at all, this belief will figure in the only part of the process not yet considered: the belief that it is make-believe that he is threatened.

For Charles to be conscious of the make-believe, he will need to believe it to be make-believedly the case that the prop which represents the slime is threatening the prop which represents himself. Carroll's denial that Charles believes this could take one of two forms. He could deny that Charles has beliefs about props or he could deny that Charles has beliefs about make-believe. In response to this, Walton can grant that is true that the movie-goer has no *conscious* beliefs about props, but argue that this is because these conventions that characterize the 'game' have been internalized. The prop he is shown on the screen is similar in appearance to the character it plays; so much so that his imagination is likely to be not contrived, but 'spontaneous' (cf. Walton 1990: 23). To support his claim, Walton can evoke explicit games of make-believe. When a child playing mud-pies sees five globs of mud in a box, he imagines there are five pies in the oven. In imagining this, he is not *conscious* of the globs of mud being props for pies. Analogously, Charles is not *conscious* of the image on the screen being a prop for the slime.

What goes for the belief about props also goes for Charles's beliefs about participating in a game of make-believe. They are an internalized (and non-conscious) set of beliefs about the principles of the game. But what are the grounds for Walton's claim that Charles has these non-conscious beliefs? Alex Neill has pointed out that the make-believe account can only explain what Charles is feeling if it attributes to him acceptance of the principle that 'when Charles experiences "quasi fear" as a result of believing that make-believedly he is threatened, then it is make-believe that Charles is afraid' (Neill 1991: 50). The question then arises (and perhaps it is best to construe Carroll's doubt this way) as to whether the movie-goer (i.e. Charles) accepts this. Walton admits there is no explicit acceptance of such a principle, but argues that Charles is implicitly committed to it. If, on finding that a glob of mud is six inches across, a child claims this as

the size of his pie, we can infer that he accepts the principle whereby the size of the glob determines, in the make-believe, the size of the pie. Analogously, Charles's disposition to claim that he is afraid on feeling quasi fear commits him to the principle that his feeling quasi fear (in the appropriate circumstances) determines, in the make-believe, that he is afraid.

But, as Neill points out, the two cases are not analogous. We assume the child knows as well as we do that the globs of mud are not really pies, hence there is no option but to attribute the principle. Not to do so would be to attribute to the child an inability to recognize the difference between pastry and mud. There is no similarly compelling reason to discount taking Charles's claim to be afraid at face value. It requires some sophisticated philosophy of mind to grasp the concept of quasi fear, which is something we have no reason to attribute to Charles. It is far from clear, says Neill, 'that it would be illegitimate to attribute to Charles, on the grounds that he pre-reflectively thinks of and describes himself as afraid of the slime, acceptance of a (fallacious) principle according to which his experience of quasi-fear makes him (actually) afraid' (Neill 1991: 50–1).

Walton considers and rejects this point. He points out that we do not take Charles literally when he says 'There was a ferocious slime on the loose; I saw it coming', so why should we take him literally when he says 'Boy, was I scared!' (Walton 1990: 197)? There is good reason for Walton's desire to rid himself of the burden of proof. If there were two adequate accounts of Charles' behaviour, one of which attributed fear to him whilst the other attributed quasi fear, the fact that Charles describes himself as scared would be a reason to favour the former. Because the self-attribution of a mental state verges on the incorrigible, Walton's account is open to being trumped by another account which takes Charles at his word.

Furthermore, Walton's attempt to shift the burden of proof does not stand up to scrutiny. There is no reason for Charles to endorse a literal interpretation of his first claim. He knows as well as anyone else that there is not a dangerous slime on the loose. The problem arises because he *would* endorse a literal interpretation of the second; Charles and the rest of us *do* believe that we feel the real-world response of the emotions to the other world of fiction. Walton therefore makes unjustified claims about

the mental state of the average movie-goer—there is no reason to attribute to such a person the principle that when he feels quasi fear it is make-believedly true that he feels fear.

Despite this criticism, the absence of an alternative account of Charles's mental state leaves Walton in a strong position. To take Charles at his word is to attribute to him a fear of an object in the absence of the characteristic propositional ground for fear: the belief that he is threatened. If we accept narrow cognitivism, Charles's belief that he feels fear is false. Perhaps what we ought to do is present Walton's account as a prescriptive rather than a descriptive theory; as recommending the adoption of the principles that constitute make-believe in order to cure ourselves of error (Neill 1991). By distinguishing between emotions and quasi emotions we can retain the commitment to narrow cognitivism.

Further worries remain, however. Alex Neill and Greg Currie have argued that the theory does not distinguish sufficiently between the psychological attitudes of participants in a game of make-believe, and those of people observing the game. Suppose I am watching a game of mud pies.[3] There is a difference between my attitude to the pies and the attitudes of the children playing the game. Let us suppose that I am aware of both the rules of the game and the role of the globs of mud. I believe that it is make-believe that (for instance) there are a dozen pies in the oven. But Johnny, who is playing the game, not only believes this, he also *makes-believe* that there are a dozen pies in the oven. If he does not have this particular psychological attitude, it is difficult to see the difference between an observer who is only watching the game and Johnny who is actually playing it. Neill puts the point neatly: 'The difference between Johnny and me is that his standpoint is *internal* to the game, mine is *external*. From the external standpoint, one has *beliefs* about what is make-believedly the case relative to the game. From the internal standpoint, one *makes-believe*' (Neill 1991: 51). As it is essential to Walton's account that Charles does participate in the game of make-believe with the slime, Neill argues that it needs to be amended so as to make the claim that Charles *makes-believe* that he is threatened by the slime.

[3] The example is a simplified version of that found in Neill 1991: 51. See also Currie 1990*b*: 210.

The point can be made by distinguishing between make-believe as a propositional attitude and make-believe as an operator on propositions (see Currie 1990*b*: 210). Walton argues that Charles has the familiar attitude of belief towards a certain proposition, the content of which is that a certain make-believe proposition holds. Neill's point is that as Charles is a participant in a game of make-believe, we have to credit him with the propositional attitude of make-belief towards the content of that embedded proposition. That is, Charles is caused to feel quasi fear by his make-believing that he is threatened by the slime.

Walton recognizes the need to distinguish within the theory between the mental states of participants in a game of make-believe and those of 'mere onlookers' (Walton 1990: 209). His solution preserves the claim that a participant in a game believes that certain make-believe propositions are true, and, instead, makes the distinction in terms of another important but familiar concept: the imagination. It is part of his theory that a proposition is make-believe if there is a mandate that it be imagined. Hence Charles, as a participant, not only believes it is make-believe that he is threatened, he is also mandated to imagine this situation. Onlookers, however, recognize no such mandate. They can rest content with simply believing that such a make-believe proposition obtains. Hence the difference between Johnny and myself in the example above is that, while we both believe it is make-believe that there are a dozen pies in the oven, only Johnny is mandated to imagine this to be so. It is his being in this psychological state which qualifies him as a participant in the game of make-believe.

In the absence of a detailed theory of the nature of make-belief and imagination, this seems merely to be a terminological variant of Neill's position. I shall adopt Walton's terminology, and talk of the imagination. Imagination is Walton's main concern and it plays a central role in his account. Although he has no fully-fledged account, the concept is discussed and partially analysed. An important distinction is that between 'imagining *de se*' and 'propositional imagining': 'Imagining from the inside is one variety of what I will call "imagining *de se*", a form of self-imagining characteristically described as imagining doing or experiencing something (or being a certain way), as opposed to imagining merely that one does or experiences something or

possesses a certain property' (Walton 1990: 29). I will return to
this distinction shortly, after saying a little about propositional
imagining. According to Walton, propositional imagining is—
along with beliefs and desires—a type of propositional attitude.
That is, to imagine that p is to take a certain attitude to the
proposition p. It is more than simply to entertain p, as p can be
entertained without being imagined. Walton has several argu-
ments for this view, but one will suffice.

suppose Dick thinks to himself that it is not the case that San Francisco
will have an earthquake by 2000. He would seem to be entertaining
the proposition that San Francisco will have an earthquake by 2000 as
well as its negation . . . Imagining (propositional imagining), like
(propositional) believing or desiring, is doing something with a propos-
ition one has in mind. (Walton 1990: 20)

Walton does not pretend this is an adequate account, but it is
enough to work with. As he says, '"Imagining" can, if nothing
else, serve as a placeholder for a notion yet to be fully clarified'
(Walton 1990: 21).

4. I shall follow Walton and consider the games of make-believe
played with depictions before tackling linguistic representations.
At least, I shall discuss briefly the nature of the game played with
depictions and then contrast it with the game a reader might play
with a literary work. In the original child's game of make-believe,
my looking at or being near a tree stump would make it fictional
that I looked at or was standing near a bear. Similarly, with a
painting (Walton's example is Hobbema's *Wooded Landscape
with a Water Mill*) the viewer's 'actual act of looking at the paint-
ing is what makes it fictional that he looks at a mill' (Walton
1990: 293). That is, in both these cases it is interaction between
the participant and the prop which generates fictional truths
about the corresponding object. From this, it is a short step to
an account of depictive representation: 'The depictive content of
a work is a matter of what or what sorts of things it is fictional
(in the appropriate visual games) that one sees when one looks
at a picture' (Walton 1990: 297).

 In the standard case, no such perceptual games of make-
believe are appropriate for the reader of a novel.

Novels are not props in perceptual games of the appropriate sorts.

When one reads *Madame Bovary* it is not fictional that what one sees is Emma, not even when one looks at passages describing her appearance. Although the reader may imagine seeing Emma, he does not imagine his perceptual act to be a perceiving of her, nor is his visual experience penetrated by the thought that Emma is what he sees. (Walton 1990: 295–6)

What, then, is the appropriate game of make-believe for a reader of a literary work to play? Walton argues that the nature of the game varies from case to case. It is fictional of the reader of *Gulliver's Travels* that he reads the journal of Lemuel Gulliver and, furthermore, he can imagine the act of reading his paperback to be the act of reading that journal. It is fictional of the reader of an epistolary novel such as Richardson's *Pamela* that what he reads are letters from various people. However, there is no such obvious role in the reader's game of make-believe for a paperback edition of *Madame Bovary* or *Diamonds are Forever*.

In the child's game of make-believe, tree stumps became props for bears by 'an initial stipulation or agreement' (Walton 1990: 23). This being done, the presence of a tree stump at a certain place generates the fictional truth that there is a bear at that place. Tree stumps are not bears; that is what makes the propositions they generate fictionally but not really true. What analogous tale can we tell for the sentence 'Darcy was not of a disposition in which happiness overflows in mirth; and Elizabeth agitated and confused, rather *knew* that she was happy than *felt* herself to be so'? In other words, how is this sentence (in my paperback) a prop in a game of make-believe and what is the fictional truth it generates?

Ignoring various complexities for the moment, the game a reader is mandated to play can take one of two forms. In the first, the sentences in my book would be reflexive props (that is, they play themselves). The propositions the reader would be mandated to imagine would be the ones expressed by the sentences. The game of make-believe would be like that mandated by *Gulliver's Travels* or *Pamela*: the reader would make-believe that the paperback is a report by a narrator of certain events. (I shall call this 'the report model'). The difference between *Gulliver's Travels* on the one hand and *Pride and Prejudice* on the other is that, in the game of make-believe, the games mandated by the first provide answers to questions concerning the

relation between the text and the reported 'events'. It is Lemuel
Gulliver who tells us about the Yahoos, but who tells us about
Darcy and Elizabeth Bennett? Where does she get all her infor-
mation?

The second form of make-believe we could play with a liter-
ary work is to keep the work outside the game by taking it to
be a recipe for a certain play of imagination. It would be as if
someone had said 'let us imagine that . . .' and then given us the
content of the novel to imagine. (I shall call this 'the recipe
model'). The sentences, although props, do not play themselves
(or indeed play anything) in the game. In the previous case the
paperback itself is part of the game—it is imagined to be a jour-
nal, report, or whatever. In the second it is a recipe for playing
a game in which it does not itself appear.

Walton himself favours the report model, arguing that a nar-
rator needs to be part of the make-believe if we are to make sense
of certain aspects of our interaction with literary works. He has
three arguments for this. First,

> we are so used to declarative sentences being employed to report events
> and describe people and situations that, when we experience a literary
> work, we almost inevitably imagine someone's using or having used
> its sentences thus. And it is scarcely a strain to regard these nearly
> unavoidable imaginings to be prescribed. (Walton 1990: 365–6)

In other words, the situation we are in when reading a novel is
sufficiently similar to a situation in which we are reading a report
of actual events (made by someone or other) that it is entirely
natural for us to imagine that the novel is just that, a report of
actual events (made by someone or other). I shall develop this
argument below.

The second argument is that 'the words of many or most lit-
erary works contain hints of feelings or attitudes or inclinations
or impressions concerning the events of the story that are best
attributed to a narrator' (Walton 1990: 366). For example, in
Mansfield Park, it is not only Fanny Price who disapproves of
the amateur dramatics; the way the tale is told makes it clear that
the narrator does so too. The narrator contrasts the integrity of
the position taken by Fanny and—initially—Edmund and the
mean, ignoble motives which drive the willing actors. She also
uses terms such as 'fortunately', 'sadly', 'apparently', and so on

to convey an attitude. So the fact that fiction is read as a report of actual events gives the author the opportunity to ascribe to the narrator an opinion on the events in the book. This provides a further dimension with which the author can work, which greatly adds to the complexity of the result. A great deal more could be said about this argument. Narrative commentary in fiction is not always as explicit as I have implied; it can take many different forms and is almost ubiquitous. It would be impossible to make a case for this without writing another book. Fortunately I am able to refer the reader to Wayne Booth's *The Rhetoric of Fiction*, which, despite occasional confusions, marshals impressive evidence for this point (Booth 1991). If, as Booth implies, all fiction contains some narrative commentary, then all appropriate games of make-believe we play with fiction will have a narrator.

The third argument specifies a distinctive kind of narrative commentary; it does not give information, but rather makes necessary affirmations.

[S]ometimes in 'real life' it is important to us that certain things be said or certain attitudes expressed, even if everyone involved fully realizes the truth of what is said or shares the attitudes expressed . . . So one would expect it to be important, sometimes, that it be fictional that things be said and that it be fictional in our games that we hear them said, quite apart from our learning that they are fictional and/or our fictionally learning or knowing that they are true. It is not enough to suppose merely that the words of the text make it fictional that the propositions expressed are true or the attitudes appropriate. (Walton 1990: 366–7)

In the light of these arguments, Walton claims that, when reading all (or almost all) literary works, we play ourselves, and the work plays a report of events as relayed by some narrator.

I have not abandoned the search for a solution to the definitional problem in favour of clarifying the game of make-believe readers play with fiction; the two issues are closely linked. The definitional problem concerns mental states that arise within the game. Once the nature of the game is clarified, and the role of those mental states within the game has been specified, it will be seen that narrow cognitivist objections to classifying them as emotions are without foundation. To that end, we need now to look at the nature of the mandated games of make-believe. The

three arguments given above, together with the arguments I give
below, lead me to the conclusion that the report model provides
the appropriate game to play with works of fiction. If there is no
narrator in the text, or if there is commentary in the text which
cannot be attributed to the explicit narrator, we need to postu-
late the existence of a narrator in order to tell the tale. This might
be the only role the narrator has in the game.[4] As this argument
for a fictional narrator stems from the structure of the make-
believe rather than any evidence in the text, it is immune to argu-
ments which take as a premiss that there are fictions in which
there is no explicit narrator.[5] This is not to say that such narra-
tors are precluded from playing any further role; the narrator
might—as Walton argues above—comment on the action or
express certain attitudes. He might even, like Marlow in *The
Heart of Darkness*, be a character in the narration itself.

 Walton himself stops short of this. He thinks that a 'thin' nar-
rator would not be worth having.

A work whose words are merely such that, fictionally, there is someone
or other who utters or writes them does not thereby have a narrator. To
speak informally, the words must, fictionally, be those of a *particular*
character. Readers are to imagine not just that the words are uttered
or written by someone; they are to imagine someone's uttering or
writing them, or someone's having done so. (Walton 1990: 355)

Walton's claim is that, within the game, the narrator must not
simply be the person, whoever he is, who has made the report.
He must play a role in the game as some particular person who
is making or who has made the report. If there is no such 'par-
ticular character' then, presumably, Walton would favour using
some other model for the game of make-believe. Walton speci-
fies two different imaginative tasks: imagining that the words are
uttered or written by someone and imagining someone's uttering
or writing them. I believe the former is usually mandated by a
game of make-believe played with a literary work and, for this
reason, the report rather than the recipe model is appropriate for
such a game.

 [4] In this I am in agreement with Greg Currie who sanctions this possibility as
the usual case (Currie 1990*b*: ch. 2).

 [5] For an example of such an argument, see Conter 1991: 324.

5. There is, in this particular area, and possibly even in the philosophy of mind generally, an element of artifice in supposing that every psychological state will fall into one or other of a number of pre-ordained categories. Hence the claim that, in reading a fiction, we only ever imagine *that* the words are uttered or written by someone, rather than imagining someone's uttering or writing them, will be open to counter-examples. There is no reason to suppose that all the games of make-believe we play with fiction will conform to a single easily-described type. However, there is a general consideration which should make us favour the report model.

Recall Walton's claim that imagining *de se* is 'characteristically described as imagining doing or experiencing something (or being a certain way), as opposed to imagining merely that one does or experiences something or possesses a certain property' (Walton 1990: 20). The difference seems the same as that Richard Wollheim makes between 'envisaging' something and 'merely thinking about' it:

When I envisage a scene or situation, it is no longer simply that there is a thought before my mind—of which I may ask whether it occurs to me or whether I think it—there is now, let us say, a person or a group of persons before my mind. What is meant by this is that I am now able to say how the person looks, what he is doing or wearing here and now, what present feeling he arouses in me—not necessarily all these things, some of them—in a way which is not open to me if I am merely thinking of him. (Wollheim 1969: 37)

Intuitively, the difference is clear; imagining being selected to play cricket for England is not imagining that one is selected to play cricket for England. Whilst I am happy to grant the difference, I am more sceptical than Walton as to the scope of our imagining *de se* when reading a literary work. Most of our imagining, I will argue, is simple propositional imagining.

What activity is being mandated within the game of make-believe generated by a novel? Are we to imagine *de se* or imagine *that* something? Walton sanctions both forms of imagining.[6] I want to argue that any *de se* imagining performed by the reader

[6] Propositional imagining is his standard construal, although non-propositional imagining is not neglected. See, for example, in the quotation at p. 39: 'Although the reader may imagine seeing Emma . . .' (Walton 1990: 295).

must be compatible with the actual experience he is undergoing at the time. That is, the experience of the game of make-believe must not compete with the experience of reading the book—the actual experience of running one's eyes along sentences. In Walton's words, the experience of imagining and the experience of reading must be able to be 'integrated into a single complex phenomenological whole' (Walton 1990: 295).

It is not obvious that the experience of imagining *de se* can be integrated with the actual experience of reading a book. The problem can be dramatized by comparing our experience of literary works with our experience of depictions. According to Walton, looking at a picture of a mill makes it fictional that the viewer is looking at a mill. The viewer is to imagine doing something, that is, imagine he is looking at a mill. There is at least a hope of integrating this experience, imagining looking at a mill, with the viewer's actual experience, looking at a picture of a mill.[7] It is more difficult to see how we could integrate the experiences of reading the sentence 'Emma groomed and dressed herself with the meticulous care of an actress about to make her debut' and the experience of imagining doing something: in this case, seeing Emma groom and dress herself in such a manner.

The absence of an account of imagination makes it difficult to establish that there is a phenomenological incompatibility between reading a sentence and imagining the content of that sentence. However, if we want an account that preserves the unity of experience, we could not do better than the report model. In the actual world, one is sitting in a chair reading the sentences of a novel. In the make-believe world, one is sitting in a chair reading the sentences of a report. The phenomenology of imagining seeing Emma Bovary—or even of imagining hearing the narrator speak—is different from the phenomenology of reading a book. If one were to hold that imagined experiences had a definite phenomenological presence, imagining seeing Emma Bovary (or hearing the narrator speak) would be a distinct experience from that of reading a book; so distinct that it might be difficult for the two experiences to happen simultaneously. If this were the case, the only *de se* imagining compatible with the actual experience would be that of imagining one is

[7] I shall argue shortly that even this would be a misconstrual.

reading a report of the tribulations of one Emma Bovary. The reader imagines of his reading the paperback that it is the reading of such a report. The contents of the report are not—this being fiction—believed. Rather, the reader imagines that they are true. Walton's gives clear examples where this is the game mandated by the work: *Gulliver's Travels* mandates the reader to imagine he is reading the journal of Lemuel Gulliver. What he is fact is doing is reading a book which is make-believedly the journal of Lemuel Gulliver. Hence, what the reader is mandated to imagine is what in fact he is doing: reading a book.

In short, the fundamental advantage the report model has over any other is that it makes a place for the sentences that are being read; they occupy the same place in experience in the make-believe as they do in the actual world. Any model that requires that we find no place for the sentences that are part of our experience is, to that extent, flawed. It is no part of my claim that the experiences prompted by reading are not rich and varied (quite how rich and varied we will come to in Chapter 5), only that a place has to be found within the make-believe for the reading itself. The content of a literary work is imagined propositionally rather than *de se*. This propositional imagining all falls within the scope of a single act of *de se* imagining: the reader imagines his experience of reading the work to be the experience of reading a true account. As the reader is performing an activity (reading a novel), it is natural for him to imagine performing a similar but different activity (reading a report). Within the scope of this *de se* imagining, he imagines that the propositions expressed in the report are true.

6. I stated in the introduction that my definition of fiction covered not only novels, but films, plays, and even paintings. The nature of the *de se* imagining will obviously vary between the different media. When a member of a cinema audience watches a film in which Indiana Jones is threatened by a boulder, he does not imagine *reading* a report of Indiana Jones threatened by a boulder; he imagines *viewing* a report of Indiana Jones threatened by a boulder. Or so I will argue for the remainder of this chapter. In doing this I will argue against an alternative view: that the appropriate game of make-believe to play with the visual

media is not to imagine viewing a report, but to imagine viewing the events themselves.

I have argued that the experience of reading about Emma Bovary dressing cannot be satisfactorily integrated with imagining seeing Emma Bovary dress. Consider now seeing an episode of a film in which Emma Bovary dresses. Surely this experience is easily integrated with that of seeing Emma Bovary dress? In the same way as there is no experiential incompatibility in both reading and imagining reading, there is no experiential incompatibility in seeing a film of a woman dress and imagining seeing a woman dress.

The proposal is that we play 'perceptual games of make-believe' with the visual media. That is, seeing a film of Emma Bovary dress mandates the viewer to imagine seeing Emma Bovary dress. The alternative is the suggestion I have made for literary works; that the viewer imagines seeing a report of Emma Bovary's life, part of which involves imagining that Emma Bovary dresses. There is an obvious consideration which favours the former proposal (which I shall refer to as 'the perceptual model'). Recall Walton's first argument for the report model: that our situation when reading a novel is sufficiently similar to a situation in which we are reading a report of actual events (made by someone or other) that it is entirely natural for us to imagine that the novel is just that, a report of actual events (made by someone or other). Or, to apply the argument to this particular case, it is the fact that the situation we are in when reading a novel is sufficiently dissimilar to a situation in which we (for instance) see the actual events that it is difficult for us to imagine seeing the events whilst reading the novel. However, the experience of seeing a film of Emma Bovary dress seems more similar to seeing Emma Bovary dress than it is to receiving a report of Emma Bovary dressing. Therefore Walton's first argument, applied to this case, seems to support the perceptual model rather than the report model.

This argument has intuitive appeal. It does seem natural, when sitting in the cinema, to imagine seeing Emma Bovary dress or Indiana Jones threatened by a boulder. Greg Currie has pointed out, however, that this intuition can be undermined.

Imagine the ways in which a storyteller might tell his story. He might describe the events in words. But instead (or in addition) he might act out a shadow play with his hands. Going further, he might use glove

puppets and then marionettes. Extending his resources still further, he might rope in others to assist, telling them what movements and sounds to make. From there it is a short step to the conventions of theatre and cinema. Through the successive extensions the teller tells his tale—he simply uses more and more elaborate means to tell it. (Currie 1990b: 95)

It is fortunate that the intuitive case for the perceptual model can be undermined, because it is dogged with insuperable problems. I shall look at two of these, and then dismiss one apparent argument in its favour. For simplicity's sake, I will concentrate on examples from the cinema.

The first of these problems (a development of which proves the key to the solution of the definitional problem) concerns the different kinds of interaction it is possible for a viewer to have with a film. Let us assume that the perceptual model is correct, and that the viewer is mandated to imagine watching Emma Bovary dress. It is fictional, therefore, that he is watching her dress. It is also fictional that the viewer *can* help Emma to get ready on time by folding up her clothes (cf. Walton 1990: 241). However, it cannot be fictional that he *does*. Furthermore, as Walton remarks, 'in appreciators' games psychological participation tends to outrun and overshadow physical participation' (Walton 1990: 240). Despite the fact there is nothing a viewer can do which would make it fictional that there is physical interaction between the viewer and the character on the screen, facts about the viewer make it fictional that there is psychological 'interaction'. The viewer, in feeling the appropriate quasi emotions, makes it fictional that he feels awe, envy, terror, hatred, and so on for the characters on the screen.

What can be said about these apparent anomalies? How can it be fictional that I can help someone, but not fictional that I do? Why is it that physical interaction is problematic, but psychological interaction not? According to Walton it is because there is no understanding within the game of make-believe whereby anything the viewer does would count as making it true in the fiction that he physically interacts with the character (Walton 1990: 194). This is a brute fact about the make-believe; it is just the way the game is played. An advantage the report model has over the perceptual model is that it has an explanation of why it is played this way. The range of things the viewer is able to make true in the game of make-believe played with the film corresponds to the

range of things the viewer would be able to make true were he faced with a report.

Take as a comparison a documentary film of a man struggling with his luggage. There is nothing a viewer of this film could do to physically interact with that man. He is, however, able to pity, admire, or get angry with the man. In viewing a report, physical interaction is impossible but psychological interaction is not. Hence, if in a game of make-believe the viewer is viewing a report these are the limits we should find on his interaction. This is exactly what we do find, so this is a good reason to prefer the report model.

The second reason for preferring the report model is that it is far better able to account for the action in films which is presented from a certain point of view. I shall use Walton's own example. In Fritz Lang's *You Only Live Once*, the final shot shows Eddie's last visual experience before he dies. (An earlier shot in the film shows the world from the point of view of a frog.) How is the viewer to cope with this on the perceptual model? It seems as if he must imagine being the person, the sole person, who has these visual experiences. The argument has been put by Greg Currie.

[I]n film . . . a single scene may be divided into many shots from different perspectives. As shots succeed one another we don't have any sense of changing our perspective on the action. Those familiar with the conventions of cinema hardly notice the cutting as the camera moves from one face to another. Many camera perspectives would be difficult or downright impossible to achieve; viewing the earth from deep space one minute, hanging from the ceiling in a drawing room the next. In some films what we would have to make believe in order to make sense of our being observers of the scene would be wildly at variance with the conventions of the story. For example, in *The Lady in the Lake*, a film of Raymond Chandler's detective story, the action is depicted through the eyes of Philip Marlowe. If we are to make believe that we are literally seeing events through Marlowe's eyes, the story would seem to have become a science fiction fantasy. This is not the impression created in the viewer's mind while watching the film. (Currie 1990*b*: 93–4)

Walton is aware of the danger of boxing himself into this corner. He suggests the viewer can either imagine himself to be Eddie (to return to his example) having his final visual experi-

ence, or imagine he is having a different token of the same type of experience Eddie is having (Walton 1990: 344). I agree with Currie that the first option ought to be rejected: this is not the impression created in the viewer's mind while watching the film. I am not impressed by the second option Walton offers us; at least not for the examples we have been given. What is it to imagine having a token of the type of experience of the last visual impression Eddie has before his death which is not imagining that one is Eddie having this experience? Unlike (for instance) the experience of toothache, this experience cannot be specified except as *Eddie's* experience. Similarly, with Currie's example, it is not enough to imagine a token experience of looking at a drowned woman in a lake one has to imagine one is having the experience of *Philip Marlowe* looking at a drowned woman (or perhaps even looking at the drowned woman one believes to be Muriel) in a lake. I cannot see how to do this without, at that moment, imagining one is Eddie or Philip Marlowe.

None of these problems arise if the film is taken to be a report of what Eddie or Philip Marlowe saw. The viewer only need only play a game in which he is seeing a report of events, including a report of what Eddie or Philip Marlowe saw. This is perfectly compatible with the experience of sitting in the cinema watching a visual presentation. Once again, the difference is that in the make-believe the report is true whilst in the real world it is a fiction.

Now to the apparent problem for the report model. The following exchange occurs in *Romeo and Juliet*:[8]

ROMEO: So shalt thou show me friendship. Take thou that. Live and be prosperous, and farewell good fellow.
BALTHAZAR [*aside*]: For all this same, I'll hide me hereabout.
His looks I fear, and his intents I doubt.

The apparent problem is that it seems as if Balthazar is directly addressing the audience. On the report model, the viewer is mandated to imagine that what he sees is a report of actual events. That is, he is to imagine the content of the play is a report of events that have happened elsewhere. It cannot, therefore, be part of the content of the play that Balthazar addresses a

[8] Most of the examples are Walton's own.

member of the audience when and where the play is performed. No such problem arises for the perceptual model. It is not incompatible with the game of make-believe in which the viewer imagines watching Romeo and Balthazar that, within the game, the viewer is addressed by them (Walton 1990: 232).

The report model would not be caused a problem if the aside were spoken by a narrator. In *How Right You Are, Jeeves*, we find: 'I don't know if you happen to take Old Doctor Gordon's Bile Magnesia, which when the liver is disordered gives instant relief, acting like magic and imparting an inward glow?' (Walton 1990: 229). One of the functions of the narrator, as we saw with Walton's second and third arguments, is to make statements to the reader. To take another example, again from the stage, Vindice begins *The Revenger's Tragedy* with the following speech:

> Duke: royal Lecher: go, grey haired Adultery,
> And thou his son, as impious steeped as he:
> And thou his bastard true-begot in evil:
> And thou his duchess that will do with devil:
> Four excellent characters!

If we adopt the report model, the likely candidate for narrator is Vindice. Within the game of make-believe, this speech can be taken as a preliminary to a tale—the teller introducing his 'characters'. It is a different matter if one of those characters addresses the audience.

This criticism—that the report model cannot make sense of characters addressing the audience—is a two-edged sword. Being addressed by a character in fiction is, in common experience, disconcerting. Any account of fiction should reflect this fact. The fact that the report model has problems accounting for such asides might even count in its favour. With this in mind, let us look at a possible defence.

The argument is, once again, due to Greg Currie.

In these cases I think the members of the audience come to play a dual role. They are both spectators *of*, and actors (or sometimes merely props) *in*, the production. They play characters participating in the action and it becomes make-believedly true that they are those characters. But they are still members of the audience, and as such they observe themselves playing these roles. As members of the audience they

are to make believe that they are taking part in a *representation* of actually occurring events, not that they are participants in those very events. (Currie 1990*b*: 96)

It is as if the narrator has encouraged one of the people helping him present the story to seek out recruits among the audience when appropriate. When addressed, the audience occupy a dual role as both spectators of, and participants in, the narration. This duality is uncomfortable, which accounts for the audience's feeling disconcerted.

An alternative defence would take the disconcerting nature of asides seriously and regard them as straightforward violations of the make-believe. The character, in addressing the audience, does not abide by the 'rules'. Games, and not just games of make-believe, can absorb violations provided they do not become prevalent. For example, if you are beating me at chess, I might even-up the sides—and make a better game of it—by pocketing your queen or exchanging a pawn for a knight. A player in a side losing badly at soccer might catch the ball with his hands and kick it into the opposing team's net. An archer might run to the target and stick his arrow in the bullseye. Such events are in no way part of the game, although they can only happen within the context of a game.

Some asides to the audience can only be construed as violations of this sort. In Stoppard's *Rosencrantz and Guildenstern are Dead*, Rosencrantz bellows 'Fire!' at the audience, and then remarks (whilst looking at the audience): 'Not a move. They should burn to death in their shoes.' This can be accounted for neither on the report nor on the perceptual model; in neither case can the content of the play be about the state of the theatre. Indeed, *Rosencrantz and Guildenstern are Dead* derives much of its humour from not allowing the audience to play any consistent game of make-believe. In the earlier example, Balthazar's aside is perhaps a 'cheating' way to communicate his inner thoughts.

Finally, I want to turn this point back onto the perceptual model. If it is fictional that we are looking at the characters in a drama, why is it so seldom fictional that they are looking at us? What accounts for its being disconcerting when they do? Walton's answer to the first question is the same as the one he gave to account for the differences between physical and

psychological interaction: it is conventional within the game that no such interactions occur: 'the question is out of place, silly. The appreciator does not ask why fictionally no one pays any attention to him. And it is not fictional that he wonders why no one does or that he tries to come up with an explanation' (Walton 1990: 236). There is nothing to be said against this answer as such: Walton has every right to appeal to the conventions which he takes, as a matter of fact, to be operative. However, the fact that the report model has the explanation as a corollary rather than as an additional hypothesis must be a point in its favour.

Walton's explanation of why asides happen less often than the perceptual model would lead us to expect is comparatively weak:

different appreciators will behave differently in front of the work; what fictionally they say and do, what they choose to attend to and how, what they mutter under their breath will vary greatly, and some will behave in ways the artist did not foresee. So the artist cannot fit her characters' responses to what, fictionally, the appreciator says or does . . . If fictionally Papageno, in Bergman's rendition of Mozart's opera, appeals to the appreciator for sympathy, it may be fictional that the appreciator willingly complies, or that he brushes off the request with disdain, or that he ignores it. (Walton 1990: 235)

Surely Walton exaggerates the problem. It is not as if the appreciator has *carte blanche* on how to react; there will be an *appropriate* reaction determined by the content of the piece. It is just not an option, if one is seriously engaged in a game of make-believe generated by a pantomime (for instance), to boo the dame and cheer the villain. The artist *can* fit his characters' responses to what, fictionally, the appreciator says or does only if the appreciator responds appropriately. Of course, the appreciator does not have to react appropriately. He *can* play what game of make-believe he likes. But, obviously, if he is to get out of the work what the artist intended him to do (and this must, in general, be a consideration: cf. Savile 1969) he must respond in the way the work dictates (even if it dictates him to suspend judgement). It seems, then, that the report model has a better account both of audience/character interaction when it occurs, and of why it does not occur often.

The proposal I wish to make may be distinguished from a recent proposal by Greg Currie. In his book, *The Nature of Fiction*, Currie argues that the report model should be accepted

for the visual media, and, indeed, I have made use of several of his arguments above (Currie 1990*b*: 94–5). However, in a more recent paper he seems to have shifted ground slightly. He argues that the relation we bear to the events on the cinema screen is not at all perceptual. We are not even to make-believe we are seeing a report. Rather,

what I make-believe in the context of a theatrical performance or movie concerns the events of the fiction, not any supposed perceptual relations I bear to those events. My make-believe is not that I see the characters and the events of the play; it is simply that there are these characters and that these events occur. (Currie 1991: 138)

Currie seeks to solve the problems associated with specifying a perceptual game of make-believe by simply abandoning it. This looks to be a version of the recipe model; the scenes played out in front of the viewer have no role to play inside the make-believe. My objection to this is the same as my objection above; the viewer is conscious of the pictures on the screen, and surely it is more plausible that the game of make-believe fits in with this than that it does not? If our consciousness is filled with things that are outside the game, where is the game being played?

The point can be made if we contrast the way we play the game in the cinema with a game which does match Currie's description. Imagine lying in bed in an unfamiliar large, gloomy, creaking old house. One hears a door bang, and rustling downstairs. One begins to imagine someone has come through the door. Then one hears a sound which could be a drawer being opened, which prompts one to imagine a knife is being fetched. This is followed by creaks on the stairs, a plodding sound in the passage and until finally the door of the room is blown open by a gentle breeze. All these are props that mandate that there is a character and that events occur, but it is a very different game of make-believe from that which is prompted in the cinema.

Jerrold Levinson's reply to Currie's paper puts forward a proposal which keeps the perceptual element. I said above, and I think that consideration of these two views reinforces the point, that there is something unsatisfactory about trying to find *the* game of make-believe played with fictions. The arguments which can be marshalled tell against some candidates amongst which we have to choose, but are not decisive in favour of one in

particular. Apart from the arguments, what we need to rely on
are intuition and explanatory power. Hence, I would claim to
have decisively despatched neither the account by Currie I have
already considered nor that by Levinson which I am about to
consider. I do not think, however, that either has the advantage
over the report model.

Levinson proposes that we make-believe that we see the char-
acters and actions, but not from the positions implied by the
intrinsic perspective of the successive shots:

> we simply imagine that something or other—some mechanism, perhaps,
> or some marvellous power—is facilitating our seeing as if from a given
> point without our actually being at that point, when to imagine we
> are at such points would generate excessive cognitive dissonance.
> (Levinson 1993*b*: 74)

Levinson clarifies his position in a footnote.

> One such means—though I should stress that no particular filling in of
> how the result is achieved is part of the content of what we imagine
> about what we are seeing—would be a system of infinitely extendible
> and movable mirrors that convey the sight or vision of X to any other
> position in the spatial world to which X belongs. (Ibid.)

According to Levinson, we do see the events before us as they go
on. However, we do not see them as they go on before us. That
is, he has preserved the intuition that the game has a perceptual
element, but abandoned something we might think goes along
with this, that what we see is happening where we see it.

The report model claims that what we see is a representa-
tion, the content of which is happening elsewhere. Levinson goes
along with this, except he claims that the link between the rep-
resentation and content is causal, but otherwise unmediated. I
have agreed that there is some intuitive motivation for the view
that we are in direct perceptual contact with what is happening
on the screen, although I have tried to dispel it above. Set against
that is the thought that, although there is no commitment to
thoughts about the nature of the causal link being conscious, it
is difficult to see how an intuitive motivation could be given for
such links being part of the make-believe. Furthermore, the
proposal inherits some of the problems with the perceptual
model: it entails that we imagine the events are brought to us in
'real time', so how can we account for months passing in min-

utes or for people growing old in seconds? How do we account
for *The Lady in the Lake*? No number of mirrors will take us
behind Marlowe's eyes. When Levinson considers the latter
problem, he is forced to appeal to the report model to explain it
(Levinson 1993*b*: 76). Much better, surely, simply to take the
report model as standard?

7. In this chapter I have endorsed a slightly narrower view of the
position offered by Walton. The appreciator (to use Walton's
phrase) engages in a game of make-believe in which he imagines
the contents of the representation are related by a narrator as
known fact. Consider how the usual case of reading a novel
emerges on this construal. We imagine reading a true account,
where this does not require us to do anything except read the
book and imagine that the contents are true.[9] Apart from the
work itself, which generates the fictional truth that there is a nar-
rator to tell it, there are no props except reflexive props. The sen-
tences in the book play the sentences being read, and we play
ourselves.

There are two points at which the account needs supple-
menting. First, we can no longer rely—as Walton does—on an
unanalysed causal connection between the props in the game and
the effect they have upon the observer. The connection between
the child dropping a glob of mud and imagining he has dropped
a pie is immediate enough for Walton to claim that his imagin-
ing just causes him to feel quasi upset. Similarly, the vivid way in
which Charles is manipulated into imagining that he is threat-
ened by the slime makes the simple causal link to his quasi fear
plausible. But imagining that I am having a tale related to me
does not put me in immediate confrontation with the charac-
ters *in* the tale. As a result it is not immediately apparent how I
can be caused to feel quasi emotions on their behalf. What is
needed is an account of how a representation can cause us to feel
quasi emotions towards those things of which it is a representa-
tion.

[9] I am not claiming that the content of the novel is identical to the claims made
by the narrator within the make-believe. Such an identity is precluded by unreli-
able, confused, or ignorant narrators. There is some complex function that takes us
from these claims to the content. I return to this point, although I do not resolve it,
in the next chapter.

Secondly, more needs to be said about communication. The game of make-believe we play with literature is to treat the text as the report of a narrator (who might himself figure in the text). Hence, within the game, the propositions are assertions and are treated as such. In the next chapter I will shift the focus to this part of the theory: treating works of literature as reports of events and looking at how the story is communicated to the reader. Once this is done, it will emerge that readers' claims to feel emotions can be taken at face value. As there is no need to reinterpret them, there is no need to impute to them internalized acceptance of principles of make-believe. We will be left with an account of fictional representation which does not have the problematic links with children's games of mud pies.

4

Engaging Fictions

1. In the last chapter I discussed Kendall Walton's attempt to account for our interactions with fictions by assimilating them to games of make-believe. I concluded that the standard game of make-believe we play with a literary work is to imagine the work to be a report by a narrator. In this chapter I intend to provide further arguments for this and to show that it does not cause the sorts of problem which led Walton to claim that we do not react to fiction with emotion. Hence, we will not need the kind of revisionary account he provides in order to rationalize the emotional reactions fictions provoke.

My argument will develop the point made in the quotation from Noël Carroll given in the last chapter. I shall argue, with Carroll, that we do not have to believe that Elizabeth Bennett has accepted Mr Darcy in order to feel compassion for them; we only have to imagine that she has. In other words, the fact that quasi emotions are felt within a game of make-believe does not mean they are not emotions. To argue this it will be necessary to show that the two arguments for the narrow cognitive theory are not conclusive. The fact that we do not believe what we encounter in fictions does not preclude our responding with genuine emotion.

The best argument for narrow cognitivism is, in summary, as follows. Emotions characteristically dispose us to action. Dispositions to action are explained by combinations of beliefs and desires. Hence, emotions embody beliefs and desires. Countering this argument was Greenspan's example of the phobic who fears and so avoids all dogs including Fido, whom she believes to be a harmless old hound. The phobic fears—and so avoids—Fido, yet does not believe he is dangerous.

Kendall Walton has suggested that the problem caused by our apparent emotional reaction to fictions is independent of the debate between Greenspan and the narrow cognitivists. For

Walton, it is not beliefs but action which is problematic: 'Fear is motivating in distinctive ways, whether or not its motivational force is attributed to cognitive elements in it . . . Fear emasculated by subtracting its distinctive motivational force is not fear at all' (Walton 1990: 201–2). In the last chapter I considered the argument that the connection between emotion and action shows that emotions embody beliefs. Hence quasi emotions, being devoid of beliefs, are not emotions. According to Walton, the detour through beliefs is unnecessary. Whatever the source, emotions have motivational force. Quasi emotions do not have motivational force and are therefore not emotions. Hence, Greenspan's claim does not undermine the case for quasi fear not being fear. I shall return to this below.

Greenspan's example does show how the other argument for narrow cognitivism provides no support for the view that quasi emotions are not emotions. This argument claims that a belief is necessary to provide identity conditions for an emotion, since the emotion's other components—its phenomenological and physiological components—are insufficient for this purpose. The argument, however, yields only the weaker conclusion that *a propositional attitude* is necessary to provide the requisite identity conditions. In Greenspan's example, the phobic's propositional attitude is able to play the right role in identifying the emotion, even though it is not a belief. It is the thought of danger, and it is a thought about Fido, but it does not amount to a belief. What *is* relevant to the identity of the emotion is the content of the propositional attitude, and the content can be possessed even by an imagined fictional proposition. Part of what makes the emotion I feel towards Mr Casaubon (of George Eliot's *Middlemarch*) dislike tinged with pity and sympathy, rather than simple hatred, is that the fictional proposition I imagine is that he is sincere and insensitive, rather than actively malicious. Hence, any argument from narrow cognitivism that we do not feel emotions towards fictional characters and situations will need to rely on the absence of the connection with action.

2. So far, in describing the arousal of emotions, I have, in the main, considered confrontations; circumstances in which the subject is face-to-face with the object of his emotion. On the functionalist account of mental states (which I have assumed), it

is true by definition that in confrontations in which normal folk-psychological explanations apply, it is beliefs which mediate between perception and action. I have argued that the game of make-believe that we play with fiction is to imagine it to be a report by a narrator. Let us move one step towards an account of this by putting confrontations to one side for a moment and considering emotional reactions to representations. Initially, I shall not consider fictional representations, but representations that are believed to be true (I shall call these 'documentary representations').

One difference between a confrontation and a documentary representation lies in the mechanism by which the beliefs are acquired. Instead of acquiring beliefs directly, the reader acquires beliefs via the representation. The readers' beliefs are caused directly by the author of the representation and only indirectly by the situation which the representation describes. This is not specific to written representations; it is a true of all communication (including speech). Reading (as Greg Currie has remarked) is the limiting case of conversation, where all the 'talking' is done by one side (Currie 1990*b*: 29). An explanation of how a reader can acquire beliefs from a written representation would be a special case of a general explanation of communication.

A general explanation of communication has been given by H. P. Grice. Grice is a clear exponent of his own views, and there are also several commentaries in the literature. Hence, I shall state the theory rather than argue for it.[1] The central claim is as follows.

'*A* meant something by *x*' is (roughly) equivalent to '*A* intended the utterance of *x* to produce some effect in an audience by means of the recognition of this intention'; and we may add that to ask what *A* meant is to ask for a specification of the intended effect. (Grice 1957: 46)

The application of the theory to written representations is straightforward. The reader is faced with sentences which he is aware have been put there with the intention that they should cause him to form various beliefs. He trusts the report, in that he

[1] Grice's theory has been used to explicate fiction in Currie 1990*b*: sec. 1.7. This contains a good explanation of Grice, as does Blackburn 1984: sec. 4.1–2.

does not believe the writer is attempting to deceive him. He therefore forms the requisite beliefs. The reader of a representation infers what the writer intends him to believe from what he reads, and *ceteris paribus* believes that.

Making the right inferences about what the author of a representation intends his readers to believe is, in several ways, more of a problem than getting the right beliefs when confronted by a situation. A representation produced for the purposes of communication is, implicitly or explicitly, produced for a particular audience. The author may assume that his audience has certain background beliefs necessary to make certain inferences which may well be necessary in order for the representation to be understood. For example, the following sentences: 'Marsh made no mistake when Gower got a thin edge off an off-swinger from Alderman'; 'Willis is a natural Number 10', could only be used to communicate with someone familiar with the background and language of cricket. To change the example slightly, different audiences might draw different conclusions from the same sentence. A modern sophisticate is likely to understand 'Jones's wife is a witch' as a metaphorical way of expressing the belief that Jones's wife is unpleasant. A sixteenth-century sophisticate would be just as likely to infer that the sentence expressed the belief that Jones's wife was in league with the devil.

This poses a problem for the reader. In order to understand a representation as it was meant, a reader will need to familiarize himself with the relevant background information possessed by the author's intended audience. He will then be able to make the inferences which would have been made by that audience (which will be the inferences the author intended be made) rather than those he might otherwise find natural. On the one hand, such advice is obvious—a passing acquaintance with seventeenth century demonology will be of use in understanding Shakespeare. On the other hand, this itself provokes philosophical problems: if the only way we can understand Shakespeare is through imaginative time-travel, this raises the question of the value of understanding him at all (cf. Williams 1993: ch. 1). I shall make no attempt to sort these problems out; I mention them simply to indicate what it would take to become a 'reasonable' or 'qualified' reader. A qualified reader is one familiar with the relevant background information possessed by the author's intended

audience, but which beliefs count as 'reasonable' will depend, in part, on his attitude to that information.

To read a novel is to make-believe that one is reading a report by a fictional narrator. The claim is that within the make-believe the Gricean mechanism explains how we grasp the content of the report. It might be thought that the Gricean mechanism, being a theory of meaning as well as communication, could be used to provide a way of specifying the content of a given fiction. Indeed, I think it can, although the full case for this cannot be made here. It is a sufficiently interesting problem, however, to merit a small digression.

In the last chapter I endorsed the view that to read a novel is to engage in a game of make-believe in which we imagine that the contents of the representation are related by a narrator as known fact. Is the content of a given fiction, then, what could reasonably be assumed to be in the mind of the fictional narrator (Currie 1990b: 75)? This view possesses a number of disadvantages, of which I shall mention two. First, there are problems with unreliable narrators. To take an example, the narrator of Ford Madox Ford's *The Good Soldier* does not believe many of the things that are part of the content of the novel. Second, there is a problem with narrators who are ignorant about general facts about the world. The narrator of Chaucer's *The Merchant's Tale* can reasonably be conjectured to believe the earth is flat. The earth, even then, was round even if nobody believed it was. Construing the content in terms of what is in the mind of the narrator is not the only Gricean formulation, however. Instead, we could hold that what specifies the content of a fiction is what a qualified reader would reasonably believe were he to believe the story was being (or had been) narrated as a documentary. Such a reader would believe of Ford's narrator that he was deceived, and believe of Chaucer's narrator that his cosmology was old-fashioned. The view faces a further obstacle, however, as we can see if we try to apply it to Beatrix Potter's *The Tale of Peter Rabbit*.

Clearly the beliefs one would form if *The Tale of Peter Rabbit* were being narrated as a documentary would be that the narrator was raving mad. The alternative would be to believe that there was a rabbit called Peter who spoke English and sported natty blue jackets. I have assumed that the hypothetical narrator

of our conditional is from the real world, where rabbits are not so clubbable. It is a version of what Walton calls 'the reality principle'; using the real world to guide us as to the content of a fiction (Walton 1990: 144, cf. Lewis 1978: 270). This is, of course, fine for realistic fiction. However, not all fiction *is* realistic; the particular problem with fiction is that it can contain the unbelieveable. On the principle I have advocated, the unbelieveable is also the unmake-believable. It would be most of the content of *The Tale of Peter Rabbit* that Peter was part of the delusions of a lunatic.

What is needed is a way to broaden the principle without altering the basic structure of the make-believe. I agree with Walton's conclusion that there is no simple formula which will deliver all and only the content of any given fiction (Walton 1990: 183 ff.). The way to reflect this indeterminacy is to introduce a second variable into the principle. As it stands, it calls for judgement as to whether it would be reasonable to believe a proposition in the hypothetical situation specified. It would obviously not be reasonable to believe rabbits talked and wore blue jackets. However, it *would* be reasonable if the narrator came from a world in which rabbits *did* talk and wear blue jackets. Modifying the principle along these lines, it becomes the following: what specifies the content of any fiction is what a qualified reader would reasonably believe were he to believe the story was being narrated as a documentary about some world or other. The flexibility in the principle comes from balancing what is true in the world of the narrator, and what is not true in what is being said by the narrator.[2]

3. I have argued above that all fictions are representations. Subsequently, I claimed that the mechanism by which we understand representations, whether within a game of make-believe or not, is that described by Grice. In this section I will begin to show that what have been taken to be problems with our relation to fictions are largely problems with our relation to representations. Hence, the solution to the definitional problem has less to do

[2] The idea of specifying content in this way can be found in Mellor 1990. I develop the idea in Matravers 1995 and 1997.

with the nature of fiction than it has to do with the nature of representation.

The crucial point to clear up is whether the arguments for narrow cognitivism apply to emotions caused by representations. For some representations, which I shall call 'transparent representations', the arguments do apply. The function of transparent representations is simply to cause beliefs. The only relevant fact about them is that they perform this task efficiently. As a consequence, transparent representations will tend to be unembellished. Utterly transparent representations are fairly uncommon, as the way information is presented is usually of some interest. The primary function of a wedding invitation is to invite the recipient to a wedding. Silver bells and pink hearts do not aid this process but, for better or worse, they are usually in evidence. On the other hand, the telegram was a medium perfectly suited to transparent representation: 'Married Fred yesterday stop Love Jane' would communicate the belief that Jane married Fred yesterday without embellishment.[3] Not all transparent representations are linguistic representations. The photograph of the corpse of Ché Guevara released in 1967 by the Bolivian government seems as unadorned as it is possible for a photograph to be.

To be transparent, a representation does not merely have to cause a belief. In general, the acquisition of a belief is only worthwhile when the belief is interesting to the person who acquires it (cf. Heal 1988). Paradigms of transparent representations are shopping-lists and notes to the milkman. Hence, the only people interested in a transparent representation will be those interested in that belief. What reason could there be to acquire an unadorned belief? Usually, the belief will fit into background beliefs the person already possesses and have a direct link to his desires and dispositions. In other words, the usual role of the belief will be cause an action, and, if appropriate, an emotion. The reader is not interested in a transparent representation *as a representation* but in the information it conveys. It is the message, not the medium, that is important.

Transparent representations are similar to confrontations in that it matters whether the relevant proposition is believed. If it

[3] Not all telegrams are transparent: cf. Hemingway's 'Upstick protest asswards'.

had been discovered that Ché Guevara was alive and that the photograph was a fake, it would have been irrational to persist in feeling sad that he was dead. Where transparent representations and confrontations differ is in the possibility of action caused by the acquired disposition. If Jane's mother is confronted with her daughter when it is made known that Jane has married Fred, she can act either by hugging Jane or by shouting at her, whichever she deems appropriate. If she acquires the belief by telegram, such direct interaction will not be possible. The same state of affairs is not usually represented to us and confronting us simultaneously; representations usually cause beliefs about what is happening elsewhere. Hence, the disposition caused by a transparent representation cannot usually be acted upon directly. There are, of course, actions the believer could perform; Jane's mother could telephone Gretna Green or send flowers. Similarly, a sympathizer in Europe in 1967 could organize a demonstration in protest at Guevara's death, but not—without travelling to where Guevara was and thereby turning the situation into a confrontation—attend his funeral.

These are both cases of the disposition being frustrated by spatial distance. Amongst our instrumental beliefs there are some which enable us to act despite such distances; we can use the post or telephone, put pressure on people on the spot to take immediate action, and so on and so forth. However, we have no instrumental beliefs—it is not possible for us to have any instrumental beliefs—which enable us to act directly over a distance.

Some representations refer to past events. It is impossible to be confronted by these events; we are separated by temporal distance. There are no instrumental beliefs—there could be no instrumental beliefs—which would enable us to interact with events once they have occurred. Jane's mother cannot prevent her newly-wedded daughter from having got married, however much she would like to. Her belief about the wedding might dispose her to other actions, however, such as buying a wedding present or altering her will. Although we cannot influence past events directly, beliefs about past events may alter our present behaviour.

4. Spatial and temporal distance hinders the disposition to action caused by transparent representations, although beliefs

about a distant event may cause actions linked to that event, even if we are not able to interact with the event directly. The more unbridgeable the distance between the representation and its object, the more this disposition to action will tail off to the bare minimum a functionalist can countenance: the truth of certain hypotheticals about how we will answer if certain questions are put. Of course, making these hypotheticals true is not itself a reason for troubling to read representations. The insight which is the primary motivation for Walton's theory is that, characteristically, representations are *not* transparent. The function of a representation is characteristically not simply to cause a belief (which may then cause an emotion), but to *engage* the observer in some way. In this, Walton is exactly right: we *do* characteristically engage with representations in ways that make them more than inessential media for conveying beliefs; there are many representations whose interest to us is not in the disposition to action they cause.

I do not mean to imply that the alternative to a representation's being transparent is that we engage with it in a single, specifiable way. It is easy to see that this is not true if we consider representations of past events—history. Unless it is very recent history a representation is unlikely to be transparent. That is, we are unlikely to read a history book to find out what to do next, and, even if we do, the connection with action is likely to be indirect. Dramatic recreations, for example de Quincy's *Flight of the Kalmucks*, engage us in the same way as fiction. However, much history is neither transparent nor engaging in this way; it merely contributes to the pool of knowledge about the events of the past. What this suggests is the futility of attempting to parcel our reactions to representations into exclusive and exhaustive groups. There are many rationales for reading a book, of which gaining knowledge of past events is only one (I shall return to this later).

I will call those representations which are non-transparent, and with which it *is* appropriate to get imaginatively involved, 'imaginative representations'. We can start investigating the engagement which is characteristic of such representations by noticing something implicit in the very term 'representation'. Something represents something else if it stands proxy for it, which suggests that one engages with an imaginative repres-

entation as a proxy for confronting its content. An imaginative representation of the execution of Lady Jane Grey will give the reader an impression—whether accurate or not—of the execution of Lady Jane Grey. This obviates the necessity for the reader to perform the impossible task of travelling back in time in order to see for himself. That is, the representation attempts to provide some kind of analogue of what the reader would have encountered were he to have experienced the event as a confrontation.

It is as well to clarify the relations between imagination, fiction and truth. Imagining is a propositional attitude. Briefly, to imagine that p is for p to be part of a structure of propositions that is before the mind. (I shall discuss the functional role of this structure below). Imagining that p is compatible with believing that p (Walton 1990: 13). Reading an imaginative representation might cause me to imagine the death of Lady Jane Grey and believe the propositions involved in that act of imagining. A proposition is fictional if an appropriate game of make-believe mandates us to imagine it, and yet it is at most accidentally true.[4] Delaroche's picture of the execution of Lady Jane Grey mandates that we imagine the executioner wore russet stockings. If this is at most a lucky guess by the artist, the proposition is fictional. Other propositions that we imagine, that she was beheaded, for example, are true rather than fictional.

5. I have already described the route of representation's content from the representation into the mind of the reader— through the Gricean mechanism. Can anything more be said about the manner in which it is represented there? On reading an imaginative representation, the reader imagines a certain set of propositions which structure an impression of the representation's content, aspects of which have the capacity to arouse in the reader an appropriate emotional response. Like Walton, I

[4] This differs from Walton's proposal, which is that a truth is fictional (make-believe) 'if there is a prescription or mandate in some context to imagine something' (Walton 1990: 39). Hence, all the propositions in any imagining would be fictional. Walton does not mean to claim that we can only imagine what we pre-theoretically think of as fictions, but that we should extend our notion of the fictional to cover everything we are mandated to imagine. On his proposal, only transparent representations will not count as fiction. My proposals do less violence to our intuitive classifications but, unlike Walton, I am not able to provide definitions of either fiction or representation (ibid.: ch. 2).

have no fully-fledged theory of the imagination and, again like him, I believe that imagining a proposition goes beyond merely entertaining it. The attitude of imagining can be compared with the attitude of believing. According to the functionalist account I have assumed, a belief is a dispositional state of which we may or may not be aware. If we are aware of the belief, if it is, as they say, 'before the mind', it is called 'occurrent'. There is, then, a distinction between beliefs which are simply dispositional and beliefs which are occurrent. The same kind of distinction can be found among propositions we imagine (cf. Walton 1990: 16–18). One can imagine that p without having p before the mind. In this case, imagining is simply a dispositional state. We will, within the game, be disposed to assert that p should the relevant situation arise (cf. Scruton 1974: Pt. II). Experience tells us, however, that when we read a representation we *do* tend to have the relevant propositions before our minds; that is, we tend to be occurrently aware of the content of what we are reading.

In order for a belief to cause an action, it need not be occurrent. When I leave the room through the door, I need not be aware of my belief that the door is to my left, although this belief will cause me to walk to my left when I want to leave. Some actions, such as writing a letter, are more likely to involve occurrent beliefs. To reiterate the point made in the previous paragraph, the contents of the imaginative representations that we read are, characteristically, occurrent. In the same way as our beliefs about the content of a letter need to be occurrent as we write it, so the contents of a representation need to be occurrent as we read it. It is a plausible psychological hypothesis that if they were not, reading imaginative representations would not have the effects they do.

Let us compare this with what happens in a confrontation. In perceiving a situation we acquire beliefs about it. Those beliefs then cause other mental states (desires, feelings, and thereby emotions) and, perhaps, actions. The attentive reader of an imaginative representation imagines the content of the representation. As he reads, he becomes occurrently aware of the content of the representation: he imagines it. The content is available to cause other mental states (desires, feelings, and thereby emotions) and, perhaps, actions. Is there anything more that can be said about how or why feelings and emotions are aroused within

a game of make-believe? At the end of the last chapter I questioned Walton's claim that the connection was straightforwardly causal. There is, surely, a question of why we should feel emotions as a result of a mental state if the contents of those states concern something beyond our control or even our experience. Why do we care about what we are imagining?

The difficulty can be seen if an imaginative representation is compared to a confrontation. To have the capacity to feel an emotion, is, *ceteris paribus*, to feel the emotion in the appropriate circumstances. What sorts of circumstances count as appropriate is the point at issue, but it is clear that confrontations and transparent representations will be appropriate if anything is. What if the representation is not transparent? If it is not the information contained in the representation with which I am concerned, why should the content of the representation cause me to react (whether the representation is documentary or fiction)? It is not the function of imaginative representations to cause beliefs—although they can—and it cannot be assumed that the explanation of why the emotions (or quasi emotions) are aroused remains constant in the light of this. We must, *ceteris paribus*, be disposed to act when faced with a starving person. It will be easier—although still difficult—to suppress such dispositions when faced with a transparent representation of a starving person. However, an imaginative representation (a painting of a starving person, an image of a starving person in a history book) will provoke no disposition that needs to be suppressed. It will have an altogether different place in our motivational structure. The question of how such representations none the less cause an emotional reaction, will be answered in the next chapter.

6. We now have all the pieces with which to solve the definitional problem. The narrow cognitivist argues that as quasi-emotions have no connection to our motivations, they cannot be emotions. The argument is common in the literature: here are examples from Radford and Walton.

If we really did think someone was really being slain, either a person called Mercutio or the actor playing that rôle, we would try to do something or think we should. (Radford 1975: 71)

To allow that mere fictions are objects of our psychological attitudes while disallowing the possibility of physical interaction severs the normal links between the physical and the psychological. What is pity or anger which is never to be acted on? What is love that cannot be expressed to its object and is logically or metaphysically incapable of consummation? We cannot even try to rescue Robinson Crusoe from his island, no matter how deep our concern for him. (Walton 1990: 196)

Fear emasculated by subtracting its distinctive motivational force is not fear at all. (Walton 1990: 201–2)

This argument proves too much, as it works just as well with imaginative documentary representations as it does with fiction. In writing *Robinson Crusoe*, Defoe drew heavily on the journal of the real-life castaway, Alexander Selkirk. A reader of Selkirk's journal could surely be moved to emotion at his suffering. However, the fact that Selkirk was marooned in 1704 (and died in 1721) makes it impossible—really impossible—for the reader to help him ('We cannot even try to rescue Alexander Selkirk from his island, no matter how deep our concern for him'). Fiction does not differ from any other non-transparent representation in its connection to action. Hence, if the absence of such a connection is no reason to deny that we feel emotions towards Alexander Selkirk, it is no reason to deny that we feel emotions towards Robinson Crusoe either.

There are two replies which could be given to this argument. The first would be to deny that we do feel emotions for historical characters and situations. The second would be to claim that non-transparent documentary representations, unlike fiction, do motivate actions. I shall consider each in turn.

Walton, in particular, might be tempted by the first reply, as his revisionary category of fiction would include Selkirk's journal (Walton 1990: 2). This seems to me an unacceptable consequence. If it really is the possibility of action that makes feeling an emotion possible, it would not only preclude historical situations and characters from being objects of our emotions. It would be *all* apparent emotions the propositional contents of which dispose the subject to an action which it is impossible to perform because there are no requisite instrumental beliefs. There is nothing I can do for the astronauts on the Space Shuttle travelling miles above the surface of the earth. Hence, the 'fear'

I feel for them has no motivational role. Walton would have to deny that we could feel fear in this instance, as well as denying that we could feel pity for anyone who is not currently suffering and whom it is possible for us to help.

The second reply would help Walton here. Non-transparent documentary representations carry the possibility of connection to action which fiction does not. Perhaps there is nothing we can do to help Alexander Selkirk, but his journal might prompt us to real-world actions which *Robinson Crusoe* would not. What sort of actions? Selkirk's journal does not seem any more likely to prompt a donation to a sailors' relief fund than *Robinson Crusoe*. Indeed, fiction can often have more of an effect on current action than documentary: George Orwell's novel *1984* has had more of an effect on political actions in the later half of the twentieth century than any of his documentary writing.

It is no good holding that the reason documentary representations and fiction differ is that the former can cause actions towards their contents, whilst fiction, if it causes actions at all, causes actions towards some person or situation relevantly similar to its content. Even if this were true, it is unclear why distinctions between types of connection to action should make a difference. However, it is not true, even in uncontroversial instances of feeling emotion. My pity for a particular starving person on the news may cause me to send a cheque to a famine relief agency which may not even operate in the relevant part of the world. Furthermore, restricting the link which emotions have to action to objects of the emotion would entail that we could not feel emotions to any content beyond reach, which would again entail that we could not feel an emotion towards anything that happened in the past.

Finally, it might be thought that documentary representations as distinct from fictions render some relevant counterfactuals true. For example, a documentary might prompt the thought that if I had been there, I would have done something. If I had been on the *Bounty*, I would have sided with Captain Bligh. However, the same counterfactuals are true of fictions: if I had been on the *Pequod* (the ship in Melville's *Moby Dick*) I would have sided with Ahab. Of course, the grounds for the impossibility of my being on the *Pequod* are different from the grounds

for the impossibility of my being on the *Bounty*. The former is because I cannot travel into the past and the latter is because I cannot travel into fiction. What is supposed to make the difference between the mental state's being an emotion and its not being an emotion, however, is the absence of a connection with motivation. In both of these cases the connection is absent. The argument does not require that the impossibility of our relations to past events have the same grounds as the impossibility of our relations to fictions. All that is required is that there is a separation of the psychological and the physical; which, I take it, there is. There would need to be an additional argument of a completely different sort that would make the grounds of the impossibility of the connection relevant.

For the person playing the make-believe, the events on the *Bounty* are not represented within the game as fictional, but as true. So, to qualify the report model, the appropriate game to play with fiction is to imagine it as being told as a documentary, but non-transparent, representation. Does this mean that it is impossible that there should be transparent fictional representations, or could a fiction mandate that we are reading a *transparent* representation in such way that an action was mandated *within the game*? If so, it would relieve my account of its simple and neat way of explaining the limits of our interaction with fiction. I have maintained that actions have no place in the make-believe because we make-believe we encounter a representation, and representations do not cause action. However, this explanation works only if the representation which we make-believe we encounter is non-transparent.

Consider what would have to be the case for us to make-believe transparent representations. It would have to be an integral part of the game that we were made aware of propositions for the sake of some further end. It is certainly true that transparent representations occur *within* games of make-believe in which the participants act and react. Paintball games, in which people are equipped with weapons which fire paint, is one such instance. A message from the commander might direct someone to the left or the right; news that the base has been taken might direct someone to surrender. The same is true of games which involve fictional role-play. The point of such games, and the rationale for involving us in them, is that they are incomplete

without our participation. This is the constraint which ensures that the games we are invited to play with fiction involve non-transparent representations.

The way that games such as paintball (or mud pies for that matter) progress depends on the input of the participants. The structure of the game, the resources out of which it is constructed, allow for this. The structure of fictions such as novels or films, however, standardly do not. A transparent representation gains its importance in relation to a wider background. However, in the game played with fiction there is no wider background: everything is in the representation we are imagining reading as a report. The representation cannot be imagined to be transparent because there is nothing else within the game from which it could derive its role. It is its own background, which is characteristic of non-transparent representations. If it were fictional that the representation were transparent, it would be fictional that the role of the representation made us aware of propositions for the sake of some further end. But what further end? There are no alternatives open to use except to keep reading. In a game of paintball there is a further end which could give a transparent representation a role. With a novel or a film this is just not so.

The argument has simplified by Walton's modification of narrow cognitivism in response to Greenspan's attack. Would the argument still work if Greenspan's example were ignored, and the stronger version of narrow cognitivism used? A little reflection shows that it should work. If a weaker version of narrow cognitivism (in terms of motivational role) fails, a stronger version (in terms of beliefs) should also fail. Recall that the claim that emotions embody beliefs was supported by the connection between emotion and action. The fact that we feel emotions in response to documentaries shows that the beliefs they embody need have no connection to action. As the connection to action is the relevant property which separates believing a proposition from imagining it, belief plays no role which could not be played by imagination. In other words, given the absence of a connection to action it does not matter whether the cognitive aspect of an emotion is believed or imagined. Once again, the conclusion follows: emotions can be felt towards fictional characters and situations.

The key to the solution of the definitional problem is the realization that the game of make-believe which we play with fictions is to imagine them to be non-transparent documentary representations. This introduces a distance between us and the (fictional) objects of our emotions which accounts for the absence of a motivational role in the same way that this lack is accounted for when we read documentaries. Hence the fact that fictions arouse states which do not motivate actions does not undermine the claim of those states to be emotions; there is no 'definitional problem'. This also fits with the account of the emotions given in Chapter 2. Let us restrict ourselves, for a moment, to emotions for objects with which we cannot physically interact. It follows that it is possible, in the paradigm scenarios for those emotions, for the objects of the emotion to be presented via a representation. What we have seen is that there is no reason why this representation should not be a fiction. The fact that there is no definitional problem underpins de Sousa's claim that we can develop our concepts of emotions through literature.

7. What of Charles, the hero of Walton's example, who claims to be 'terrified' of the slime? Narrow cognitivism claimed that what Charles feels can be terror only if he believes he is threatened. The above argument shows that the belief is inessential, and that Charles need only imagine that he is threatened. All agree that Charles does not believe he is threatened. There is, however, a problem, as the account I have given appears to make it impossible for Charles to imagine that he is threatened either.

I have claimed that when Charles sees the film he imagines seeing an imaginative documentary representation. In short, it is fictional that Charles is seeing a report. In the same way that it is true that Charles cannot be threatened by the machete-wielding maniac he sees on the evening news, it is fictional that he cannot be threatened by the slime which he sees in the report he is watching. The same unbridgeable gulf that exists between Charles and the news in the real world exists between Charles and the report in the fictional world. Because of this, Charles cannot imagine that he is threatened (cf. Neill 1992).

It is not only Charles's reaction which is anomalous in this respect; the behaviour of the slime is similarly irregular. Within the make-believe, the slime appears in a report, not (so to speak)

in person. Hence, it is fictional that it cannot threaten Charles. So why does it behave as if it can? Charles's terror is a result of an 'aside' from the slime: 'a greasy head emerges from the undulating mass, and two beady eyes fix on the camera. The slime, picking up speed, oozes on a new course straight towards the viewers' (Walton 1990: 196). One option would be to abandon the claim the Charles feels fear, and describe his reaction in terms of non-emotional states such as shock and alarm (Neill 1993: 5; cf. Robinson 1995). Consider an undersea photographer suspended in a shark-cage in which he has complete confidence and which is being attacked by sharks. It might be plausible to describe his reaction as shock, even if he might describe it as terror. This does not, however, do justice to the complexity of Charles's reaction: we need an explanation of at least the following. First, we need to explain why, in comparison with emotions felt for other people, emotions felt for oneself are so unusual in fiction. Secondly, the connection between reactions such as Charles's and what I have called 'asides' needs to be made clear. Thirdly, we should explain why the frequency of such emotions varies between media: Charles's reaction may be unusual in the cinema; it is unknown in the library.[5]

On the perceptual model, there is no problem accounting for the interaction between Charles and the slime. In the game of make-believe that Charles is playing, he and the slime occupy the same fictional world. Embracing this would mean embracing a theory with many flaws, some of which I have discussed and some I will go on to discuss. If Charles and the slime occupy the same fictional world, what accounts for the limits on interaction? Why are asides, and therefore emotions felt for oneself, so unusual? Does Charles, sitting in the cinema at Cambridge watching the screen, really imagine that he lives in New York in the 1950s and is being chased around the streets by a monster? This seems to me a consequence best avoided.

For the structure of a more adequate reply, compatible with the report model, consider Edgar Allen Poe's tale, *The Fall of the House of Usher*. It seems that the tawdry romance Roderick is reading is being played out around him; whenever a loud noise

[5] An instructive example to think about is the scene in the film *Harvey* in which Mr Wilson looks up 'Pooka' (1950, dir. John Beck).

is reported as happening in the novel, that same noise resounds around the house. Roderick's friend knows he is hearing a fiction, yet the fiction is not behaving itself. The listener is understandably concerned: 'Oppressed, as I certainly was upon the occurrence of this second and most extraordinary coincidence, by a thousand conflicting sensations, in which wonder and extreme terror were predominate . . .' The vivid nature of the surroundings allows the subject easily to dwell on the grounds for the belief that he is safe; a belief in which, in cooler moments, he would have complete confidence. The fact that the House of Usher is a gloomy mansion, that Roderick is going mad, that there is a storm outside, and that Lady Madeline has just been buried in the vault downstairs does nothing to calm the listener's nerves. He believes he is hearing a tale (he thinks the noises 'an extraordinary coincidence'), but the bizarre situation forces him to imagine something he knows to be false: namely, that the fiction is coming true around him. He does not believe this, he has 'a thousand conflicting sensations', but it does worry him and inspires feelings 'in which wonder and extreme terror were predominate'.

This may all sound a little fanciful, but it does mirror the problem rather well. It is no part of any account, least of all mine, that Charles doubts that what he is watching is fiction; that belief is completely secure. Recall, however, that Charles is imagining he is being shown a (true) report. Within the make-believe the report starts misbehaving itself in a vivid and overwhelming fashion. There is a terrifying slime which, to all appearances, seems to be bearing down on him. The report has had Charles on the edge of his seat (both in the game and in real life) and (in the game) his confidence that he is seeing a report is thrown into a maelstrom. Like Poe's listener, he is forced to review all the things he knows to be 'true': for example, that this is a report, so the slime cannot be trying to get him. If the reaction of Poe's listener is credible, so is this construal of Charles's state. Within the fiction, it is not true that the slime can get him, but it is true that the behaviour of the slime undermines his confidence that he is safe in a particularly vivid fashion.[6]

[6] For an interesting discussion along the same lines, see Levinson 1993*a*: 300–3, especially n. 27.

At no time need Charles imagine that he is threatened by the slime; the account produces none of the implausible consequences or the special explanations required by the perceptual model. It also explains why reactions such as Charles's are unusual, in comparison with experiencing emotions *for* characters; unlike those reactions, Charles's reaction is not part of the usual game. It explains the role of asides, as they are an essential cause of the peculiar initial reaction. Finally, it explains why Charles's reaction happens in the cinema and not in the library. Charles has to be manipulated into it; he has to be put in a state of heightened expectation so that his reaction is out of order, even in the make-believe. This is much easier in an immediate, vivid medium such as a film or a play than in the detached, cognitive world of a book.

As I said above, Charles's reaction is as seldom encountered in our dealings with fiction as Poe's listener's is in our dealings with life. Indeed, if it were not for the fact that fear for oneself as a reaction to fiction is the central example in the best-known work in this area, Kendall Walton's 'Fearing Fictions', I doubt whether it would receive much attention. Walton has remarked (in conversation) that he took the example of fear for oneself because it was the most difficult. The danger is then that of underestimating its peculiarity and distorting one's general account of fiction.

8. The definitional problem has been solved. Mr. Keith's problem, however, has not. Recall Mr Keith's complaint:

> It saddens me to see grown-up men and women stalking about in funny dressing gowns and pretending to be Kings and Queens. When I watch *Hamlet* or *Othello*, I say to myself: 'This stuff is nicely riveted together. But, in the first place, the story is not true. And secondly, it is no affair of mine. Why cry about it?'

In other words, even if what we feel in response to fiction is an emotion, what is the point? What is the point in getting emotional about something that never happened?

I have stressed throughout that, with respect to psychological interaction, the distinction between representation and confrontation is more important than the distinction between fiction and non-fiction. I should thus like to broaden Mr Keith's ques-

tion and consider the rationality of responding to a represen-
tation with an emotion. First, then, we need to answer the ques-
tion of whether it is rational to react emotionally to the content
of representations which we *do* believe: that is, documentary rep-
resentations (a category which includes history). In the light of
what has been said above, it is difficult to see that reacting with
emotion to history would make any more sense to Mr Keith than
reacting with emotion to fiction. If the link between the belief
and the possibility of action is severed, does feeling an emotion
make sense? Why should my pity for Alexander Selkirk make
any more sense than my pity for Robinson Crusoe? After all, it
is impossible that I should meet him or do anything to alleviate
his plight.[7]

The mere presence of belief in the Selkirk case should not
impress Mr Keith. If the point of having beliefs is to interact with
desires so as to cause successful action, what is the point of
having beliefs that we know *could never* cause such action? This
question is not much considered by modern analytic philosophy
of history, although it is not unknown for history and fiction to
be compared—for example, in the following quotation from
R. F. Atkinson.

Historians tell stories, at least they all used to and many still do; and
these may be valued, as are novels and plays, for the insights they
offer into human character and behaviour. But with this similarity there
is the enormous difference that the historian's stories, like the conclu-
sions of scientists, purport to be true. (Atkinson 1978: 6)

Although true, this is of no help to us. The 'enormous difference'
would only justify reading history rather than fiction if there
were a good reason to read only representations which are true.
That, however, is the question at issue.

We have already seen that the attempt to justify reading his-
tory through its indirect effect on our actions will not do.

[7] It might be thought that emotions involve a commitment towards the exist-
ence of their objects, which would render problematic our feeling emotions towards
fictional characters. I think this is an illusion, stemming from the feeling that there
must be some difference between our reception of fictional and historical represen-
tations. However, such a difference is not necessary—I might be indifferent as to
whether what I am reading is fiction or not. Hence, what grounds the difference can-
not be constitutive of our reception. I give more plausible grounds for the differ-
ence below. I am grateful to Jerrold Levinson for bringing this point to my attention.

Certainly beliefs about past events may influence my behaviour in the present, but there is no a priori difference in the effects on our behaviour of documentary and fictional representations. Consideration of what *could have* happened guides our decision-making just as much as the consideration of what *did* happen.

The chief justification for studying history is, presumably, that people want an accurate picture of what happened in the past. Exactly why people should want such a picture need not detain us here; it might simply be a matter of being inquisitive. The point is that they do. The justification for studying history is different, therefore, from the justification for acquiring beliefs about our immediate surroundings. Furthermore, even given this justification for studying history, there is an additional problem for those seeking to justify our reacting to history with emotion. The justification for the project of ascertaining what happened to Lady Jane Grey might not extend to the justification for feeling an emotion for her. Indeed, such emotional involvement could be disparaged as bringing with it the danger of clouding a clear assessment of the evidence.

It is no surprise to find, therefore, that the rationale for and emotional reaction to events in history is the subject of controversy. Collingwood, for example, believed the historian should re-enact within his own mind the thoughts of the person or persons whose activities he is studying (Collingwood 1936). De Quincy thought it a valuable exercise for a historian who was trying to appreciate a historical situation to place himself imaginatively in that situation. If such a view were right, an emotional reaction to history would be justified as part of the exercise of building an accurate picture of past events. Whether this is the best way to study history or not, the moral—for my purposes—is clear. Even if a belief cannot justify an emotional reaction to the suffering of a long-dead person in the way that it justifies an emotional reaction in a confrontation, it does not follow that the former reaction is unjustified. It is justified only if such a reaction is part of the project of studying history, and that project is itself justified.

I have suggested that the study of history is justified by the desire for an accurate picture of past events. Is a rationalization of a similar kind available for engagement with fictional representations? Can Mr Keith be answered? To do so one would

need to produce an account of the value of fiction. Such an account would itself be a valuable contribution to philosophy and culture and could, I believe, be given. To argue that fiction has no value is not, however, incomprehensible: Mr Keith might be wrong, but he is not illogical.

I have argued, when considering representations of historical events, that what justifies the project of reading such representations does not necessarily justify reacting with emotion to them. By contrast, once one has justified the reading of fiction, to justify reacting with emotion to it is less of a problem. Whilst it is comprehensible that a historian might simply want to know about a tragic situation without seeing the need to react with emotion to it, the project of merely wanting to know what happened to a fictional character without the desire to become emotionally involved with that character is more difficult to understand. There are circumstances in which such a motivation would be comprehensible: perhaps a reader merely wants to know what happens in a novel in order, for example, to impress someone in conversation. Such a motivation does not, however, stand up on its own; presumably, he wants the person he is trying to impress to believe that he has read the book at an involved level (rather than simply so as to drop learned quotations).

A historian can be motivated by the desire to know the way the world was, and the means to such knowledge is a history book. There is no analogue of this motivation for the reader of novels. Reading *Pride and Prejudice* is not a means by which to discover what happened at Pemberley because there is not now, nor ever has been, such a house. There is no knowledge, independent of the book, to which reading *Pride and Prejudice* provides access. Rather, what can be learned from the book emerges by *engaging* with it in the way I have described. For this reason, an account of the value of literature is likely only to rationalize the motivation for engaging with fiction at a level which includes emotional engagement.

In summary, the justification for engaging with documentary is to discover facts about situations that are distant from us, either in time or in space or both. The justification for engaging with fiction is to have the kind of valuable experience provided by reading fiction. Usually, it will be important for the reader to know whether a representation is documentary or fiction, but

there are times at which it will not matter. If part of the reader's motivation for engaging with the representation is that he believes that the representation expresses truths about the actual world then, obviously, this belief will be important. This can be illustrated with an example of a representation with which we engage for different purposes: Shakespeare's *Richard III*. If the purpose in reading the play is aesthetic, the reader will build an impression of what is happening from the content of the representation, and take from the experience whatever is valuable about reading great literature. That is, he will engage with it as a fiction and imagine those propositions in the representation which he would believe, were he to believe the report accurate (which he can do whether he believes the events reported to be actual or not). Hence, whether or not he believes that Richard *actually* killed the princes in the tower is irrelevant to the experience. This is not true if he has a different purpose in reading the play; namely, to build an accurate record of Richard's actions. In such case, he will only be interested in the propositions if he trusts Shakespeare to be reporting what actually happened (which, if he is sensible, he will not).

A representation need not be true for it to be rational for us to engage with it, but whether or not it is true might be important. There is a set of propositions which, if we believed them, would give us an accurate account of the actual world, and, if we want to know what actually happened, we want to know those propositions. For example, in her book *Jigsaw* (described by its publishers as fiction) Sybille Bedford describes a visit by the poet Roy Campbell to her mother's house in Sanary. When I came to this passage, my purpose in reading the book changed. Instead of engaging with the book as a fiction, I became interested in finding out about Campbell, in whom I have a particular interest. Immediately the question arose as to whether, in addition to imagining these propositions within the game generated by Bedford's novel, I should add them to the beliefs I have about Campbell. Thus the question arises, as it arises in the case of *Richard III*, whether the author's account may be trusted as the report of something actual.

Reflection on such cases provides grounds for the irritation felt by some at the deliberate blurring of the distinction between the fictional and the actual. The genre of 'drama documentary'

is felt by many to be unsatisfactory because, while we can im-
agine the relevant propositions when we engage with such a rep-
resentation, we do not know whether we ought to add these
propositions to our stock of *beliefs*. In trying to build a coherent
picture of what somebody did, or what their character was like,
it is important not to impute to that person actions they did not
perform.[8]

9. There are many more points that could be made concerning
the difference between fictions and documentary representations.
One problem lies in what we can take for granted in building our
impression of the content of the representation. In particular,
what are the principles by which we infer what is going on in a
fiction from what we are explicitly told? To work through these
problems would take the rest of the book, so I shall reluctantly
leave these and other threads hanging.

There is one thread, however, which deserves to be tied up as
it has the potential to unravel the tapestry. I have argued that a
reader is mandated to imagine the propositions contained in a
fiction. I have also made claims about Captain Ahab from *Moby
Dick*, and suggested that *Pride and Prejudice* is (amongst other
things) about 'what happened at Pemberley'. There is, however,
neither a Captain Ahab nor a Pemberley for these books to be
about. The problem stems from the semantics of proper names.
For example, reading Plato's *Phaedo* as history causes the reader
to believe that Socrates drank poison. According to a plausible
and currently fashionable theory of the meaning of proper
names, 'Socrates' refers to a specific person, to which its use in
this context is connected by a relevant causal chain (Kripke
1980). If there were no such person, there would be no such
causal chain, in which case 'Socrates' would fail to refer and thus
be meaningless. This is obviously a problem for the proper
names of fictional characters. In the absence of some other

[8] There is a parallel argument concerning characters in fiction. Ian Fleming's
widow opposed the idea that a different writer should continue to write James Bond
books on the grounds that the character would be changed and start to exhibit less
rigorously macho virtues. Here the qualification for a proposition to belong to the
set concerning the character of a person is not that he was actually like that, but that
his creator conceived him to be like that. (In the event, despite the first such book
being written by Kingsley Amis, Anne Fleming has been proved right.)

account, 'Captain Ahab', as it does not refer, would be meaningless. What is more, if a part of a sentence is meaningless, it is generally thought that the sentence as a whole is meaningless. Thus, it would follow that 'Captain Ahab was obsessed' would be meaningless: that is, it would not express a proposition. Hence, there would be no such proposition for a reader of *Moby Dick* to imagine.

I have principally been concerned to discuss the nature of the game of make-believe that we play with fiction (whether we imagine ourselves as in contact with events or as in contact with reports of events) and the relation of this imaginative project to action. I have argued that fictions cause us to imagine propositions; therefore, to be complete, my solution should contain an argument to show how fictional discourse is meaningful. As I have not provided such an argument, the solution is, to that extent, incomplete. There are several accounts of the semantics of fictional discourse in the literature, and the reader is welcome to choose the one that best fits their ontological beliefs.[9] However, once it has been shown that such discourse is meaningful, other problems remain. It is these problems in which I am interested, and thus I, in common with Radford and others, am content to leave the semantic and ontological problems to someone else.

[9] Including Matravers 1991*b*. More interesting accounts can be found in Currie 1990*b*: ch. 4 and Walton 1990: ch. 10.

5

Causal Stories

1. I have claimed that readers of fiction imagine they are reading reports by narrators who believe them to be true, and thus (once adjustments have been made for unreliable narrators and the like) they imagine that the propositions contained within these reports are true. What has guided me in making this claim is the desire to find an accurate description of the reader's experience. I have been able to do this using a relatively unproblematic concept of the imagination: propositional imagining. This has an apparent cost; for if propositional imagining is relatively unproblematic, it is also relatively detached. Like believing, propositional imagining need not be occurrent; a marked contrast to visualizing or imagining doing something. This fuels the suspicion that propositional imagining is not sufficient to explain the arousal of emotion by a representation. It is *too* detached; a more involved form of imagining is needed. In this chapter I will show this suspicion to be unfounded. In doing so I will complete the task left unfinished at the end of the previous chapter: namely, explaining the connection between the reader's experience of a representation and any consequent emotion.

Those who claim that propositional imagining is insufficient for an analysis of readers' emotional involvement with fiction are right in so far as merely imagining that p (where p is some relevant proposition) is often not sufficient to arouse an emotion. Imagining that Mr Darcy has proposed to Elizabeth Bennett can leave one totally unmoved. The fact that readers of *Pride and Prejudice* generally do not remain unmoved by this imagining suggests there are other less prominent but equally necessary causes of the emotion. Indeed, it is rare, not only in fiction but also in life, that having a proposition in mind (even the right sort of proposition) causes an emotion. For example: I had a toothache this morning. Whether you believe or merely imagine this, I would be surprised if you were moved to pity—this is a

case in which focusing one's attention on a proposition is not sufficient to cause an emotion.

The point is obvious and examples abound. Some examples are unexpectedly disconcerting. Consider, for example, the famous newsreel of a member of the Vietcong being shot in the head during the Vietnam war. Presumably, prior to seeing the film the American public believed that such things happened, but the bare belief was not sufficient to cause the revulsion towards the war that was generated when their belief was caused by seeing a visual image of an event, rather than by simply hearing (or reading) about it. The pictures themselves, the prisoner standing up straight, the execution and death, had a richness which filled out the belief and made it sufficient to cause an emotion. More recently, the growing concern of the British public about famine in Africa has been attributed to television news coverage. Prior to such news reports, it was a common belief that people were starving in Africa but, once again, the accompanying pictures presented the observer with more; enough both to cause emotion and to inspire action.

It is obviously important to any writer who wants his readers to be affected by the plight of his characters to realize that imagining a proposition does not always cause the appropriate emotion. So what does a writer need to do, in addition to conveying propositions? To reiterate, this is a problem not only for makers of fictions but for makers of all representations. Serious newspapers (to take a paradigm of factual reporting) do not merely provide lists of connected facts. The facts are woven together as a narrative, complete with embellishments to sustain the readers' interest and stimulate their imagination. Consider how much more is contained in this piece of cricket reporting by Edmund Blunden than is sufficient to convey the beliefs about what happened:

Bradman's score was 254, the sunshine was such as conspires with batsman and not bowlers, and he meant to go well beyond that 254. He drove one of Tate's accurate-length balls as before, but the hit was a little off the ground; Chapman was sensitive to this from the start, and with a long right arm, he collected the hit a few inches from the floor and Don Bradman was out. I could not have dreamed of this, nor could most of us, but it was done. Chapman mopped his forehead.

There is the slightly literary suggestion that the forces of nature were conspiring with the batsman, contrasting with the forceful clarity of the words that express Bradman's intent. There is Chapman's 'long right arm' (presumably no longer than his left, although it can look that way when a fielder takes a difficult catch), and the informationally superfluous assertion that Bradman was out. Then there is the hyperbolic reaction on behalf of the writer to bring home the horror of an idol deposed. The final sentence is a classic of conversational implicature; the point of detail that Chapman mopped his forehead effectively communicates both his pride and his relief.

How can these observations be made compatible with my claim that an attentive reader imagines that the propositions in a representation are true? The alternative is to accept what is on offer in Walton's theory: that readers not only imagine that propositions are true, they also imagine doing or seeing something; they get more intimately involved. Apart from the fact that there is no guarantee that even this will generate sufficient conditions to arouse the reader's emotion, this option was ruled out in the previous chapter.

The inability of the account I favour to explain these facts is merely apparent. Readers engage with representations on a cognitive level by imagining that the propositions are true, but their engagement goes beyond the cognitive. There are other ways by which the reader is affected by the text. Representations contain more than is sufficient to cause a reader to imagine a proposition, and this 'more' is sometimes sufficient in combination with the imagined proposition to cause an emotion. This is not true for transparent representations (considered in the previous chapter) because, by definition, their sole function is to convey belief. The belief may or may not arouse an emotion, but, if it does, this will not be because of other properties of the medium by which it was transmitted. In this chapter I shall discuss the sorts of properties non-transparent representations possess which are not directly involved in causing the reader to imagine a proposition, and the mechanics by which they come to affect our emotions and other mental states.

So far I have argued that some representations have properties whose function is not to cause the reader to imagine a proposition, but rather to act on the reader in ways designed to capture

his attention; act directly on his feelings and so on. This claim has an important corollary: namely, that the existence of such properties accounts for the fact that the experience of a work of art is central to its appreciation. To appreciate a work of art it is not usually sufficient merely to have heard of it or heard about it, one has actually to have experienced it. Any account of our engagement with works of art which denies this claim or under-estimates its centrality is, in that respect, deficient.

It could be held that our engagement with works of art is pri-marily cognitive, in the sense that the experience of a work of art is fully described by the cognitive states it causes and the effects of those states on the feelings and emotions. Such an account has not to my knowledge been explicitly stated by anyone, but it approximates to some accounts which will be encountered later. The argument against such an account has the form of a *reductio*. Assume that aesthetic experience can be exhaustively characterized in this way—let us take for our example the final scene of *King Lear*. Thus the experience would be captured in terms of imagining propositions such as that Edmund is killed by Edgar, that Goneril poisons Regan and then stabs herself, and that Cordelia is hanged before she can be saved by her father. These propositions might then cause the observer to feel vari-ous emotions for the characters. However, if *all* that needs to happen is that the observer is caused to imagine various propos-itions (and for these propositions to cause emotions) the process by which the observer came to imagine them would be of no consequence. All that would be needed for a full aesthetic experi-ence would be for the observer to be caused to imagine the propositions which he would be caused to imagine were he to watch the play. But this conclusion is counter-intuitive. It is not only the propositions that the play expresses which are impor-tant, but the way in which they are expressed. The work of art is not an inessential medium for conveying propositions; it pre-sents the possibility of a full experience of which imagining these propositions forms only a part. Thus, the experience of a rep-resentational work of art goes beyond imagining propositions: there are properties of the work which cause reactions inde-pendently of the cognitive content.

This can be further illustrated by considering two different reactions to the emotional content of a play. A philistine might

know (maybe from reading the programme) that the scene being played out is tragic without actually appreciating it *as* tragic. He could imagine all the right things about the scene and yet not appreciate the scene in the way a sensitive person might. The scene causes the sensitive person to imagine propositions, but only as part of a fuller *experience* which goes beyond the cognitive. Aesthetics deals with a kind of experience given in perception; it does not deal only with the propositional content of that experience. The point is put clearly by Frank Sibley.

It is of importance to note first that, broadly speaking, aesthetics deals with a kind of perception. People have to *see* the grace or unity of a work, *hear* the plaintiveness or frenzy in the music, *notice* the gaudiness of a colour scheme, *feel* the power of a novel, its mood, or its uncertainty of tone. (Sibley 1975: 137)

As appreciating a work of art is 'a kind of perception', appreciation must go beyond imagining propositions, for propositions can be imagined without perception.

2. The role of the non-cognitive aspects of the experience are best explained by looking first at the central case. If an emotionally normal observer is confronted with a situation for which an emotional reaction is appropriate he will, *ceteris paribus*, feel that emotion. Being faced with a distressed person causes an observer to believe that the victim is distressed, and this combines with other properties of the situation to cause an observer to feel pity for the victim. However, as we saw in the example in which I reported my toothache, there is no reason to expect an emotion to be caused merely by imagining a proposition. What is the difference between the two cases? One obvious difference, discussed briefly in the previous chapter, is immediacy. The observer is faced with a person who is (let us say) crying, showing signs of injury, and thus making strong claims on the attention. The reader is faced with a sentence reporting the fact that someone they have never met, whose plight is not immediate to them, once had toothache. In the former case the situation is presented with such vivacity that the observer (typically) will be unable to prevent the arousal of the emotion. In the latter case, the observer is confronted with a bare proposition which he is perfectly able to ignore. The question we need to answer is: what

would need to be done to the representation to make it as likely to cause an emotional reaction as being confronted by the situation itself?

In some way, the representation must cause in the reader an experience which is appropriately related to the one he would have were he confronted with the situation.[1] That is, the representation must substitute for immediacy and vivacity something which will play the same role; something to stimulate the imagination so that the situation represented strikes the reader with something of the force that it would possess were he confronting it. There are two ways in which it might do this. The first is to make the propositions the reader imagines efficacious in causing the sort of reaction which would be caused in the central case. The representation must present its content in a way that stimulates the interest of the reader, so that the content is vivid before the reader's mind. It is not enough that the reader simply imagines the propositions: there are many propositions which we imagine but which do not strike us (as we might say) sufficiently for them to play the appropriate functional role in mental causation. Secondly, properties of the representation could stimulate the feelings directly, without a cognitive intermediary. An illustrative example might be the purely formal properties of Lear's speech on his entrance bearing the body of the dead Cordelia. This can, with its repetition and broken metre, cause a feeling of near panic which allies with the shock and sadness caused by the death of the most morally upright character in the play.

In summary, the difference between merely imagining that *p* and being struck by *p* is that in the latter case we react in a way similar to the way in which we would react in the central case. 'Being struck by something' is the state of imagining propositions in such a way that they cause other mental states which would be caused were we confronted with the situation described by those propositions. Whether or not a reader is struck by a representation depends not only on the propositions he imagines,

[1] This is similar to a formulation presented by Roger Scruton in *Art and Imagination* (Scruton 1974: 72). Although my conclusions are similar to those of Scruton, our arguments are very different. I am happy to acknowledge Scruton's trail-blazing work in this area (of which more later).

but also on the effects of the non-propositional properties of the representation.

It follows from what I have said that the full explanation of an emotional reaction to a character or situation in a representation will be in terms both of the propositions imagined and of the effects which the non-propositional properties of the representation have on the observer. I shall not deal with all the consequences of this non-cognitivism here; problems will be discussed as they appear in subsequent discussion. There are two consequences, however, which are particularly relevant to the problem of reacting with emotion to representational art.

First, the properties of a work are not themselves exclusively representational or exclusively not.[2] A single property of a work can cause the reader both to imagine a proposition and to react non-propositionally. For example, the white blindfold in Delaroche's *The Execution of Lady Jane Grey* causes the reader to imagine that she is blindfold, which might, in turn, be a contributory cause of the feeling of pity aroused towards her. In addition, white is the colour generally associated with innocence. This might, without our conceiving it as such, be a contributory cause of feelings characteristic of sympathy. The important difference between having a feeling caused by imagining a proposition and having it caused directly is that in the former case the connection is not only causal, it is rational. I can *justify* the pity I feel for Lady Jane Grey on looking at the picture of her execution by citing the propositions which the picture causes me to imagine: that she is distressed, that she is blindfold, that she is going to have her head cut off, and so on. I cannot justify my emotion by saying that her blindfold is white and that this has a funny effect on me. Citing the whiteness of the blindfold can help *explain* my reaction, as can many other properties of the picture. Of the properties of a work of art that arouse our feelings, in the relevant manner, those that act by causing a belief also justify the emotion, those that do not help only to explain it. This point will be discussed further in Chapter 11.

The second point I shall discuss appears to constitute a thorny problem for any account which counts aroused feelings as aesthetically relevant. Evidently, there are plenty of causes of our

[2] For a detailed discussion of representational properties, see Scruton 1974: 62–3.

'being struck by' a character in a fiction, not all of which are aesthetically relevant. The pity a playgoer feels for Othello might have less to do with the play than the state of the playgoer's own marriage. What, then, divides this reaction from one that *is* aesthetically relevant? The short answer is that a reaction is aesthetically relevant only if it is caused in the appropriate way, which will at least involve attention to the properties of the work itself. I shall assume that what counts as 'the work itself' can be determined independently via the creator's intention. The biggest problem is saying what is meant by 'the appropriate way'. What if the work simply acts as a trigger for some feelings the observer has repressed? What if the observer uses the work simply as a prop in a self-indulgent daydream? What if the observer is in some way bizarre, and reacts with excessive feelings of sympathy to any character who has lost a handkerchief? It is certainly true that the observer might be unable to pinpoint the cause of his reaction and be misled into overestimating the play's capacity to provoke pity for the deceived husband. As a result, any such belief—that is, one caused by what the observer takes to be his reaction to the work—is fallible. These are good questions, which will be explored further in Chapter 9.

3. I have argued that representational works of art act upon an observer's emotions in two ways. First, by causing the observer to imagine a proposition in such a way that it arouses a feeling, thereby causing an emotion; secondly, by arousing a feeling directly, without a cognitive intermediary. The argument applies to all imaginative representations, and therefore applies to fictions. This completes the answer to the definitional problem I presented in the last chapter. There I explained the mechanism by which a reader comes to represent the content of fiction to himself. In this chapter I have explained how, if the representation is good enough and the reader is paying sufficient attention, such a representation can arouse the reader to an experience akin to the one he would have were he confronted with the content. For the appropriate content, such an experience will be predominantly emotional. My explanation is borne out, I think, when viewed in the light of some concrete examples.

Consider a film featuring the horror character, Count Dracula. The representational properties of the film would cause an

observer to imagine that certain things are true: that the Count drinks blood, preys on defenceless young women, is several hundred years old, and so on. Other properties of the representation—the setting, the lighting, the menacing music, the Count's appearance, the way he moves, and so on—might strengthen the effect of such propositions by acting directly on the observer's feelings. The total effect is more than could be achieved by the propositions alone; two films telling the same story need not (as a matter of fact) have the same effect. The observer will, if he is struck by the film, be aroused to a creeping, cold revulsion. This is a result not only of the situation brought vividly to mind, but also of the feelings being manipulated.

The fact that the creator of a representation needs to consider both its propositional content (henceforth I shall drop the 'propositional') and the way that the content is represented opens the possibility of the representation's creator playing one off against the other. Sometimes this conflict appears despite the intentions of the creator, as has become the case with horror films from the early days of cinema. In the past, the conventional way of presenting a threatening character involved the use of heavy make-up, low camera angles, and stylized acting. To modern movie-goers, whose sophisticated tastes have outgrown such stylization, this is generally a cause of amusement rather than alarm. Count Dracula, who retains all his proposition-inducing horror, is betrayed by his mode of presentation.

More seriously, the separation of content and the way the content is presented is necessary for at least one sort of irony: namely, the intentional undermining of a message by the way it is delivered. For example, the final passage of Thomas Hardy's *The Return of the Native* is ostensibly a description of Clym Yeobright, fulfilled in his vocation as an itinerant preacher. The way that Hardy describes the situation renders Yeobright a pathetic and deluded figure. It is not the propositions about Clym which we are caused to imagine that inspire this feeling, but partly the rather snide tone which runs throughout the passage, and the fact that there are details that Hardy obviously could include but does not; for example, that the audience are better for having heard Clym's sermon. The emotional reaction caused by what Hardy says about Clym is undercut by the way in which he says it.

As an emotion is partly constituted by a feeling, and as a feeling can be affected directly by properties other than a representation's representational properties, these properties will affect the identity of the resultant emotion. The lighting and music of a Dracula film might cause a feeling of disgust. This feeling, together with various propositions the observer is caused to imagine by the film, might cause revulsion. The propositions, however, might not have been sufficient to cause revulsion; they might equally have caused fear. Hence, the non-cognitive reaction, disgust, has partially determined the identity of the felt emotion.

This emotion can itself cause further beliefs; for example, that Count Dracula is revolting (rather than, say, frightening). As the content of these beliefs is determined by the nature of the emotion, it follows that this content will also be partly determined by our non-cognitive reaction. Noël Carroll has argued that our belief that a character is horrifying or that he is terrifying is (at least in part) dependent on our emotional reaction to him. I cannot claim Carroll as an ally in this matter, as he believes a feeling can only be caused via some cognitive state: the perception causes (in his terms) the thought, which causes the feeling and therefore the emotion. He does not acknowledge that the feelings can be influenced directly. However, his definition of horror suggests that he ought to:

Assuming that 'I-as-audience-member' am in an analogous emotional state to that which fictional characters beset by monsters are described to be in, then: I am occurrently [horrified] by some monster X, say Dracula, if and only if 1) I am in some state of abnormal, physically felt agitation (shuddering, tingling, screaming, etc.) which 2) has been *caused* by a) the thought: that Dracula is a possible being; and by the evaluative thoughts: that b) said Dracula has the property of being physically (and perhaps morally and socially) threatening in the ways portrayed in the fiction and that c) said Dracula has the property of being impure, where 3) such thoughts are usually accompanied by the desire to avoid the touch of things like Dracula. (Carroll 1990: 27)

Part of this rather baroque definition is the claim that the various emotional reactions listed are partly caused by the thought that 'Dracula has the property of being impure'. About this Carroll says:

The impurity clause in the definition is postulated as a result of noting the regularity with which literary descriptions of the experiences of horror undergone by fictional characters include reference to disgust, repugnance, nausea, physical loathing, shuddering, revulsion, abhorrence, abomination, and so on. (Carroll 1990: 28)

Carroll has noted correctly that characters such as Dracula cause feelings of revulsion. Because he thinks such feelings can only be caused by Dracula via the causal intermediary of some cognitive state, he postulates some suitable property of Dracula which can form the content of the requisite belief: impurity. It is difficult to see this as anything other than an *ad hoc* move to save the assumption that all the relevant feelings here are caused by cognitive states. If there were a single property corresponding to the term 'impurity' which causes a cognitive state which causes these reactions, why does Carroll not specify it independently of these reactions? Perhaps because he, like me, cannot think what such a specification would be. The alternative view has the twin virtues of obviousness and simplicity. To be impure is simply to have the disposition to cause the reactions; there is no role for a cognitive intermediary to play. Dracula has certain properties which cause reactions of disgust, and (if impurity enters into the picture at all) it is this fact which causes the belief that the Count is impure.

On this view, the belief that Dracula is impure, and therefore the belief that he is a creature of horror rather than terror, is caused in part by the feelings the character causes. Hence, whether or not Dracula is horrific depends not only on imagining the relevant propositions, but also on the feelings aroused. Which properties of the film cause which feelings is something learned from experience. As with other cases, properties' effects can be predicted using the usual inductive methods. However, also like other cases, this prediction can go awry for one reason or another. The effects of representations are particularly difficult to predict, as they tend to be quite complicated. If there are many different properties all acting on the observer, their effects might reinforce each other, undercut each other, or cancel each other out. For example, if a film-maker puts too much emphasis on properties of the film which he hopes will cause people to feel fear, the result may cause amusement and the belief that the characters are ludicrous. As any film-maker will testify, it is difficult

to be sure in advance what effects reasonably complicated representations will have on those who perceive them.[3]

4. Not all aesthetic judgements which use emotion terms are caused by, or about, specific characters and situations. Judgements are also made about—for want of a better way of putting it—the representation itself (rather than about its content). A representation, or part of a representation, can be shocking, sad, exuberant, intense, and so on. Indeed, such judgements are the standard fare of good criticism. To take an example, Hemingway's early short stories are admired for their skill in expressing particular moods, emotions, or feelings; *Hills Like White Elephants*, for example, expresses a powerful combination of anxiety and sadness. It is not merely that the work is about anxiety and sadness, or even that anxiety and sadness would be an appropriate reaction to its content. Rather, the story *itself* expresses these things.

It is easy to show that such judgements are not caused by the content of the works they are about. If the content of the story is the sole cause it would be a sufficient cause. But imagine all the individual propositions found in *Hills Like White Elephants* listed in basic English. Such a list would not express what the story expresses. Furthermore, the judgement that this set of propositions tells a sad story is different from the judgement that the story (the work of art) expresses sadness. The latter judgement deals not only with what is said but with the way the creator has said it.

On the face of it, the belief that a piece of writing is sad is puzzling. For if it does not mean simply that the story is about sad events, what does it mean? How can a story or other piece of prose be sad? We saw in Chapter 2 that emotions were bound up with states of consciousness. Roughly, to say that someone is sad is to say that they are in a certain mental state which is comprised of cognitive, physiological, and psychological states. What, to return to the question as it was posed in Chapter 1, is

[3] Points arising from those raised in this paragraph are explored in greater detail in Chapter 11.

the connection between this complex mental state and a piece of prose that is sad?

A natural line of thought would run as follows. The content of our belief about the work is that *it* is sad: namely, something about the work. We must detect this 'something' in the work; that is, it must be something we recognize. By specifying what it is we recognize, we will clarify how we come to believe the work to be sad. This mirrors what the cognitive theory claims happens in a confrontation. I recognize Fred's expressions of sadness for what they are, which causes me to believe that Fred is sad. What explains and rationalizes the reaction is the content of the belief gained in perception. Because of this similarity it is appropriate to label this account of judgements about a work's expressive properties, 'cognitivist'.

If I am correct in the arguments I have given above, this solution will be incomplete. I have distinguished between the content of a work and the way the content is presented. The former arouse our feelings through a cognitive intermediary, the latter can arouse our feelings directly. If—as I claim—the belief that a work is expressive is caused at least in part by the feelings it arouses, it follows that the belief that a work is expressive depends on more than the propositions the work contains. The alternative to the cognitive solution is the claim that the belief that a work is expressive depends on all the work's properties that arouse feelings—whether directly or via a cognitive intermediary. What explains the belief that a work is expressive is *that* it arouses certain feelings, rather than that there is a cognitive rationalization of those feelings.

The debate here is about the grounds for the judgement. The cognitivist claims the grounds are the recognition of some property of the work, I claim the grounds at least partly consist of some qualitative state caused by the work. Of course, the cognitivist can appeal to a wide range of properties discernible in the work. It is not only what is expressed in the work, but the way in which it is expressed, that could count as a recognizable property; the cognitivist is free to rationalize the way the content is presented to his own satisfaction. In art as in life, something can be said happily, sadly, nonchalantly, and so on. It is this that a careful listener or reader will recognize: the emotion in the 'tone of voice' which will cause the belief that the piece expresses the

emotion that tone matches. So, to return to our example *Hills Like White Elephants*, the response would be that the style of the writing is such that it is *as if* it had been narrated by a sad person. Hence, reading the story causes us to imagine that it is the expression of a sad person, and this is the content of the belief that it expresses sadness. Imagining this might, in turn, cause the reader to feel sympathy or pity for the (fictional) narrator.

There are cases in which all will agree that the narration expresses the feelings of the narrator. For example, Marlow, the narrator of Joseph Conrad's *Lord Jim*, tells the story in a way that leaves no doubt that he loved Jim and mourns his fate. This does not, however, result in the book's being sad: it is not a sad book. This does not in itself refute the cognitivist claim; it remains possible that all stories which *are* sad have this as their explanation. The cognitivist, however, faces another problem. The account relies on explaining the belief that a tale expresses sadness in terms of the belief that the narrator is sad about the tale he is telling, and, I would argue, there is no obvious way to move from the latter belief to the former. To explain expression in terms of the narrator's emotional attitude, there must be evidence for that attitude within the tale. This is a quite specific literary device which is, for example, found in *Lord Jim*. It has no obvious connection with the narrator's expressing emotion and the tale being expressive of an emotion, and not every tale that expresses an emotion employs this device. To return to the example given above, there is no expression of an emotional attitude by a narrator in *Hills Like White Elephants*.

The cognitivist might complain that I am interpreting the solution too narrowly. According to the account given in the last chapter, *all* fictional representations have a fictional narrator. Hence, if the representation is sad it simply follows that the narration is sad. A natural interpretation of the narration's being sad is that it is narrated sadly. The narrator's emotion does not need to be explicit, hence the cognitivist's solution cannot be refuted by showing that there are cases of expression in which no trace of the narrator's emotion can be found. But the cognitivist's argument here is specious, trading as it does on an equivocation in the term 'narration'. This can mean either the act of narrating or the tale narrated. There may well be a logical connection between the act of narrating being sad and the sadness (real or

feigned) of the narrator. But there is no such link between the *tale* narrated's being sad and the sadness of the narrator. Sad, happy, or indifferent narrators could all narrate a sad tale. The fact that we are dealing with the fictional narrator not the real author makes the cognitivist's task no less difficult. There still need to be grounds for claiming that the narrator is in some emotional state. If the emotional state of the narrator is to be the explanation of the expressive tone of the tale, there must both be evidence of the narrator's sadness in the tale and it must be shown that this is what makes the tale sad. The counter-argument is, therefore, valid: there are expressive fictional representations in which there is no such evidence.

The failure of the cognitivist attempt to explain expression in terms of recognizing the 'tone of voice' of the account is even more apparent if we move from the genre most favourable to the cognitivist's case—realistic prose fiction—to other representational media such as painting and poetry. Why does Ernst Gombrich believe that Watteau's *Fête in the Park* is suffused with 'a sweet and almost melancholy calm' (Gombrich 1978: 359)? On the analogy with the above argument, the cognitivist would have to claim that it was painted in a melancholy way. But what would such a way be, and what evidence for it could be found in the picture? There is no characteristic expression of sadness in paint.

Of course, this is not to say that the explicit expression by the narrator cannot *contribute* to the expressive tone of a work. It can, along with many other sorts of property. Consider, for example, Keats's *La Belle Dame Sans Merci*. Both the content of the tale and the emotion expressed by the fictional narrator justify the term 'sad'. However, the explanation for the belief that the poem is sad goes beyond these two aspects of it. For even a superficial look at the poem reveals, among the causes of its melancholy tone, the expression of powerful sexual fears and anxieties which underlie the surface content. Then there are the repeated images of death and decay, together with some purely formal properties: the use of repetition, the prevalence of sibilance, and the metre, which gives each stanza a flat, dead, final line. As these properties are neither part of the content of the poem nor expressions of sadness on the part of the narrator, some other explanation of their effect needs to be found.

It is difficult to see what cognitive connection there could be between the properties listed above and the belief that Keats's poem is sad. The formal properties do not have any rational connection with sadness: they are not the characteristic expression of a sad person. If this is true, it is difficult to see how unalloyed cognitivism could provide a complete explanation of the way in which we come to believe the poem is sad. The alternative, continuous with my account of our reaction to fictional characters, is to look at the effect these properties could have on the feelings. I have already discussed a number of points which support such a solution. First, as we have seen, the propositions which an observer is caused to imagine are not sufficient to explain the emotion he is caused to feel. Secondly, the experience of a work is not simply cognitive: we do not read Keats for the propositions we acquire from the poetry.

The alternative account, which I will be developing for the remainder of the book, is that our application of an emotion term to a poem is grounded in the fact that the poem arouses feelings similar to those which we would feel were we confronted with a person expressing that emotion. Art is expressive because it arouses feelings characteristic of our reactions to people who are expressing emotion. The arousal of these feelings causes the belief that the work expresses that emotion to which these feelings form part of the characteristic response. This account postulates no difference in kind between our reaction to expressive art and our reaction to expressive people. It suggests neither an ambiguity in our emotion terms nor a dichotomy in our emotional lives. Instead, it provides a unified account of the emotions in art and emotion in life.

The argument against the cognitive theorist is, as yet, suggestive rather than conclusive. That an aroused feeling forms part of the grounds for the belief that a work is sad does not imply that it is part of its content. The ground for my belief that it will rain might be a feeling that it will rain, yet the content of the belief is quite independent of that feeling. On the other hand, the account of the grounds of colour judgements has consequences for the sort of property we take colour to be. Whether or not grounds have consequences for content depends on the relation between them: roughly, whether it is constitutive or epistemological. I shall argue that the meaning of our judgements

that a work of art is expressive, provided this is not merely a matter of the work's content, is given in terms of the work's effect upon us.

Before proceeding, I should give the cognitivist a final word. It would be wrong to leave the impression that there is no answer a cognitivist could give to the points I have made against him. It would also be wrong to leave the impression that the non-cognitivist solution to these problems I favour is an unproblematic alternative to a problematic cognitivism. Any solution which explains the belief that a work of art is expressive in terms of the feelings (or emotions) it arouses faces a host of objections. One of these I have alluded to already: a work of art might arouse an emotion for all sorts of reasons that have nothing to do with expression; that is, arousing an emotion is not sufficient for expression. Neither does it seem necessary: we can form the belief that a work expresses an emotion without feeling anything at all. The cognitivist's replies to my criticisms and objections to my account will be faced in due course, once the discussion has been broadened along the lines described in the next section.

5. I began with the problem of providing a rationale for our emotional reactions to the plight of fictional characters. I went on to consider the problem of providing a rationale of judgements we make, not on a work's content, but on the work itself. Although the content of the work does influence these judgements, they are neither about, nor explained by, the content. There are obvious parallels between these judgements and—to introduce the second of the two problems mentioned in the introduction—judgements in which emotion terms are applied to instrumental music. The fact that music is, in general, non-representational is not a problem for the non-cognitivist account I favour; since representational properties are not necessary to account for expression, the absence of such properties from expressive music does not preclude the account from being generalized to that case. Showing that such an account does solve the problem of expressive music is the task of the remainder of the book.

I will conclude this chapter by providing an example of the sort of judgement on music which I take to be problematic. The

following extract, a discussion of Beethoven's Fifth Symphony, is from Gerhart von Westerman's *Concert Guide*.

The third movement returns to the world of ideas manifested in the first allegro. A theme that seems to wish to escape from the low region where it started leads to a derivative of the fate motif. As it feels its way ahead with gliding limbs, the strokes of fate recur, now hard and threatening, and then later, softly reverberating in the distance. An animated dance is introduced in the basses; a game that is an attempt at gaiety. This pales and flies off into nothingness. The dark lines start their climb as at the beginning, and the fate theme returns again, but with less life than before. An uncanny, heavy mood starts to spread, a mood of scary suspense, and it is from this that the victorious last movement breaks out, in all its elemental strength. (von Westerman 1968: 138–9)

The purpose of such a description is to enable someone who does not know the work to find their way in it. What is described are the experiences they should undergo as they listen to the music. If von Westerman's description is accurate, such experiences have a strong emotional aspect. In the music the listener is expected to hear, amongst other things, threat, gaiety, an uncanny, heavy mood, and triumph. This might lead him to judge that the music is threatening, gay, frightening, sad, or triumphant. But what is the connection between these uses of emotion terms and their use in the central case?

What has been identified is a set of uses of feeling and emotion terms which are applied to works of art without apparent justification. I shall call these uses 'expressive uses' and the judgements in which they appear 'expressive judgements'. As I have said already, I believe expressive judgements are caused and justified by the effect expressive works of art have on the feelings of the observer (or listener, or whatever). Before presenting the theory in any depth, I shall look at other solutions to the problem of expression. In doing so, I hope to achieve two things. First, I shall be able to clarify my own position and refine the arguments I have given against cognitivism in this chapter. Second, the formulation of the problem I have given both in this chapter and Chapter 1 is, I think, only part of the story. I have taken the problem as that of finding a link between the central cases of the use of emotion terms and their expressive uses. What the deficiencies of certain other accounts reveal is that this would

not be sufficient as an account of expression. What is also needed is an account of what it is to *experience* a work as expressive.

6

Expression as Metaphor

1. The description of the problem of expression I gave in the introduction—that of finding the link between the application of emotion terms to works of art and their application in the central cases—seems to have fallen out of favour in recent years; however, it had general appeal in the 1950s and 1960s. In his 1950 article, 'The Expression Theory of Art', O. K. Bouwsma clarified the problem of what I have called 'expressive judgements' by showing it to be independent of the then fashionable 'expression theory of art' (Collingwood 1938). As a result, the problem has remained, even though that particular theory has long since fallen from favour. Bouwsma states the problem by describing a listener's ('Verbo's') confusion after describing a piece of music as 'sad':

the moment he said this he became uncomfortable. He fidgeted in his seat, looked askance at his friend, but said no more aloud. He blinked, knitted his brows, and he muttered to himself. 'Sad music, indeed! Sad? Sad music?' Then he looked gloomy and shook his head . . . This then is how I should like to consider the use of the phrase 'expression of emotion'. It may be thought of as arising out of such situations as that I have just described. The use of emotional terms—sad, gay, joyous, calm, restless, hopeful, playful, etc.—in describing music, poems, pictures, etc., is indeed common. (Bouwsma 1950: 73–4)

The way to rid Verbo of his perplexity is—according to Bouwsma—to show that his use of 'sad' to describe a piece of music is continuous with the central uses. This formulation of the problem was generally accepted by philosophers following Bouwsma, for example, by John Hospers and Monroe Beardsley (Hospers 1954, Beardsley 1958).

It is an obvious step for anyone working with this formulation of the problem to see it as a special case of a more traditional problem in philosophy, the problem of metaphor, to which it bears a close structural similarity. According to the *Shorter*

Oxford English Dictionary, a metaphor is 'the figure of speech in which a name or descriptive term is transferred to some object to which it is not properly applicable'. The relation between the central use of a word and its metaphorical use is strikingly similar to the relation between the central use of a feeling or emotion term and its use in an expressive judgement: namely, both relations are asymmetrical.

This is best illustrated by example. The correct answer to an appeal to give the meaning of 'camera' in Christopher Isherwood's metaphor 'I am a camera' is to cite its central use. The correct answer to an appeal to give its meaning in 'The camera recorded the wedding' would not, on the other hand, be to cite Isherwood. Similarly, the meaning of 'sad' in an expressive judgement is elucidated by citing its central use in human emotional life. By contrast, someone who did not understand the word's meaning (that is, someone unable to apply it correctly to people) would not be helped by exposure to its use in expressive judgements. The explanation of this in both cases is that the central use of the term is primary. That is, one would not understand Isherwood if one knew only the metaphorical application of 'camera'. The central meaning is essential to our understanding of the metaphor. Similarly, in expressive judgements, one could not understand what a critic meant by a work's humility and sadness if one were ignorant of the central uses of these terms.

Metaphor and expressive judgements issue the same challenge to the philosopher: that of rationalizing the link between the primary and secondary uses of a word. This has suggested, as I remarked above, that the problem of expressive judgements is a special case of a more general problem, that of metaphor. Indeed, the view that expressive judgements are metaphors is often assumed at the outset of discussion. In this chapter I will argue that, if not actually a mistake, construing the problem in these terms is unhelpful. Even if expressive judgements are thought of as a sub-class of metaphors, they present particular problems which the usual solutions to the problem of metaphor are not adequate to solve.

In particular, the problem with expressive judgements is, as we have seen, not simply that a word is being used in a context apparently precluded by the connotations of its central use, but that none of the standard explanations we might give to account

for such uses appear to apply. Therefore, if it is part of the definition of metaphor that they can be accounted for by the standard explanations, expressive judgements will not stand inside the realm of metaphor, and calling them metaphors will not solve our problem. In other words, it will not help to call expressive judgements metaphorical unless there is a tenable theory of metaphor which provides an explanation of the connection between the use of an emotion term in these judgements and their central, non-expressive uses.

2. Although several philosophers have tried to solve the problem of expressive judgements by considering them as metaphors, there is no single general solution to the problem of metaphor on which they all agree. There are not only differences in emphasis, but different claims about what the problem is supposed to be. The most complete account of expressive judgement considered as metaphor is that of Nelson Goodman (Goodman 1976), although traces of the account can be found in philosophers as widely different as Ernst Gombrich and Philip Pettit (Gombrich 1962, Pettit 1983). I shall discuss Goodman's work in particular, and then proceed to criticize the over-emphasis on semantic considerations which characterize this kind of solution. This will bring me to the aforementioned re-evaluation of the way in which the problem of expression is usually formulated.

As one would expect, Goodman's view on metaphor has its root in the nominalism which characterizes his philosophy. The example around which his discussion revolves fits in very well with those we have been considering:

Before me is a picture of trees and cliffs by the sea, painted in dull grays, and expressing great sadness. This description gives information of three kinds, saying something about (1) what the picture represents, (2) what properties it possesses, and (3) what feelings it expresses. The logical nature of the underlying relationships in the first two cases is plain: the picture denotes a certain scene and is a concrete instance of certain shades of gray. But what is the logical character of the relationship the picture bears to what it is said to express? (Goodman 1976: 50)

Presumably for the reasons stated above, Goodman then introduces metaphor:

since, strictly speaking, only sentient beings or events can be sad, a picture is only figuratively sad. A picture literally possesses a gray color, really belongs to the class of gray things; but only metaphorically does it possess sadness or belong to the class of things that feel sad. (Goodman 1976: 50–1)

For Goodman, for *a* to express *b*, *a* must possess or be denoted by *b* and *a* must refer to *b*. Let us examine each in turn. Goodman analyses the properties a work of art possesses in terms of what predicates denote that work (Goodman 1976: 51). So the picture possesses greyness (is grey) if and only if 'grey' applies to it and possesses sadness (is sad) if and only if 'sad' applies to it. The difference between the former and the latter is that 'sad' applies metaphorically; something which still needs to be explained. Of course, a picture does not express whatever metaphors are true of it. A picture which proves to be a good investment does not express being a gold mine, even though that metaphor applies to it. How, then, can Goodman distinguish between metaphors that are 'possessed' and metaphors that are not?

This appears to be the role of the second part of Goodman's definition: 'expression, like representation, is a mode of symbolization; and a picture must stand for, symbolize, refer to, what it expresses' (Goodman 1976: 52). The mode of reference favoured by Goodman is exemplification. The clearest way to describe this is by example. A tailor carries swatches; samples of the cloth from which he makes his suits. The swatch exemplifies those properties it has and refers to, for example, 'colour, weave, texture and pattern'. Properties it has but does not refer to, 'size, shape or absolute weight or value', it does not exemplify (Goodman 1976: 53). It is clear that an object can only exemplify a property it possesses. Hence, we can put problems about exemplification to one side and look for the deeper problem in Goodman's account. That lies where one would expect to find it; in his use of the concept of metaphorical possession.[1]

As we have seen, Goodman thinks the predicate 'grey' applies to the picture literally and 'sad' applies metaphorically. But what

[1] A look at the drawbacks of Goodman's account, including a thorough investigation of the problems with exemplification, can be found in Davies 1994: ch. 3. See also Budd 1989: 133.

is it for a predicate to apply metaphorically? Goodman's reply is that the use of the predicate to apply to the picture falls within a secondary extension of the term 'sad'. But, as we have seen, this does not really answer the question. What would distinguish the expressive use of 'sad' from a simple ambiguity? That is, what makes it a secondary use rather than primary use in a second extension? Goodman gives a straightforward nominalist answer:

the several uses of a merely ambiguous term are coeval and independent; none either springs from or is guided by another. In metaphor, on the other hand, a term with an extension established by habit is applied elsewhere under the influence of that habit; there is both departure from and deference to precedent. When one use of a term precedes and informs another, the second use is a metaphorical one. (Goodman 1976: 71)

But this is not nearly enough. If I come across a cactus I have never seen before, I may well apply the term 'cactus' to it. This would be an application of a term with an extension established by habit applied elsewhere under the influence of that habit, but the new use would not be metaphorical. Unless Goodman says more about why calling the new use metaphorical is explanatory, the problem has not been solved.

In fact, he does say more: '[The phrase "the picture is sad"] *likens* picture to person by picking out a certain common feature: that the predicate "sad" applies to both, albeit to the person initially and to the picture derivatively' (Goodman 1976: 78). But if the common feature is simply that the same predicate applies, this does not help; it does nothing to rule out the case in which 'cactus' is applied to a new and unusual plant. The fundamental difficulty of the problem we are considering is being ignored: the expressive use of an emotion term cannot be construed as just another use of that term. There is something peculiar about the expressive use, a peculiarity which Goodman is attempting to explicate using the concept of metaphor. But obviously there is no explanation to be had if Goodman's account of metaphor does not go much beyond saying that it is a novel use of a word.

What is needed is an account of why calling an expressive use of a word 'metaphorical' is explanatory. The first step towards this might be an account of what sort of similarity must obtain between what a predicate applies to metaphorically and what it

applies to literally. This is exactly the question Goodman claims it would be a mistake to ask. He argues that the question makes as little sense here as it would in the literal case.

[W]e might ask . . . what sort of similarity must obtain among the things a predicate applies to literally. How must past and future things be alike for a given predicate, say 'green', to apply literally to them all? Having some property or other in common is not enough; they must have a certain property in common. But what property? Obviously, the property named by the predicate in question; that is, the predicate must apply to all the things it must apply to. The question why predicates apply as they do metaphorically is much the same as the question why they apply as they do literally. (Goodman 1976: 78)

No doubt there is some causal (and non-justificatory) account which would explain why we come to whatever utterance we do; that much we can grant to Goodman. It might even be, as he later claimed, that every aesthetic use of the word is caused by 'a common structural property' (Goodman 1972: 127). But this by itself cannot provide us with a way of classifying that utterance. Is the word used in a novel way, but still within its primary extension? Is it an ambiguous use of a word? A metaphor? A mistake? A use with some other justification? Goodman cannot attempt to answer these questions by appealing to the semantic considerations discussed earlier, because it was the shortcomings there that lead us to the current considerations. There is a wide circle here with no explanatory bite.[2]

Goodman is wrong to claim that the metaphorical use of a word stands in as little need of justification as a literal use. I need not justify my application of 'green' to green grass to any competent user of English, because that is just the sort of use that needs no justification: such a circumstance is exactly that in which the term should be used. On the other hand, if I describe the stock exchange as an orange, a request for justification is perfectly in order. Was it a slip of the tongue? A piece of surrealist wit? A metaphor? If I say subsequently that I meant that

[2] D. E. Cooper thinks that the problems with Goodman's account are an instance of a general worry for nominalism. Because nominalists take the application of predicates as primary, it is unclear (as we have seen) that they are able to distinguish different sorts of uses. He suggests that the whole nominalist ship might founder on this apparently small rock (Cooper 1986: 29–30).

it was difficult to get into, but, once inside, full of the good things in life I demonstrate that I meant the utterance metaphorically. Without such a description nothing is explained, and it is just such a description that Goodman thinks is not available. The expressive use of an emotion term is the sort of utterance that needs a justification; the use of an emotion term to describe a work of art is not simply another unproblematic use of the term. Therefore it needs the kind of explanation and justification Goodman is not able to give us.

3. Although Goodman's account fails, the structural similarity between our problem and the problem of metaphor remains. Could there still be, therefore, an account of metaphor which will solve the problem of expression? Not, I shall argue, if we make the reasonable assumption that the purpose of a metaphor is to draw attention to (or create, on some accounts) a resemblance between two things or types of thing. For, at its most basic, resemblance is a relation that exists between things that share a common property. Hence, if metaphors do relate things through resemblance, it should be possible to specify the respect in which the things resemble each other simply by specifying the common property. Put in less abstract terms, a speaker should be able to support any metaphor with an explicit statement of similarity.[3] But, if this claim is correct, the appeal to metaphor becomes an uninteresting sidestep. For such a statement of similarity would be enough to provide the link between the expressive and the central use of emotion terms which would justify our application of emotion terms to works of art. Now, either we can specify such a similarity or we cannot. If we can, the problem of expressive judgements has been solved and there is no need to appeal to metaphor. If we cannot, the appeal to metaphor has explained nothing.

What we need to consider, therefore, is whether the claim that all metaphors can be supported by an explicit statement of sim-

[3] As Wittgenstein seems to think: 'If I say "For me the vowel 'e' is yellow" I do not mean: 'yellow' in a metaphorical sense, —I could not express what I wanted to say in any other way than by means of "yellow"' (Wittgenstein 1956: 216e). I interpret this comment as drawing attention to the distinction between metaphor and the kind of problematic expressive judgement I am considering.

ilarity is indeed correct. A strong argument for the claim is that without such a supporting statement there could be no way of telling the difference between a metaphor and a piece of irrelevance; what Ryle called a 'category mistake' (Ryle 1963: 17). Consider the earlier example. To call the stock exchange an orange is to identify two things which are not only known to be distinct, but which would seem to exhibit no relevant similarity. As an effort at communication this is likely to be a failure; the listener is simply left nonplussed. However if the utterance is supported by the similarity mentioned earlier, the meaning is clear; it is a metaphor, if a rather poor one.

Kendall Walton, in an aside in his 'Pictures and Make-Believe', effectively makes the possibility of the specification of a common property criterial for something's being a metaphor (Walton 1973: 298; see also Budd 1989: 131–2, Davies 1994: 150–62). His claim is that if anything is a metaphor, it can be paraphrased using a literal sentence.[4] This paraphrase puts, in literal terms, what the metaphor is trying to get across. That is, it simply states the resemblance that the metaphor indicates. For example, one might paraphrase 'John is a terrier' by 'John is tenacious'. Walton points out that neither literal sentences nor what we have been calling expressive judgements are thus paraphrasable. The example he uses is 'The music is anguished'. There is nothing analogous to the direct paraphrase of the metaphor which we were able to give above. The only way to paraphrase 'The music is anguished' would be to use a synonym; whereas 'is tenacious' is by no means a synonym for 'is a terrier'. Unlike metaphor, to utter 'The music is anguished' is not to attempt to cause a belief other than that expressed by the words uttered. Walton maintains, plausibly in my view, that this disanalogy shows that expressive judgements are not metaphors.

An important role of metaphor in communication is to cause a belief the content of which is not captured by the metaphor itself, but rather by a statement of similarity. The role of

[4] There are similarities between this question and a debate that has been raging for a while in work on metaphor, that is, whether or not metaphor can be paraphrased in some deeper sense. All I mean by 'paraphrase' is that a supporting and clarifying statement can be given. This is separate to the question of whether the entire upshot of a sentence can be captured using different words.

expressive judgements, however, is to cause a belief the content of which is captured by the expressive judgement itself. Hence explanations of metaphor, explanations of how statements cause beliefs which are not captured by the statements themselves, are irrelevant to explaining expressive judgements. This conclusion, I would argue, accords with our intuitions. The statement 'That piece of music is sad' is more akin to such uncontroversially literal statements as 'That piece was long', 'That was a waltz', than to statements such as the uncontroversially metaphorical 'That music set the place alight'. The metaphor *compares* music and fire, whilst the expressive judgement makes no such comparison. If communication is successful, anyone who hears the expressive judgement will not come to some belief about some independently specifiable common properties of the music and sad people, but will simply come to believe that the music is, in fact, sad.

It cannot simply be assumed that expressive judgements are metaphorical; that claim would need to be argued for. In the light of considerations just discussed, I do not believe such an argument could be successful. However, in the next chapter I will look at a popular view of expressive judgements which has as a corollary that they can be supported by an explicit statement of similarity. In the remainder of this chapter I will fulfil my promise to look again at the terms in which the problem has been posed.

4. So far, I have followed the traditional formulation of the problem of expressive judgements: namely, that a familiar word (the emotion term) is used in a context (the aesthetic context) outside its usual truth (or assertion) conditions. But, as Bruce Vermazen has pointed out, this leaves it unclear why we say that works *express* emotions (Vermazen 1986). Why is this the word we use? What distinguishes secondary uses of a word which it is appropriate to describe as expression from those—including metaphor—which it is not?

Paradigmatically, it is people who express emotions. What, then, are the similarities between a person expressing an emotion and a work of art expressing an emotion which justifies the extension of the term? For a person to express an emotion is for

them to feel the emotion and for the emotion to cause them to appear and behave in a certain way, where this appearance and behaviour is a criterion for that emotion (cf. Wollheim 1966). To be a criterion for an emotion is to be an appearance or piece of behaviour characteristically caused by that emotion, and recognizable as such by others. There are uses of 'express' which are not covered by this definition—we might say someone expresses an emotion even if they do not feel it. It might simply be a fact about their physiognomy that their face expresses sadness. However, this use of express is parasitic on the other; someone's face expresses sadness only because it is the sort of face characteristically seen on someone who is in fact sad. Hence, the definition captures the primary use of the term on which this and other uses depend.

There are two important aspects of the central use to which I would like to draw attention. First, from what I have said it appears that only emotions can be expressed. One does not express wealth by buying expensive goods, or delicate health by coughing. Second, expression has duration; it is an activity. In this it is more like walking (for example) than it is like acquiring a belief. Acquiring a belief is something that can happen at an instant, whilst expressing an emotion, like walking, cannot.

What can we learn from this about works of art expressing emotions? The first point, which also confirms the point made in the previous chapter, is that an expressive work is analogous to the person who is expressing the emotion. As a consequence, the person experiencing the work is analogous to someone *witnessing* the expression of emotion. This, as we shall see, is important to the project of characterizing the spectator's experience of expressive works of art. The second point is that, if we keep similar constraints on 'express' in the aesthetic as in the central case, it is only emotions that can be expressed. Thus a work can express sadness or joy, but not brittleness nor the state of the working class in Victorian England. Again, there is a whiff of stipulation about this, objections to which can be answered by a similar reply to that given in the central case. It is true that we use 'express' in a variety of ways, and it does not sound too odd to say that a work of art expresses the state of the working class in Victorian England. But there is a difference between a work's expressing such a thing and its expressing an emotion. I propose

to mark this difference by restricting the term 'express' to the latter.

The third point concerns the claim about duration. As with the other points I have made, the importance of this can be appreciated only within the confines of a theory. Thus, a full exposition of it will have to wait until I am in a position to deliver one. However, a few things can be said here by way of a preliminary. At first it is difficult to see how there can be an aesthetic analogy of duration. Some works of art (pictures for example) have neither literal moving parts (as perhaps a play does) nor figurative moving parts (as perhaps music does). In what sense, then, could an expressive picture be said to be undergoing an activity with duration? This is indeed a good question. I shall argue later that expression is defined in terms of the experiences of the spectator, and, in these terms, the analogy is fairly clear. I claimed that expressing an emotion could not happen at an instant. Analogously, expression by a work of art is not something that can happen at an instant. The experience of a work of art as expressive is, therefore, not something that can happen at an instant. It makes no sense to ask when, during the performance, the second movement of the *Eroica* expressed grief or when, during our inspection of it, Goodman's picture expressed sadness. Rather, the expression is part of, and can last as long as, the experience.

These three points together demonstrate that the characterization of the problem employed by Goodman and myself in Chapter 1 is too general. The problem of expression is not simply that of finding an explanation for familiar words used in unfamiliar places. It is, rather, a particular instance of this with its own particular problems. Some rationale must be given of the difference between describing a work of art as expressive of a certain emotion, and the figurative description of a work by a term (whether an emotion term of not). That is, we need to explain *expression*. What is going on over the period of time during which we hear a piece of music as sad? How does an emotion 'enter into' our experience of art? What is the relation between this and the belief (or judgement) that the work expresses an emotion? None of these questions can be answered by a purely semantic account of an allegedly figurative use of language. In the next chapter I will look at some contemporary

attempts to solve this problem which go beyond semantic considerations.

7

The Cognitive Theory

1. There are two obvious candidates for an account of expressive judgements. Putting these candidates in their roughest and least plausible forms, the arousal theory claims that music is sad if it makes us sad; cognitivism claims that music is sad if it resembles a sad person. The most prolific champion of cognitivism in recent years has been Peter Kivy. His is the most sustained recent attempt to solve the problem of music and the emotions, and has, at least according to Joseph Margolis, 'come to be regarded as the indispensable locus for a promising theory of musical expression' (Margolis 1989: ix). Drawing on some of his arguments, I shall try to construct a train of thought which might lead someone to the cognitive solution. According to Kivy, the problem of music and the emotions is that it seems a necessary property of anything's being (for instance) sad that it feels sad. As music cannot feel sad, it simply cannot be sad (Kivy 1989: 6). This is not quite right, however, as the equivalence claim is too strong. Plenty of things can correctly and unproblematically be described as sad without their actually feeling sad: take, for example, the plight of refugees in wartime. This use of 'sad', like other non-central uses, is justified by finding an appropriate link between it and central uses of the word. It is not difficult to find the link in this case. Sadness is (roughly) the appropriate response to death or disappointment either to oneself, one's friends, or people in general. The plight of refugees is such that pain, misery, and possibly death are being experienced by large numbers of people. The fact that sadness is the appropriate effect of such a situation legitimates our calling the situation itself 'sad', as we can legitimately extend a term from the name of a state to something which is the appropriate cause or effect of that state.

Would it be possible to use the sort of justification we have for applying 'sad' to the refugees' situation to justify our applying 'sad' to certain pieces of music? According to the cognitivist, the

justification gets some of the way there. The music is sad because of some fact about it, which listeners are able to recognize. Hence, in both cases we are able to recognize the situation as sad, independently of its effects on us. However, there is a crucial disanalogy. The refugees' situation is the sort of situation to which sadness is the appropriate reaction—appropriate, because it is sanctioned by the definition. This is not the case with sad music. The definition of sadness does nothing to suggest that the closing of the second movement of the *Eroica* is sad. The music is not sad in the way that the refugees' situation is sad, any more than it is sad in the way that a person is sad. Rather, as we saw in the previous chapter, the music *expresses* sadness; we *experience* it as sad. It is because of this that we call it sad, not because such a use would be sanctioned by the definition of sadness.

If we are going to borrow the justification for what Kivy calls 'emotive criticism' from an established use of emotion terms, we need to find a use which describes objects which can be recognized as appropriate causes or effects of emotions *and* as expressing emotions. The obvious candidate is the characteristic appearance and behaviour of people who are in the grip of an emotion. This is both an appropriate effect of an emotion and an expression of emotion—in fact, it is a paradigm example of each. That we call music sad for the same reason that we call a person's appearance or behaviour sad is, in a nutshell, the theory that Kivy presents. (Hereafter, I will talk only about behaviour, with appearance being understood.)

However, this approach does not seem to have escaped the initial difficulty. Surely behaviour is expressive of emotion because it is caused by an emotion. So, for example, my tears are expressive of my sadness because they are caused by my being sad. We do not seem to have come very far; it is still necessary to feel an emotion in order to express it. Hence, the expressiveness of music cannot be modelled on the expressiveness of behaviour for the reason which caused the initial problem: that music is insensate. Kivy makes a familiar cognitivist move here, drawing his terminology from Alan Tormey's *The Concept of Expression* (Tormey 1971). Certain behaviour, Kivy argues, expresses an emotion regardless of whether, on a particular occasion, it is caused by the emotion itself. All that is needed is that the behaviour is characteristic of the emotion. For example, somebody

can have a face that is characteristic of sadness (turned-down mouth, lacklustre eyes) even though he does not actually feel sad, and this could correctly be called a 'sad face'. To mark this distinction Kivy says that behaviour characteristic of an emotion which is caused by that emotion *expresses* that emotion, whilst behaviour characteristic of an emotion which is not caused by that emotion is *expressive of* that emotion. For example, my tears express sadness if they are caused by my sadness, but are expressive of sadness if they have some other cause (the cutting of onions, for example). We apply emotion terms to music on the same grounds as we apply such terms to behaviour *expressive of* emotion.

Although sound, it is not clear that this distinction is of any use to the cognitivist. The whole point of investigating expressive behaviour is that things such as the situation of refugees do not *express* sadness and are not *experienced* as sad. But it is unclear that we can justify our experiencing behaviour which is only *expressive of* emotion as sad either. If I know that your tears are caused by your cutting onions rather than by some felt emotion, what justification can there be for emotion to 'enter into' my experience of your tears (cf. Budd 1985*a*: 141)? This problem can be postponed until later. If the cognitivist manages to provide an account of expression in music in terms of its appearance that will be a significant achievement. It would then be a further question as to whether they could explain our emotional reaction to such expression. In fact, Kivy does not believe we react with emotions to music; for him, at least, the problem would not arise.

2. The theory is that to be expressive, music must possess some property in virtue of which it resembles the expression of an emotion by a person. The theory can be interpreted in two ways. First, as an account of the *cause of* the experience of music as expressive and the expressive judgement. Secondly, as an account of the experience itself and the meaning of the judgement. As I said in Chapter 5, to identify the cause of something is not to identify the thing itself. The grounds for an expressive judgement might be the resemblance between the music and a person in the grip of an emotion, without that resemblance providing the meaning of the judgement. Philosophically, the interesting

questions concern the meaning of expressive judgements rather than the cause of our making them. Hence, I will begin my rebuttal of cognitivism by considering whether the resemblance between music and expressive people could be an account of expression itself, rather than the explanation of how we come to hear music as expressive.

It is not surprising that as an account of expression itself, cognitivism has been, and continues to be, more popular than the arousal theory. Its analysis of expression as a fact about the music, independent of the listener's perception of it, immediately confers four advantages over its rival. First, according to the cognitivist, the predicates used in expressive judgements straightforwardly refer to properties of the music. There is no need, as there is with the arousal theory, to explain how an effect of the music comes to be taken for a property of it. Secondly—a phenomenological version of the same point—expression seems to be an audible property *of the music*. It seems wrong to analyse hearing music as sad as the arousal theory does: hearing music and feeling sad. Thirdly, because expression is analysed independently of the listener's response, the theory can account for the listener's responding with an emotion that is different from that which the music expresses. For example, a listener might be irritated by a trite but joyful tune. On the arousal theory, it appears that the music must be expressive of whatever emotion it arouses. Finally, separating expression from the listener's response to it allows us to explain why the listener has the reaction he does—the listener responds with sadness because the music is sad. The arousal theory would seem to be committed to putting things the other way around, and thus depriving itself of an explanation at this point. This independence also allows the cognitivist to explain how a listener can identify the emotion being expressed incorrectly; it is not clear how the arousal theory could do the same.

In the light of these points, and others that will emerge in the course of the discussion, philosophers have tended to assume that some form of cognitivism must be right and that it is only a matter of time before the problems with the account are ironed out. I shall argue that, despite its initial promise, cognitivism is irredeemably flawed. Furthermore, I shall argue that the advantages cognitivism appears to have over the arousal theory have

derived support from the mistaken belief that it is the only game in town.

The first problem in considering the purported resemblance between the music and an expressive person as an account of the meaning of an expressive judgement, is that the mere fact of resemblance is not enough to specify a single account. Malcolm Budd has pointed out that Kivy, in particular, seems to provide support for a number of quite different analyses in his work. Only by considering each in turn can we resolve the issue of whether or not cognitivism provides a justification of the emotive description of music. I shall begin with the analyses listed in Budd 1991: (1) that the listener hears the music *as* a human utterance (or gesture) expressive of emotion (Kivy 1989: 58); (2) that the listener hears the music *as appropriate for* the expression of emotion (Kivy 1989: 50); (3) that the listener hears the music *as resembling* a human utterance (or gesture) expressive of emotion (Kivy 1989: 53).

Hearing the music as an expression of sadness. On this analysis, our experience of the music is the same as the experience of the audible expression of human sadness. Hence, when we judge the music to be sad we mean (literally) that it sounds like a sad person. This clearly would justify the claim that the music expresses sadness. Human behaviour which is expressive of an emotion is behaviour which is a *criterion* of that emotion: namely, behaviour that is characteristically caused by the emotion. Such behaviour will include speech as well as other sorts of action. For example, banging one's fist on the table, shouting, or saying 'I am angry' are expressions of anger. Sobbing, crying, or saying 'I am sad' are expressions of sadness. The question we are asking is whether, when we hear music as expressive of emotion, we hear it as the audible components of such behaviour.

It is certainly true that there are occasions when we hear music not as music, but as some other sound. In Beethoven's Sixth Symphony, for example, one can hear a bird calling; in the *Rheingold* one can hear the sound of anvils being struck. Could it not be true, therefore, that we hear sad music as the sound of someone who is sad? It is obvious that this claim is not generally true. Sad music neither represents nor reproduces[1] the charac-

[1] See Scruton 1983 for more on this distinction.

teristic sounds of sad people; it is not comprised of audible sobs and cries. There is clearly a difference between experiencing the second movement of the *Eroica* and experiencing the sounds characteristically produced by someone in grief. This is, I think, the least charitable interpretation of Kivy and one he himself rejects (Kivy 1989: 64 ff.).

Hearing the music as appropriate for the expression of sadness. For us to be able to hear music as appropriate for the expression an emotion we must at least be able to hear it as an expression of that emotion.[2] For, in the absence of a completely different explanation altogether, something cannot be an appropriate doer of something unless it in fact does it. This analysis, therefore, is a refinement of the previous one and falls to the same objection.

Hearing the music as resembling a human behavioural expression of an emotion. This, I think, is the natural reading of the theory. To hear music as resembling a human behavioural expression of an emotion, some characteristics of that behaviour must be replicated in the music. There seems to be a good candidate for this in the replication of human movement. For example, some music moves slowly and methodically in a way that is, arguably, characteristic of sad people. Hence, it may be that hearing a piece of music as sad is to be analysed as hearing characteristics that are common to the music and a sad person.[3]

We should distinguish between two senses which the word 'movement' can possess when applied to music. The first is movement in time or, in musical terminology, 'tempo': the music can either be played quickly or slowly. In its second sense, 'movement' describes the relation of notes to each other in what has been called 'musical space' (see Scruton 1983). When we listen to a melody, notes seem to have a 'position' relative to each other. We talk naturally of one note being 'higher' or 'lower' than another, and of the music 'rising' or 'falling'. That is, the notes are moving, but in relation to each other, rather than to the clock. It will be movement in the second sense which will be

[2] Cf. Barwell 1986. Barwell proposes this analysis and it is clear that she accepts this point. She does not realise that it is fatal to her case.

[3] This is the most popular candidate for the common property among cognitive theorists, including Bouwsma 1950 and Davies 1980, 1994.

most likely to resemble human movement. I propose to ignore the problems associated with describing music in this way, and grant that this kind of description does not beg any relevant questions.[4] For even this, I shall argue, cannot contribute to an analysis of musical expression.

The analysis is that in listening to certain pieces of music, we are made aware that it possesses some properties also possessed by sad people. The principal problem with this analysis is that it is unclear how such an awareness could constitute the experience of expression. What form would such an awareness take? To recapitulate on what was said in the previous chapter concerning this particular problem for the cognitivist, imagine you have just listened to a performance of the second movement of Beethoven's *Eroica*—the conclusion of which has been described by Donald Tovey as 'broken with grief'. When, during the experience of the performance, did you hear the emotion in the music? The question is an odd one; analogous to asking someone when, during his experience of a sunset, he saw it as red. The experience of expressive music is, phenomenologically, a unitary experience: that is, the experience of the grief in the music is not something that happens at *some time* during our experience of the piece. There is a single experience of the music expressing grief as, in the colour case, there is a single experience of the sunset as red. Both these experiences last for as long as the object continues to be perceived, provided—of course—that it continues to exemplify the relevant property. The cognitivist account must explain such enduring unitary experiences.

Let us consider one form which the awareness of common properties could take. The listener acquires an expressive belief through *recognition* of some relevant aspect of the music. If this were the case, it would be difficult to account for the central role of experience. The problem is that in contrast to asking when, during the experience of the performance, you heard the emotion in the music, it does seem sensible to ask when, during the experience of the performance, you recognized some property of the music. That will be the time at which the belief is acquired. The acquisition of a belief at a time is not, however, an endur-

[4] For a discussion of the problems see Scruton 1983, Budd 1985*a*: ch. 3, Budd 1985*b* and Davies 1994: 229–40.

ing unitary experience. Hence, it is difficult to see how the cognitivist could develop an account of the *experience* of expression over time in terms of the *recognition* that the music had some property.

An alternative way of characterizing the awareness would be in terms of holding onto a belief. The listener forms a belief about the music and, for as long as the music is expressive, he holds this belief concurrently with experiencing the music. If anything, this seems to me a step away from an account of experiencing music as expressive. There is, as I have claimed, a problem in accounting for the way that an emotion can 'enter into' our experience of music. Such experiences have a particular phenomenological character which is not simply that of being aware of music. Given that holding onto a belief is not a state with any phenomenological character at all, it is difficult to see how the sum of holding onto a belief and listening to music will equal the experience of listening to music as expressive. It is difficult to see what other account the cognitivist can offer, given his limited resources. This important aspect of the expression of emotion by music would seem to remain unexplained.

The cognitive theorist might attempt to draw on a general theory which seeks to explain *all* perception in terms of the acquisition of beliefs (see Armstrong 1968). If perception can be explained in terms of belief, the perception of emotion in music would seem to be merely a special case of this. But this will not, in fact, help the cognitive theorist. For the problem is not about experience generally, but about one particular sort of experience. Suppose the general theory were true. In that case, the experience of music by a listener would be explained (very roughly—the details are irrelevant for my discussion) as the acquisition of beliefs that sounds are being produced in his vicinity. But what is it for that experience to be the experience of the expression of emotion? Cognitive theorists would be unwise to hold that the beliefs involved are that *sounds expressive of emotion* are being produced in the vicinity, for that would be to assume what they need to explain. The explanation open to them, in fact the one they give, is that there is an additional second-order belief about the musical experience: namely, that the experience in some way resembles a sad person. This leaves cognitivists in very much the same position that they occupied before they appealed to the

general theory. It is difficult to see how either the acquisition or possession of a second-order belief will explain the experience of expression. Hence, there is nothing for the cognitive theorist to gain in appealing to the general theory.

3. The two most developed cognitive theories, those of Peter Kivy and Stephen Davies, do not present their final analysis of expression in terms of the awareness of common properties. Instead, their accounts take a dramatically different turn which, I would argue, changes their nature entirely. After a long discussion, which has thus far maintained resemblance at the centre of the argument, Kivy claims: 'we tend to "animate" sounds as well as sights. Music may resemble many other things besides human expressions. But just as we see the face in the circle, and the human form in the wooden spoon, we hear the gesture and the utterance in the music' (Kivy 1989: 58). That is, the experience of expression is *not* the awareness of resemblance. It is the animation of music, by us, such that we 'hear the gesture and the utterance in the music'. The change in Davies's account is equally dramatic. Having previously claimed that to hear music as expressive is to hear it as presenting 'emotion characteristics in appearances' (Davies 1994: 254), we suddenly get this: 'as I have described it, musical expressiveness is an aspect (or an emergent property, or a supervenient property) depending for its character on the structure of musical movement' (Davies 1994: 256). Despite the pages of argument to the effect that expression was in some way to be analysed in terms of resemblance, this turns out not to be the case. Expression is something else altogether: a perceptual property we project onto the music, according to Kivy, or an equally mysterious emergent or supervenient property, according to Davies.

I shall focus on Kivy's account, as it is the more detailed of the two. Sadness enters into the experience of music not simply because it has some properties of sad people, but because the listener *invests* the music with sadness. We are told that expressive music shares some properties with the characteristic expression of emotion in people which *causes* a listener to 'animate' it so as to experience it as expressive. We are still left without an account of *what it is* to experience music as sad and what we *mean* by applying an emotion term to music. It is not enough to be told

that we 'animate' the music; we need to know (at least) how the experience relates to the central cases of experiencing an emotion and how it provides the grounds for our judgement.

Kivy's claim that expressive music is music which has been animated in a particular way opens the door to a different analysis of musical expressiveness: namely, an account of what it would be to hear music as so animated. And Kivy does, in fact, give two analyses along these lines. His general claim is that there are two possible objects of a listener's experience. On the one hand there is the music, construed as a collection of notes (the analogue of the circle and the wooden spoon), and on the other there is the music once it has been 'animated' (the analogue of the face and the human form). There are two familiar accounts of this sort of experience in the philosophical literature: Wittgenstein's 'seeing an aspect' and Wollheim's 'seeing something *in* something else'. Kivy uses both; in *Sound Sentiment* he claims that in our experience of music, seeing an aspect and seeing in are all part of the same phenomenon (Kivy 1989: 172).[5] We need to consider, therefore, two further analyses: (4) that the listener hears a human utterance (or gesture) expressive of emotion *as an aspect of* the music; (5) that the listener hears the human utterance (or gesture) expressive of emotion *in* the music.

That the listener hears a human utterance (or gesture) expressive of emotion as an aspect of the music. Wittgenstein's discussion of 'seeing an aspect' ('seeing as' for short) is notoriously difficult. However, the issue is fairly clear. The central cases are certain drawings[6] which can be seen as a representation of one of two (or more) things. The most famous example is the 'duck/rabbit' drawing, which can be seen as representing either a duck or a rabbit. That is, one can perceive the drawing as being of a duck and then have a 'change in aspect' after which one perceives it as being of a rabbit (or vice versa). Nothing in one's visual field has changed, despite the change in what is seen. Kivy's example of 'seeing as' is the circle containing three horizontal lines which, he

[5] I shall ignore Kivy's claim that seeing as and seeing in are identical phenomena. For the difference, see Wollheim 1987: 360.

[6] Wittgenstein also mentions objects such as faces, but for ease of explication I shall restrict my discussion to drawings (Wittgenstein 1956: 197).

says, can be seen either as a jumble of marks or as a drawing of a human face.

Initially, this analysis seems plausible because there does seem to be an analogous pair of experiences in our experience of music. The first is the experience of music on a technical level; one notices the formal merits of the piece and how it is played. The second is to hear the music as expressive; instead of listening for the proficiency of the orchestra, or the way the conductor has tackled certain problems that arise in the performance of the piece, one hears it as expressive. Whether one chooses to hear the music in the first way or the second will depend very much on what one wishes to get out of it. Interesting music criticism often directs us to switch between the experiences.

This all seems true, but it is of no help to Kivy. For the second experience is just what is supposed to be explained by this account in terms of 'seeing as'. There is no analysis of musical expressiveness to be gleaned from claiming that we can hear music as music (for want of a better way of putting it) *or as expressive*. Hence, we will have to look for a different pair of experiences if we are going to explain what it *is* to hear music as expressive. Which two experiences will justify my judgement that the music is sad? The only option is the experience of music as music, and the experience of it as the actual expression of emotion. Perhaps this is what Kivy means when he claims that in listening to music expressive of sadness he hears 'sadness as well as sounds' (Kivy 1989: 59).

But this fails for at least two reasons. First, even if we grant that part of my experience of sad music is the experience of the expression of sadness, this is no reason for me to characterize the expression as a whole as sad. For it is sad only when experienced under the aspect of sadness, otherwise it is experienced as music. The second problem is that this is not a significant advance on the first analysis. For the claim here is that while listening to a piece of sad music we experience it as the actual expression of sadness. But we saw in the earlier discussion that this claim cannot be substantiated.

That the listener hears the human utterance (or gesture) expressive of emotion in the music. 'Seeing' objects in stains on the wall or discerning diaphanous creatures in frosty windowpanes

are instances of a fairly common experience; the experience, according to Richard Wollheim, of seeing something *in* something else. 'Seeing in' differs from 'seeing as' in that the latter involves two distinct experiences and the former a single experience with two different aspects.[7] Wollheim describes it thus:

The two things that happen when I look at . . . the stained wall are, it must be stressed, two aspects of a single experience that I have, and the two aspects are distinguishable but also inseparable . . . The two-foldness of seeing-in does not, of course, preclude one aspect of the complex experience being emphasized at the expense of the other . . . One aspect of the experience comes to the fore, the other recedes. (Wollheim 1987: 46–7)

Again, this seems to capture something important in our experience of music as expressive. Our common auditory experience of music does seem to have two 'aspects': that of the music as music and that of the music as expressive. But for arguments parallel to those given in discussion of the previous analysis, this will not serve Kivy's turn. Kivy's claim needs to be that the two aspects are that of the music as music and that of the music as the actual expression of an emotion. The same two problems arise. First, no justification is provided for our experiencing the aspect of music as music as sad, and secondly, it has already been shown, in the discussion of the first analysis I considered, that we do not experience sad music as the actual expression of emotion.

Kivy seems half-aware of these flaws in his account. In attempting to evade them, he takes the step of making part of the experience of sad music unconscious. He says:

in listening to . . . music, we need not be, and often are not, conscious of the 'life' in the music, when, by means of it, we hear the expressiveness in the music. If there is something analogous to Wollheim's 'seeing in' here, it is our hearing the expressive properties in the music: that is what we are fully conscious of in our listening experience. The perception of that analogy of music to human expressive behaviour must lie at some deeper, non-conscious and pervasive level. (Kivy 1989: 173)

Whatever the truth in this, it is irrelevant to the analysis. Kivy

[7] 'Aspects' construed in the normal sense, rather than in the technical sense of 'seeing an aspect'.

admits that 'hearing the expressive properties in the music: that
is what we are fully conscious of in our listening experience';
but he tells us nothing about what these expressive properties
are. It may be, as I shall explore below, that there is some causal/
psychological account involving music 'suggesting' (on an uncon-
scious level) analogies with human movement, but that is not to
the point. We need a *justification* of our use of emotion terms in
these contexts, which will also involve *making sense* of our
experience.

4. The alternative to construing the property of music in virtue
of which it resembles an expressive person as a contribution to
the meaning of the expressive judgement is to construe it as part
of the cause of our making expressive judgements. This, indeed,
is the only way of making sense of the final twist in Kivy's and
Davies's accounts. The claim would be that it was resemblance
between the music and the appearance or behaviour of sad
people that *caused* the listener to hear it as expressive. It would
be likely that the experience of the music as expressive would
take some of its character from the experience of this resem-
blance (although the details of this remain unfurnished).
 Such a causal account would explain why it is no accident
that music which is expressive of sadness is, generally, describ-
able in terms which also describe sad people: a *slow* tempo and
low register being familiar examples. Indeed, the cognitivist has
a plausible range of examples to which he can appeal, from those
which resemble the rise and fall of the human voice—the open-
ing of Monteverdi's *Arianna's Lament* (Kivy 1989: 20)—to those
which resemble the appearance of emotion in a broader sense:
'the brisk tempo, driving rhythm, open texture, bright scoring,
etc. in the overture to Mozart's *Marriage of Figaro*' (Davies 1980:
77).
 Even as an explanation of the causal ground of expression,
however, the appeal to resemblance is not convincing. Kivy him-
self remarks that

although resembling emotive expression might perhaps be a necessary
condition of the kind of expressiveness I am talking about, it is not,
one could rightly insist, a sufficient condition. If A's resembling B were
a sufficient condition for A's being expressive of B (or expressive of
something related to it), then music would be expressive of everything

it resembled: the waves of the ocean, and, for all I know, the rise and fall of the stock-market or the spirit of capitalism. (Kivy 1989: 61–2)

Indeed, it is this point that prompts Kivy's claim that listeners 'animate' music with emotion. The reply is 'a frankly empirical one': namely, 'that there be some psychological link between the music and what it expresses'. Music expresses emotions, rather than something else, because we 'cannot help' but experience it in this way.

This reply further reduces the role played by resemblance in the overall account. No longer constitutive of expression, even its role as a cause is under threat.[8] Resemblance does not seem to constitute a very significant constraint on our being able to see one object as another. Accepting the truism that all things resemble each other to some degree, a wooden spoon does not resemble a human being in any obvious sense. To reiterate, I am not claiming that resemblance has no role in an overall account; obviously it does. I am claiming that the role does not lie in explaining why we animate music (if indeed we do). Resemblance is not necessary for such animation to occur.

Once it is conceded that resemblance is merely playing a diminished causal role in the account, there seems no reason for the cognitivist to maintain that it is the *only* cause of our hearing music as expressive. In fact, the counter-examples are so obvious that no cognitivist does claim this. Kivy, once more, concedes the point:

Does the minor third bear any more resemblance to behaviour expressive of grief than does the major; or the major bear any more resemblance to behaviour expressive of joy? Just to ask the question is to see its absurdity. Neither the major nor the minor bear any resemblance to either. And again we find a ubiquitous element of musical expressiveness for which, as yet, we have no satisfactory account. (Kivy 1989: 70)

Kivy's solution to this is to provide, once more, a 'quite different . . . theory' (Kivy 1989: 77): that elements of music which do not resemble the expressive appearance of emotion obtain what expressiveness they possess in conventional association. This

[8] This problem is rather acute for Kivy as his position here seems to contradict his well-known antipathy to the claim that aesthetic concepts do not exhibit positive condition-governing (Kivy 1981).

establishes conclusively that Kivy's is a causal account. He cannot mean to present two distinct analyses of expression, as this would render expressive judgements ambiguous: 'The music is sad' would *mean* different things depending on whether the salient property were resemblance or conventional association (cf. Levinson 1981*a*, Budd 1991). There is no problem, however, in there being more than one cause of our hearing music as expressive.

Interpreted causally, therefore, what the theory amounts to is that prominent among the causes of our hearing music as expressive is the resemblance it bears to the appearance of emotion in people. Even the arousal theorist can grant that such a resemblance plays a part in our hearing music as expressive, without granting this for all cases. Take, for example, the opening of Mozart's *Requiem*. The important properties here seem to be connected with, to put it simply, the way the music sounds; the relations between the different qualities of sound produced by bassoons and basset horns, trombones and choir. So, even if we can make a case for a resemblance in the dynamic qualities of music, it is only one relevant causal property amongst many.

5. Interpreted as an account of the grounds of expressive judgements, cognitivism barely amounts to a theory at all. To succeed in its aim of showing that expressive judgements express beliefs about perceivable properties of works themselves, it must account for the content of expressive judgements. As I indicated at the beginning of this chapter, the theory appears to have all the marks of truth. Indeed, we must not lose sight of the fact that expressive judgements are assertions: they make claims about the work. Any theory, to be adequate, must account for this. For the remainder of this chapter I will look at two further cognitivist accounts. I shall then consider attempts to explain expression which draw on the arousal theory. In the next chapter I will develop my version of the arousal theory (introduced in Chapter 5) and show that despite expression's being analysed in terms of aroused feelings, expressive judgements can still be satisfactorily accounted for as being about the work.

The first of these other cognitivist solutions is that of Bruce Vermazen. As mentioned in the last chapter, Vermazen distinguishes between expressive and merely figurative judgements.

The account he provides makes the expression of emotion by works of art parasitic upon, and closely associated with, the expression of emotion by people. By maintaining a close link between the central and aesthetic application of emotion terms, Vermazen is able to offer the prospect of convincing accounts both of the meaning of emotion terms when applied to art and of the experience of art as expressive. How, then, does Vermazen propose to do this? At the heart of his account is the claim that, in saying what a work of art expresses, we are attributing mental states, events and processes to an imagined utterer ('the persona') of the work. On hearing a work, Vermazen claims,

> we can construct a certain contrary-to-fact conditional concerning the expressive object or behavior, saying, 'This object or bit of behavior would be produced by a person if . . .', where we fill in the ellipsis with a list of the characteristics (as I would say) of the persona. Then we sort the characteristics into two categories: one category comprises those characteristics we have built in or presupposed, for example that the person intended to write in English, or intended to write a tonal piece in sonata-allegro form; the other category comprises those characteristics that we go on to infer on the joint basis of those presuppositions and the properties of the object or behaviour. The characteristics in the former category are not expressed: the poem does not express the intention to write something tonal in sonata-allegro form. But the mental characteristics in the latter category, the ones whose presence is inferred, are exactly those which are expressed by the utterance. (Vermazen 1986: 200)

Both the question of the meaning of emotion terms when applied to works of art, and the demand for an account of the experience of art as expressive, can be rephrased in Vermazen's terms. I have taken the semantic problem to be one of finding some justificatory link between the central and the expressive uses of emotion terms; for Vermazen, it is a matter of showing why expressive works of art provoke the inference he claims they do. We would be justified in claiming that, were the sound of weeping to be produced by someone, that person would be sad, but what justifies us in claiming that, were the second movement of the *Eroica* to be produced by someone, that person would be sad? The music, as I have repeatedly stressed, sounds nothing like the sound produced by a person who is sad. As for the question of the experience of expression, Vermazen needs to explain

how the experience of music can be the experience of the expression of the persona's sadness; it seems to have little in common with the experience of the expression of a person's sadness.

Despite much worthwhile discussion and defence of his position from more peripheral objections, Vermazen fails to confront these problems. He repeatedly talks of the work of art as 'evidence' for the state of mind of the persona, but says nothing as to how it qualifies as this. Whatever the merits of Vermazen's criticisms of others, the existence of his positive account depends upon answers to the two questions posed in the previous paragraph. Failure to answer them is not so much a flaw in an account as an absence of one.

Perhaps the omission of such an account indicates that Vermazen does not believe that a positive account is necessary. The alternative would be to take the expression of emotion by a work of art as a primitive, to be explicated by its incorporation into the kind of scheme Vermazen suggests. This seems to be the view of Jerrold Levinson. The fact that sad music does not sound much like a sad person leads, Levinson argues, to the theorist making the more sophisticated claim that 'sad music is music we construe *as if it were* a sad person expressing sadness' (Levinson 1990: 338). This is close to Vermazen's formulation and does not in itself provide answers the two questions which, I have argued, would constitute a positive account.

Levinson, however, seizes on the fact that the conditional nature of the formulation allows for the possibility that the music sounds nothing like a characteristic expression of sadness, as grounds for the claim that he is not required to answer these questions. Expressive music, he says, is an instance of a different sort of expression altogether:

The idea is that expressive music is heard *as if it were* an alternate, audible but sui generis mode of behaviorally manifesting psychological states, emotional ones in particular. It is a mode imagined or felt as akin to singing, gesturing, posturing, dancing and so on, but not as equivalent to any of them, presenting itself instead as a novel and distinctive alternative to ordinary modes of personal expression. (Levinson 1990: 338)

Many things, including structural resemblances between a piece of music and the standard behaviours for expressing an emo-

tion, will typically play a large part in bringing about the experience of expression, but those things themselves are not the analysis. Rather, Levinson says, 'expressiveness of α in music is thus favored *hearability as* (a new sort of) human expression of α' (Levinson 1990: 339).

Does Levinson mean that music expressive of α is hearable *as* a new sort of expression of α, or hearable *as if it were* a new sort of expression of α? The quotations above support both interpretations. The latter construal is weaker; if we hear a noise *as if it were* a cry for help the noise would not have to sound like a cry for help; the listener would only need to regard it as though it did. Therefore, this construal would seem to be to Levinson's advantage, as it relieves him of the need to explain how a sound could simultaneously be music *and* an expression of emotion; it would only need to be regarded as such. But because Levinson is committed to the mode of expression being *sui generis*, this alternative is not open to him. A listener can regard a noise as a cry for help only if he knows what it would be to hear a cry for help. The noise and that which the noise is regarded as being need to be distinct. Similarly, to hear music as if it were an audible mode of expression of α requires an independent understanding of this mode of expression. As Levinson maintains that it is a *sui generis* mode of manifesting psychological states, we *could* not understand it independently of expressive music. Hence, Levinson might as well maintain the stronger interpretation—namely, that we hear music expressive of α as such an expression.

But it seems a desperate philosophical remedy to postulate such a mode of expression. Levinson introduces it as something 'felt as akin to singing, gesturing, posturing, dancing and so on'. However, *comparisons* cannot aid the elucidation of the notion of a *sui generis* mode of expression; that they are *sui generis* makes them, as a mode of expression, incomparable. There is, by definition, no explicable relation to the central cases of expression. We cannot make clear, either to ourselves or to others, what makes our experience of the music one of emotional expression rather than something else.

There is something unobjectionable in Levinson's account: namely, that the content of an expressive judgement is that we hear the music as expressive of emotion. However, it is in what

is said next, that is, what *this* claim commits us to, that the theory reveals its commitments. Levinson's account is *not* free of commitment; it is not a simple nominalism which would hold that all we can sensibly say in elucidation of the expression of sadness in a piece of music is that the label 'sad' applies to it. The content of the expressive judgement is that the work expresses some phenomenal property, an 'emergent expressive gestalt' of 'ready-perceivability-as-expression' (Levinson 1996: 111, 108). We are committed to there being a fact about our experience which justifies our expressive judgement, which is in principle unrationalizable. Questions such as: What reason have I to call this sad? How do I know it is sad? would admit of no more than the trivial answer than that I hear it as sad. The introduction of such properties lends only a specious clarity to the discussion. It makes the whole notion more mysterious than it needs to be, as well as rendering it impossible to answer what appear to be perfectly sensible questions.

6. The provision of an account of the content of expressive judgements—that is, an account of to what we are committed in using them—will almost certainly involve an appeal to broader issues in the philosophy of mind. This perhaps explains why some philosophers have been, albeit tentatively, exploring the arousal theory to see whether it can be grafted onto a form of cognitivism in order to overcome some of the problems. Aaron Ridley's book, *Music, Value and the Passions*, contains just such an account.

I am not going to discuss much of the valuable work Ridley does prior to his central account of expressive judgements. In that discussion, Ridley shows how an account based on resemblance can explain some of the judgements made about music which flourish in the same hedgerow as expressive judgements. As in an earlier paper, Ridley refers to resemblances between expressive music and expressive people as 'melisma' on the grounds that other terms (Kivy uses 'contour', whilst Levinson prefers 'physiognomy') fail to 'reserve a natural place for the timbral and rhythmic factors crucial to the resemblance between music and the human voice' (Ridley 1995*a*: 57; 1995*b*: 75–6). Ridley is not, however, a straightforward cognitivist. He is fully aware of the charge that cognitivism is an account of the *grounds*

of expression rather than expression itself (Ridley 1995b: 120). An account of expression must 'take us beyond melisma' (ibid.: 121) into the arousal theory.

Ridley works with a comparatively weak conception of the problem of expression: 'Something is expressive of a passion if, first, by virtue of certain of its features it calls that passion to mind; and if, second, that passion does not need to be thought of as *someone's* passion' (Ridley 1995b: 73). It is the first of the two conditions that concerns me here. For Ridley, in order for a work to be expressive, it is only necessary that it 'call a passion to mind'. For something to call a passion to mind, it need only provoke the thought of that passion. However, experiencing something as expressive seems to demand something more; that, to use Ridley's term, the passion 'enter into' the experience of the work. Quite what that amounts to is, I would maintain, a large part of the difficulty in the problem of expression. With this caution, let us proceed to the theory itself.

Ridley distances himself from what he calls 'the strong arousal theory', calling his account 'the weak arousal theory'. The arousal of a feeling in the listener plays an essential part; 'it provides a bridge from mere *resemblance* . . . to *expressiveness* proper' (Ridley 1995b: 134). The broad strategy Ridley employs is as follows: he investigates the role of the arousal of feeling via the expressive behaviour of people (that is, the central case), and then attempts to transfer the lessons learned there to solve the problem of expressive music. In the central case, recognition of expressiveness is conceptually related to our capacity to feel. Ridley contrasts our position with that of a robot, which is able to derive 'beliefs' of the sort 'Fred feels sad' from Fred's appearance and behaviour. The robot is deficient in two ways. First, since it does not know what sadness is like, it has no appreciation of the significance of the attribution of sadness to Fred. Second, the robot is unable to experience the sort of state which would be an appropriate cause of Fred's behaviour. Because of this, its judgements of what Fred is going through will be 'schematic and routine'. By contrast, 'we know what it would be like to be in the state which his gestures reflect' (Ridley 1995a: 53; 1995b: 131-2). Hence, we will in fact know more than we can say; we might share the robot's form of words ('Fred is sad') but we will have a grasp of the shade of sadness which Fred is

experiencing. In summary, there are three mental states in question: the recognition that Fred's gestures are expressive, a sympathetic feeling, and the belief that Fred is sad. The first causes the third and the second adds a finer appreciation of the content of the third.

One immediate difficulty in applying this to the problem of expressive music is that this seems to involve four mental states: attention to the music; the recognition of a similarity between the music and expressive behaviour; a sympathetic feeling; and the belief that the music is expressive. It is not clear to me in what way Ridley thinks these are related.

At times Ridley appears to want to identify the second and third mental states: 'a sympathetic response—of sadness, say— is related to the music that occasions it as a mode of apprehension of certain qualities *in* the music' (Ridley 1995*b*: 134). That is, the sympathetic feeling is itself the recognition of a similarity between the music and expressive behaviour. There are two problems here. First, this is not the lesson learned from the central case; my sympathetic feelings for Fred are not identical to my belief that he is sad, even if the former informs the latter. Second, it is difficult to see how these two states *could* be identical; the former is a non-propositional state, a feeling of sadness, and the latter is a state with a certain propositional content: that the music is similar to the behaviour of an expressive person.

One option might be to claim that a sympathetic feeling is a feeling *for* the suffering person and therefore a recognition that he is suffering. Once transferred to the case of music, the claim would be that the sympathetic feeling is feeling *for* the music. However, in the central case what is felt is an emotion which has a cognitive aspect: the belief that the person is suffering. We do not believe that the music is suffering and therefore we do not feel sorry for *it*. The connection between the feeling and the music cannot be made via a cognitive component of the former. The claim that it can is, I should add, explicitly disavowed by Ridley.

What then is the relation between the sympathetic response and recognition of the musical melisma? Two quotations will help us out.

[I]n attending to the musical gestures, I come to be aware of their heavy-

hearted resolute quality through the very process of coming myself to feel heavy-hearted but resolute. (Ridley 1995*b*: 128)

and

I believe, then, that the capacity for affective response to music is critical. Melisma would be a possibility without it—rather as some unremarked feature of the natural world might have expressive potential; but until someone has responded to it, the possibility must remain unrecognized (or unperceived). (Ridley 1995*b*: 133)

The feeling aroused in the listener by the music makes him aware of the music's expressive qualities. Or rather, according to the second quotation, the fact that the feeling is aroused makes it the case that the music is actually rather than only potentially expressive. Ridley's view seems to be that the melismatic gestures in the music arouse a feeling which the listener recognizes as being of a particular sort. The listener then recognizes the melisma as cause of that feeling. This causes him to believe that the music is expressive. What the music expresses is the emotion which is (a) of the same type as the feeling aroused and (b) of the type that would, in the central case, cause the behaviour the music resembles.

Ridley claims that, in this primary sense, all music expressive of emotion (call it *e*) resembles the expression of *e* by a person *and* arouses *e* in a listener: 'my affective response has much the same character as the general state of which the behaviour that the music resembles is expressive' (Ridley 1995*b*: 128). Unless this identity—of the feeling and the general state of which the behaviour that the music resembles is expressive—is simply to be a coincidence, it must be part of the structure of the account. One way it could be part of the structure would be if the listener *recognized* the gestures as resembling the expression of *e* and this caused (because of a disposition, acquired in the central case, of responding to gestures of this type) a feeling of *e*. However, as we have seen, the listener becomes aware of the melismatic nature of the gestures (in canonical circumstances at least) by having the feeling aroused; recognition does not come into it. This leaves open the possibility that the music, because it resembles the expression of *e*, *causes* that feeling in the listener. Thereafter, when the listener attends to the music in the light of the feeling, he will find the right sort of melismatic gesture. The

claim is that, to be relevant to the analysis of expression, it is necessary that the listener's feeling of *e* is caused by the music's resemblance to the natural expression of *e*.

Not all feelings aroused by music are relevant to expression. As Ridley points out, we may associate a piece of music with an emotional event in our lives and hearing it may arouse correlative feelings. However, even on Ridley's own account there appear to be non-melismatic properties of music that arouse feelings which are relevant to expression. What, otherwise, distinguishes melisma which does arouse feelings from melisma which does not? It seems clear that it is not merely resemblance that counts: in checking the make-up of an actor whose face is covered in artificial tears (to take an extreme case in which the resemblance is total) I can recognize the appearance of sadness without having my feelings aroused in the least. Of course, this does not show that melisma is not necessary for expression. However, it does prompt the question why, if there are properties that arouse feelings in the right kind of way, could they not do so in the absence of melisma? Minor chords arouse feelings of a different sort from major chords; why cannot this fact be used to account for their expressive nature? In short, the charge is that, for Ridley, melisma is the cause of expressive judgements, but also plays the role of a reason. However, as it is only one cause among many, its role as a reason is seriously undermined.

There are two replies Ridley could make here. The first would be that all music expressive of *e* is melismatic in some degree. This is true, but only because *everything* is melismatic in some degree. Ridley would not need to claim that the music resembles behaviour expressive of *e* to a greater extent than it resembles anything else—a claim which is obviously absurd. Given that the listener has been aroused to a sympathetic response, he will turn to the music looking for melisma rather than, for example, resemblances between the music and the rise and fall of waves on a beach. Unless the theory is to be trivial, however, he does need to discover *some* significant resemblance in the music. I cannot see why there should be such a resemblance in all cases. What grounds the a priori elimination of the possibility of music which is not melismatic but which causes sympathetic feelings which are relevant to expression?

Secondly, Ridley could claim that melisma is necessary in

order to distinguish aroused feelings that are relevant for expression from aroused feelings that are not. The jolly music that irritates us does not thereby express irritation. However, one can accept that such cases need to be excluded without being forced to accept his method of doing so. It may be the *way* sympathetic feelings are aroused by music that causes us to believe the music is expressive rather than there being some other explanation. This would relieve us of the task of turning again to the music to discover (or invent) some resemblance between it and an expressive person. The strong arousal theory has the advantage in that, if it can provide an account of the distinction between aroused feelings that are and aroused feelings that are not relevant to expression, it does not require the counter-intuitive claim that all expressive music is melismatic. I attempt to provide such an account in Chapter 9.

7. The final account I am going to consider is another much-cognitivized version of the arousal theory. It attempts to analyse expression in terms of the same notion of imagination discussed in Chapter 3. Versions of this view have been put forward by Kendall Walton and Malcolm Budd. The crucial passage, from Walton, is from his paper 'What is Abstract about the Art of Music?':

We mentioned the possibility that music is expressive by virtue of imitating behavioral expressions of feeling. Sometimes this is so, and sometimes a passage imitates or portrays *vocal* expressions of feelings. When it does, listeners probably imagine (not necessarily consciously, and certainly not deliberately) themselves hearing someone's vocal expressions. But in other cases they may, instead, imagine themselves introspecting, being aware of their own feelings. Hearing *sounds* may differ too much from introspecting for us comfortably to imagine of our hearing the music that it is an experience of being aware of our states of mind. My suggestion is that we imagine this of our actual introspective awareness of auditory sensations. (Walton 1988: 359)

I am going to overlook Walton's first suggestion, regarding the musical representation of feelings, and concentrate instead on the remark about expression. Expressive works, says Walton, 'do not actually arouse feelings but they do induce the appreciator to *imagine* himself experiencing them' (Walton 1988: 360). The music *induces* the listener to imagine himself feeling

emotion; the connection is causal and not rational. To that extent, Walton is an arousal theorist. However, it is clear that the state which the music induces in the listener is not simply a feeling.

Walton develops his account of what his imaginative project actually involves in his later paper, 'Listening with Imagination: Is Music Representational?'. Sounds, he says, are peculiar in that 'we tend to think of them as independent entities separate from their sources, in a way we do not think of sights; we reify or objectify sounds' (Walton 1994: 57). That is, sounds exist 'in the mind' in a way that sights do not: sights exist 'out there'. Substituting the less problematic 'awareness' for Walton's 'introspection', we get the following account. We imagine, of our awareness of the sounds, that it is the awareness of our emotions. To revert to the standard example, the music is sad if it causes us to imagine of our awareness of it that it is the awareness of our own sadness (with all the usual caveats to be built in).

Walton has been criticized for overloading the listener with too much conscious psychological activity (cf. Ridley 1995*b*: 141). This would be just were he claiming that to listen to expressive music meant to indulge in two conscious activities simultaneously: namely, the awareness of the music and the imagining of it that it is the awareness of emotion. He need not, however, make this claim. A comment in the second paper suggests another reading: 'Music that induces me actually to feel exuberant, thereby induces me to imagine feeling thus' (Walton 1994: 56). Having been induced to exuberance, one has *thereby* been induced to imagine feeling thus. The imagining is not a further activity; it is merely the best description of the state into which the listener is induced by the music. This is confirmed in a passage commenting on Elliott (Elliott 1967):

R. K. Elliott, in a perceptive and suggestive essay, describes what he calls experiencing music 'from within'—experiencing it 'as if it were our own expression' and feeling the expressed emotion 'non-primordially.' Elliott's characterization of this experience is sketchy, but it clearly has much in common with the experience I have described. He has the listener enjoying something akin to an experience of the emotion expressed, not just (somehow) observing the emotion in the music. Arousal theories, which in the crudest and least plausible form say that music expressive of exuberance or grief is simply music that makes lis-

teners exuberant or stricken with grief, at least recognize that to appreciate expressive music is to *feel* something. (Walton 1994: 55)

The music induces the listener to feel something, and this is best described in terms of the listener's imagining being aware of an emotion. But why is it best described thus?

There seem to be two reasons for Walton's claim. The first can be found in the quotation above. It is implausible to maintain, as Walton says crude arousal theories do, that music is expressive because it induces actual feelings and emotions. It can, but it need not and usually does not. What is needed is a description of a state which is like the experience of a feeling or emotion, but which is not really such. Elliott employed the term 'non-primordial'; Walton appeals to the more familiar notion of the imagination. So the first reason is that this not-quite-real experience of the feeling or emotion needs to be described somehow, and 'imagining' seems to perform the task.

The second reason relates to Walton's desire to overcome the most serious problem for the arousal theory. In Bouwsma's pithy phrase, 'the sadness is to the music rather like the redness to the apple, than it is like the burp to cider' (Bouwsma 1950: 98). The expression is perceived as a property of the music, not, as the arousal theory would need to claim, an induced state of the listener. My own solution to this problem will be given in Chapter 9. If, as described above, feelings and sensations are conceptualized in similar ways, the claim that we imagine, of our awareness of the sounds, that they are our awareness of our emotions, looks as if it might result in a single object of attention. If so, this problem, a traditional hurdle for arousal theories, will not be a hurdle for Walton.

The account I have given of Walton's views has been stitched together from a series of scattered remarks, made in papers which are not primarily about expression. It is no surprise, therefore, that the details of the account are lacking. I am in sympathy with much of what Walton says, including, of course, the rejection of (what I am calling) cognitivism. However, when it comes to what is distinctive about the account, namely, the role of the imagination, I remain sceptical. The claim that a listener is imagining the awareness of, for example, grief is made true by the listener being in a certain state, induced by the music. What

is the nature of that state? It is not a propositional attitude, it is a feeling. The feeling must possess an identity sufficient to render it true that the listener is imagining grief, as opposed to awe, sadness, joy, abandon, or whatever. In other words, the feeling must be, however attenuated, a feeling of grief. Despite the technical apparatus, I do not see how Walton escapes being a strong arousal theorist and his theory needs defending as such.

My response to the first reason for involving the imagination that I have attributed to Walton is that I do not see what is gained by calling this attenuated feeling 'imagining the awareness of grief'. The term is being used at a distance from its usual employment, without its being apparent why. It is, in these circumstances, no clearer to me than Elliott's term 'non-primordial'. Similar reasons lead me to scepticism regarding the second reason I have attributed to Walton. What is it to imagine, of our awareness of sound, that it is our awareness of our emotions? How does this achieve a unity of the sound and our feeling (if indeed that is Walton's intention)? Without further elucidation I do not know what to make of the suggestion.

8. Malcolm Budd discusses a number of different ways in which the claim that a piece of music (M) is expressive of emotion can be analysed in terms of make-believe. He finds a number of these ways inadequate, before settling on the following formulation as the most promising for a successful analysis ('*p*(MB)' is to be read as 'it is make-believe that p'):

In its simplest form: 'M is anguished' is to be understood as 'It is the nature of M that makes it the case that *anguish is being experienced* (MB).' In other words: 'It is make-believedly true that anguish is being experienced, and this make-believe truth is generated by M.' (Budd 1989: 135)

This reflects a more substantial role for make-believe than is contained within Walton's analysis. The music generates make-believe truths, it does not merely cause the listener to imagine being in an emotional state. Budd is frank about the incompleteness of this as an analysis, specifically the incompleteness generated by the role of a work of art in a game of make-believe. Recalling the basis for games of make-believe which was outlined in Chapter 3, it is clear that the prop which generates the

appropriate make-believe truths could, provided the game was set up in the right way, be played by many things. For example, it could be a principle of a game of make-believe that when a red light appears in a box (which contains lights of different colours) it is make-believedly true that anguish is being experienced, when the light is yellow it is make-believedly true that joy is being experienced, and so on. This would conform to 'the simplest form' of Budd's analysis given above. Without more explanation of what is meant by 'it is the nature of M', the analysis says nothing about what is distinctive about the expression of emotion by works of art.

This problem is more serious than Budd seems to realize, for it is bound up with the problem which the account is intended to solve: namely, clarification of the relation between the music and the inferred expressive belief. For, to put the problem once more, music expressive of α seems to contain no *grounds* for the claim that α is being experienced. The reply offered by Budd is that the grounds are already built into the game of make-believe. He illustrates this by appeal to a familiar example:

consider the hobby-horse that is make-believedly a horse. Just as the hobby-horse is a material object of which it can be said that it is make-believedly a horse, so a piece of music is a process of which it can be said that it is make-believedly an experience of an emotion. (Budd 1989: 134)

Just as the hobby-horse need not contain, independently of the game, the grounds for the inference that it is a horse, M need not contain, independently of the game, the grounds for the inference that it is expressive of anguish.

What, then, *does* justify the inference from 'Fred is sitting astride a broomstick' to *Fred is riding a horse* (MB)? The answer surely rests in the rules and conventions 'governing' the game. In setting up the game it was stipulated (or, perhaps, in the case of traditional games such as this, accepted) that sitting aside a broomstick is to count as riding a horse. If Budd's explanation is for music to be construed along the same lines, the same kind of answer must apply. But, as Budd himself argues, this answer will not do for the musical case. Music is not expressive of emotion by virtue of a set of conventions governing composition. Furthermore, Budd states, 'the existence of rules (in the sense of

conventions) of make-believe is not intrinsic to the conception of make-believe truth' (Budd 1989: 135). But if Budd is eschewing conventions, what is his account of the justification for the inference?

Rather than provide one Budd retreats to a weaker position, retaining only 'the underlying idea of the make-believe approach':

the idea that emotionally expressive music is designed to encourage the listener to imagine the occurrence of experiences of emotion—without demanding that there should be conventional rules which govern the creation and interpretation of emotionally expressive music. (Budd 1989: 135)

However, this claim—that expressive music disposes a listener to imagine occurrences of experiences of emotion—seems to have abandoned the attempt to specify the link between music and the emotions in a manner adequate to explaining expression. Disposing a listener to imagine occurrences of experiences of emotion is not peculiar to music. The same is true (for example) of holiday snaps, which does nothing to make *them* expressive; a picture of the chalet-maid might prompt me to re-live my holiday romance without its expressing holiday romance. It is perhaps for this reason that Budd does not propose this as a complete analysis, suggesting in a footnote a way of supplementing his account which is reminiscent of Kivy:

Perhaps the best way of filling the lacuna is to require that if I hear M as being expressive of anguish, my awareness of the make-believe truth that anguish is being experienced must be generated through an experienced resemblance between M and anguish. But there are many forms that a requirement of the kind could assume, and the plausibility of the approach rests on the particular way in which the requirement is developed. (Budd 1989: 138)

Although this certainly indicates a worthwhile line of enquiry, I am pessimistic about the chance of success. Whatever its chances of success in the long term, it does not provide us with the solution to our problem.

Budd attempts to bridge the gap between its being make-believe that the emotion is experienced and the experience of the music in a way reminiscent of that I have attributed to Walton.

If I experience music is conformity with the . . . make-believe account, my experience of the music will be informed by the realization that it is make-believedly true that an emotion is being experienced, and in this sense it will be true that I am imagining an occurrence of that emotion. (Budd 1989: 136)

Let us consider imagining in two different forms. First, there is propositional imagining; a disposition to assent to a proposition only within certain games of make-believe. Second, there are 'stronger' forms of imagining such as envisaging and imagining doing something. For example, I can imagine myself as a famous personality and indulge narcissistically in the more outlandish consequences of this fiction.

The trouble is that neither of these mental states seems appropriate for a person who is listening to expressive music. Budd claims that such a person 'imagines an occurrence of that emotion'. Construing this as 'imagining that', experiencing a piece of sad music is analysed as hearing a piece of music and being caused by the music to imagine that sadness is being experienced. Hearing music is a sensation, having a propositional attitude is not. It is difficult to see how hearing a piece of music whilst having in mind the proposition that an emotion is occurring could constitute the single phenomenological experience of hearing music as expressive of emotion. Such a proposition is just not the sort of thing which could constitute what is distinctive about hearing music as expressive. The alternative is to construe the experience of sad music as hearing a piece of music and being caused to imagine sadness being experienced. This account at least has the advantage that these are both conscious experiences. But hearing and imagining are different experiences which are not easily combined. The state of mind of someone who is hearing a piece of music whilst trying to imagine (in the experiential sense) the experience of a persona is not the state of mind of someone listening to expressive music. The 'make-believe' theory requires an account of what it is a listener is supposed to imagine, and the way that this combines with hearing the music to form a state which we would recognize as that of experiencing music as expressive.

In this chapter I have reviewed various solutions to the problem of expression and found them wanting. In the next chapter I will begin to propound my own solution, built around a claim

which people have not so much ignored, as been unsure what to do with. Budd himself says, 'it is a significant fact about the musical expression of emotion that we can react emotionally to it' (Budd 1989: 136). But he, along with the others we have considered, underestimates this as the basis for a theory of expression. Why they do so—and why they are wrong to do so—will become clear.

8

Defending the Arousal Theory

1. At the end of Chapter 5 I produced a quotation from Gerhart von Westerman in which he describes the third movement of Beethoven's Fifth Symphony in explicitly emotional terms. My task in this chapter is to justify this form of criticism. As we have seen, it would be a mistake to assume that all that needs explaining is the use of emotion terms in aesthetic contexts. The experience itself also needs explaining: how do emotions 'enter into' the experience of objects which cannot feel and which are not obviously connected with the expression of emotion by people? We already have some understanding of the experience of expressive works of art, available simply by reflecting on what it is like to appreciate them. Building on this is, I believe, the key to solving the problem.

I have already suggested that the experience of expression in art can be explained analogously to our experience of the expression of emotion in people. The most important facet of the analogy between expressive music and expressive people concerns the way in which it is appropriate way to react in either situation. In Chapter 2 I argued that it is inappropriate, when faced with a human expression of emotion, merely to form a belief to this effect. The appropriate reaction is, rather, to feel some kind of emotion oneself (cf. Ridley 1995*b*: ch. 6 sec. II). The same is true of our reactions to expressive art. It is inappropriate merely to recognize that a work expresses an emotion and register the fact in the form of a belief. In optimal circumstances, one would appreciate the work by reacting with an appropriate emotional experience.

Such a view has been argued for by R. K. Elliott in his eloquent and persuasive paper 'Aesthetic Theory and the Experience of Art' (Elliott 1967). 'Some works of art', Elliott claims, 'are capable of being experienced as if they were human expression, and we do not experience expression exactly as we experience

objects or ordinary objective qualities' (Elliott 1967: 146).[1] That is, the experience of expression is not merely the formation of a belief; it also involves some kind of experience. This is supported by the conclusion arrived at in the previous chapter: that expression cannot be analysed within the limited conceptual resources of the cognitive theory. Taking that experience to be the experience akin to that of reacting to the expression of emotion in the central case, we arrive at the following:

> A work of art *x* expresses the emotion *e* if, for a qualified observer *p* experiencing *x* in normal conditions, *x* arouses in *p* a feeling which would be an aspect of the appropriate reaction to the expression of *e* by a person, or to a representation the content of which was the expression of *e* by a person.

In the last chapter I argued that Kivy in particular, and cognitive theorists in general, are best read as arguing that the resemblance between music and expressive people (such as it is) is a cause of, rather than an analysis of, the expressive judgement. Similarly, one could argue that the feeling aroused by a piece of music was the cause or prompt of our judgement, and not its analysis. I intend it as the analysis of expressive judgements; it is what we mean when we (for example) call music sad. The arguments in this and following chapters should be read as an attempt to establish this conclusion.

The claim that it is appropriate to react to expressive art with a feeling or emotion, natural as it appears to some, is viewed with great scepticism by others. The claim itself exists in weak and strong, plausible and implausible versions. The strong and implausible version is that the emotional state it is appropriate for an expressive work to cause is of the full-blooded kind for which tears, action, or gnashing of teeth would be an appropriate manifestation. The weak and more plausible version is the claim that a purely cognitive response is inappropriate when faced with an expressive work of art. Amongst the mental states caused by perceiving such a work, it would be appropriate if

[1] This view—that expressive music has an effect on the feelings of the listener—has been experimentally verified. Subjecting people to expressive music is a standard mood-induction technique in experimental psychology.

there were a state (or incipient state) whose nature were in some way bound up with the emotions. The belief that arousal theories can only exist in the strong version explains, perhaps, the generally hostile and dismissive attitude they provoke in the literature.

Peter Kivy has led the cognitivist assault with a range of arguments intended to expose as absurd the claim that expressive art arouses emotions. In *Sound Sentiment* he produces four such arguments. I shall consider three here; the fourth fits naturally into the next chapter. After considering those arguments, I will tackle two more: the first also by Kivy, but from an later book, and the second by Robert Stecker.

Kivy's first argument is simple, and he states it with persuasive force:

Normally, emotions are associated with modes of behavior: they are not merely psychological episodes with no behavioral implications whatever. When I am angry, I strike out; when I am melancholy, my head droops and my appetite wanes. But no such consistent behavioral manifestations of the emotion are observed in the concert hall or (as far as I have been able to determine) in front of the hi-fi. (Kivy 1989: 155–6)

Kivy does indeed have a point. As he says later, '[the emotivist must] be making some substantial claim to the effect that real sadness—the kind that feels bad and really has an effect on us—has been aroused by the music, or else the claim seems contentless' (Kivy 1989: 162–3).

In Chapter 2 I said that I would be assuming a cognitive theory of the emotions and a functionalist account of propositional attitudes. According to the cognitive theory, an emotion is comprised of a number of things including one or more propositional attitudes. Functionalism then defines propositional attitudes in terms of their place in a causal network of inputs, outputs, and connections with other mental states. These assumptions seem to make my view vulnerable to Kivy's attack. For to be in an emotional state is, according to the cognitive theory, to have a propositional attitude and to have a propositional attitude, will, according to functionalism, involve some 'outputs' characteristic of that attitude.

The force of Kivy's criticism is diminished, however, to the extent that it depends on the work of art arousing a state which embodies a propositional attitude. The characteristic state

aroused by an expressive work of art is, in the terminology intro-
duced in Chapter 2, a feeling and not an emotion: that is, it does
not have a cognitive component. We saw in Chapter 2 that the
'object-directedness' of emotions is a consequence of their cog-
nitive aspect; the intentional object of the cognitive state is also
the intentional object of the emotion. The state which is aroused
by an expressive work of art (for a qualified observer in the
appropriate conditions) has no object. It is neither 'sadness *about*
something' nor 'sadness at the thought *that* something'.

Of course, it is *possible* for the expressive properties of a work
of art to cause a mental state involving a propositional attitude.
If this does happen—that is, if the expressive work of art does
cause an emotion—that emotion will not have the work as its
intentional object; it will have something external to the work;
for example, thoughts of a dead grandmother or a lost love. This
constitutes a problem for the arousal theory, as—it is generally
agreed—such reactions are not aesthetically relevant. If I am
'triggered' by a work of art into an emotion whose object is
something external to the work, such a reaction cannot be the
grounds for an aesthetic judgement on the work. The arousal
theory will need to provide a way of distinguishing the former
sort of reaction from the latter. This challenge is taken up in the
next chapter.

It is clear from what has already been said about the arousal
theory that it entails that the relevant mental state aroused by an
expressive work of art is devoid of cognitive content. In Chapter
5 we saw that an expressive judgement on a work is not directed
at the propositional content of that work. Of course, one can
have an emotion directed at a fictional character or situation
which is caused by, and partly constituted by, an imagined
proposition. Such an emotion would not lead to an expressive
judgement however, but a judgement about that character or
situation. If a work arouses a mental state which causes the belief
that the work itself is sad (or expresses sadness), this is not an
attitude which is directed at the content of the work. Such a state
would neither be caused by, nor would it embody, a proposition.

This aspect of the arousal theory—that the appropriate
reaction to expression is a feeling not an emotion—might be
thought to be in conflict with the guiding analogy between our
response to art which expresses emotion and our response to

people who express emotion. For it is certainly appropriate to respond to the latter with an emotion—that is, a state with a cognitive component. Faced with a sad person, we respond with *sadness*, or perhaps *pity*. My reply is that the basic structures of the responses are analogous, even if we remove considerations regarding the cognitive content. Putting aside the various qualifications for a moment, this leaves the analogy as follows: a piece of music expresses an emotion *e* if it causes a listener to experience a feeling α, where α is the feeling component of the emotion it would be appropriate to feel (in the central case) when faced with a person expressing *e*. Hence, music expressive of sadness will cause a listener to feel sad (or maybe the feeling component of pity if that is a different state),[2] and this feeling will cause him to believe that the work expresses sadness. The cognitive content is necessary neither to the arousal theory in general nor the analogy in particular.

2. Modifying the analogy in this manner seems to lead to further problems, however, as it now appears to contradict one of the motivating intuitions behind the cognitive theory of the emotions. The arousal theory maintains that the feeling aroused by an expressive work causes a belief as to what the work expresses. In order for this belief to be correct, this would seem to require that a listener be able to discriminate between the feeling components of emotions in the absence of their propositional counterparts. That is, to be able to discriminate between the feelings associated with, for example, hope, awe, anger, sadness, and despair. As we saw in Chapter 2, one intuition behind the cognitive theory is that this cannot be done. The arousal theory's contravention of this intuition appears to be a damning objection to it.

Far from being damning, however, coping with this objection further reveals the arousal theory's explanatory power. The criticism would be justified if the arousal theory maintained that a listener needed to *infer* that the music expressed *e* on the grounds that it caused him to feel α. This would require that the listener be able to identify α. However, the arousal theory does not main-

[2] The difference between a sympathetic and an empathetic response will be discussed below.

tain this; it maintains that the aroused feeling α *causes* the belief that the music expresses *e*.

It is a familiar claim in the philosophy of mind that not everything about a mental state is available to introspection. In particular, this is true of intentional states: we can be wrong about our beliefs, desires, intentions, and so on. This is because these intentional states are defined by their causes and effects, and we might be in a state that plays the appropriate causal role and yet not know that we are. Is the same true of feelings? If we recall that a feeling is able to cause a belief it is difficult to see why not. The cognitivist and I both agree that a feeling is some state with physiological and phenomenological aspects. It also has the capacity to cause in the person who has the feeling the belief that they have that feeling. The cognitivist challenge is to imagine focusing on the intrinsic nature of a feeling and detecting a difference between that and various other feelings. This ignores the possibility that the identity of a feeling may lie, in part, in the belief it causes.[3] Hence the conclusion of the thought experiment (that there are feelings between which we cannot discriminate in introspection) can be accepted without conceding that the feelings would therefore cause the same beliefs.

The cognitivist will object that this makes the arousal theory blatantly circular. The belief is defined in terms of the nature of the feeling, but the feeling is defined in terms of the content of the belief. Of course, this does nothing to show that the arousal theorist is not describing what actually happens. The claim is that the music arouses a feeling of a certain nature which causes a belief with a certain content. That we cannot know the nature of that feeling except by reference to the belief it causes does not show that the arousal theory is wrong. What it does show is that we have—in the absence of independent motivation—no reason to believe it.

Fortunately, the circle can be broken. There are two arguments which, although independent of each other, can be fitted

[3] The relation between the feeling and the belief is causal and not constitutive. A feeling can cause a false belief as to its nature although the reliability of the link makes this very unusual (cf. Smith and Jones 1986: 215). The point that we can have feelings we cannot describe is used by Jerrold Levinson in reply to cognitivist criticisms of his view described below (Karl and Robinson 1995; Levinson 1995).

into a single train of thought to provide convincing grounds for
the arousal theorist's case. The first shows that there is some
non-cognitive mental state which is a causal intermediary
between the music and our expressive judgement. The second
casts doubt on the claim that we are unable to identify that state
through introspection.

We have met the first argument before, in Chapter 5. There I
quoted Frank Sibley's claim that 'People have to . . . *hear* the
plaintiveness or frenzy in the music' (Sibley 1975: 137). Consider
the belief that some music is plaintive. Although this belief could
be caused by reading a programme note, appreciation of the
expressive nature of the music requires that the belief be caused
by an experience: the experience of the music as plaintive. Being
plaintive must be a characteristic of the experience, not a belief
held in addition to the experience. If it were simply a belief plus
the experience, somebody who had the belief from an inde-
pendent source (a programme note) who heard the music would
be in the same position as someone who heard the music as
plaintive. The situation is analogous to appreciating the colour
of an object. This does not involve experiencing the object and
believing it to be a certain colour (I shall pursue the colour ana-
logy in Chapters 10 and 11). Whatever the final analysis, expres-
siveness is a characteristic of the experience of hearing music
and the belief that music is expressive (although it can be caused
in other ways) is caused, in the central case, by this experience.

Of course, this does not tell us anything about the character
of this experience. To ascertain its character we must introspect.
From common experience of expressive music (recalling the quo-
tation from Elliott above) I shall assume that we find the experi-
ence *in some way* emotional. The cognitivist complaint is that,
in the absence of cognitive content, we do not know which par-
ticular way. But is this true? Jerrold Levinson for one does not
think so (the fact that he uses a more complicated model of the
emotions than I do makes no difference to the point at issue).

Even if it is granted that the standard emotions—and even more so, the
'higher' emotions that especially concern us—are defined, logically indi-
viduated, and necessarily conceived in terms of their respective cogni-
tive components, it does not follow that there is nothing else that is in
fact distinctive or characteristic of the individual emotions. Emotions
comprise, at the least, affective, hedonic, conative, behavioral, and

physiological components as well, and there is nothing to show that reliable and cognizable differences in the total constellations of non-cognitive components of the various emotions could not exist. On the contrary, it seems more than plausible that with all such factors taken into account—qualitative feels, desires, and impulses, varieties of internal sensation, degrees of pleasure and pain, patterns of nervous tension and release, patterns of behavior (gestural, vocal, postural, kinetic)—each of the emotions standardly distinguished in our extra-musical life would have an overall profile that was subtly specific to it, even leaving its cognitive core to one side. (Levinson 1990: 334; cf. Levinson 1995)

The cognitive theorist standardly elicits the intuition that supports his case by a thought experiment. We are asked whether we could discriminate, by introspection alone, between the feeling components of the different emotions. The cognitive theorist assumes we will return the answer 'no'; Levinson suggests we should answer 'yes'.

Levinson certainly has a point. Introspection is one of several babies thrown out with the Wittgensteinian bath water. Let us accept, for the moment, what Levinson offers us. What we then have is this: the experience of the music is in some as yet unspecified way bound up with the experience of a feeling, which causes the belief that the music is expressive. The nature of the feeling identifies an emotion, and the music expresses whatever emotion it is to which that emotion would be the appropriate reaction component in the central case. The feeling is identifiable, as a feeling of that sort, independently of the belief.

In fact, the arousal theorist does not need to adopt Levinson's claim in any very strong form. Indeed, weakening the claim makes the theory better able to account for the nature of expressive judgements. To appreciate why this is so, recall that the link between the kind of feeling that is aroused by a work and the belief it causes is established in the central case. It is because the feeling α is a component of the emotion which is the characteristic reaction to the expression of e by a person, that α causes the belief that the music expresses e. In Chapter 2 I argued that expression and reaction can be paired in this way only at a fairly general level of description. That is, although we can claim that (against an idealized background) sadness or pity is an appropriate reaction to sadness, it is difficult to specify context-free

appropriate reactions in very specific terms. Take the case of Hash who, according to P. G. Wodehouse, 'looked like one who had drained the four-ale of life and found a dead mouse at the bottom of the pewter'. It would be impossible to describe the appropriate reaction to Hash's situation at the same level of specificity.

If the arousal theory were correct, then, we would expect expressive judgements to describe works in fairly general terms. This is, in fact, what we do find. As Malcolm Budd says,

> music's ability to express emotion should not be exaggerated: the scope of the musical expression of emotion is not the complete field of the emotions, and unless a literal conception of states that involve emotion is adopted the list of kinds of emotion that music—the music we are familiar with—can express is embarrassingly short. (Budd 1989: 129)

The main point here is that the list of *kinds* of emotion that music can express is 'embarrassingly short'. A brief and unsystematic review of music criticism (on the programme note level, these being descriptions intended to capture the experience of music) supports this view. Certain emotion terms occur with much greater frequency than others. Among the most popular we find terms such as: melancholy, gay, gloomy, joyful, and calm. Thus the problem for the arousal theory is not as might have been supposed. If there are only a small number of kinds of expressive judgement, there need be only a small number of distinct *kinds* of feeling aroused by music. This, it seems to me, is very probably true.

In brief, the central case provides us with characteristic links between emotions expressed and emotions aroused at a level of generality characteristic of expressive judgements. Furthermore, the fact that we are dealing with emotions painted with a fairly broad brush lends support to Levinson's argument that the feelings aroused by expressive music are identifiable through introspection. Levinson and the cognitive theorist have a clash of intuitions. Levinson finds it plausible that feelings should be identifiable from their phenomenological profile alone, the cognitivist finds this implausible. However, even the cognitivist should agree that fairly broad differences can be detected in introspection. The phenomenological profile of melancholy differs from that of joy and, I suspect, differs from that of sadness and gloom

as well. At the level of discrimination that the arousal theory needs, intuition seems to favour Levinson.

One final point before I pick up the thread of Kivy's objection. There are many puzzling things about the experience of instrumental music. One of them is that the beliefs we form about the experience often seem inadequate to describe the experience itself. More is going on than we are able to specify. One reason for this might be (to return to a claim made earlier) that the causal capacities of the aroused feelings are finer than the ability to discriminate between feelings. The feelings acquire their causal capacities because of the role they play in the central cases. It is because α is the feeling component of the appropriate reaction to the expression of e that, when a piece of music arouses α, we are caused to believe that it expresses e. I have argued that there is no reason why there might not be fine distinctions between feelings, resulting in slightly different beliefs, which are not detectable through introspection. The listener will be caused to have a belief as to the character of the music without having access to the grounds for that particular belief (as opposed to a belief of that sort). I do not rule out the possibility that a listener could come to be a better discriminator of his aroused feelings; introspection, like other skills, might improve with practice.

3. I have argued that the relevant reaction to expressive works of art does not have a cognitive component (although it usually does, of course, *cause* the belief expressed in the subsequent expressive judgement). This, however, is not sufficient to dispose of Kivy's objection that the reaction to expressive works of art does not, characteristically, have an external manifestation. It is not only cognitive mental states which have visible manifestations; feelings do as well. Hence, even if Kivy grants that the audience do not have the beliefs to cause the actions he is looking for, he could argue that the demeanour of the audience provides no reason to think they are experiencing feelings either. In the absence of manifestations of feelings in an audience, it would be wrong to attribute feelings to them.

Recall the sort of manifestations Kivy is looking for: 'When I am angry, I strike out; when I am melancholy, my head droops and my appetite wanes.' Kivy's target is an absurdly strong ver-

sion of the arousal theory in which the postulated feeling is strong enough to overwhelm any thought of restraint. It may be true that the feeling associated with anger does characteristically cause one to 'strike out', but it does not invariably do so. If the person experiencing the feeling is in a situation in which action would be inappropriate, the action can be suppressed. Clearly, a concert hall is an inappropriate venue for such an action. Hence, the absence of the action does not entail that a listener is not feeling angry. Similarly, even if a listener were feeling melancholy, he would probably not let his head droop for the good reason that he would then not be able to see the orchestra. It is altogether unsurprising that an audience should not act so as to mar their experience of the concert, hence the absence of such action is no guide to their psychological state.

I have already remarked that the arousal theory need not maintain the implausible view that the mental state aroused by expressive art is always overwhelming. Such a view is, however, Kivy's target. He argues, quite plausibly, that the following questions, when put to the listener, would elicit the answer 'no': 'Was [the feeling] anything like the way you felt when your canary died or when you lost your favorite pair of earrings? Did you really have that feeling of palpable distress?' (Kivy 1989: 161). The attack is against a straw man: the arousal theory does not require the listener to have feelings of this order. Consider the experience of reading a newspaper. As one reads the news one can be amused, indignant, heartened, disheartened, saddened, and so on. Certainly there are occasions on which one is provoked into a very strong feeling about something, but generally one can breeze through the paper whilst drinking tea, eating muffins, and suffering no 'feelings of palpable distress'. Kivy is assuming that one either has a feeling or one does not, and if one has it one gets the works. But this assumption is false; feelings come by degrees, and the degree of feeling generally provoked by expressive art is sometimes comparable to that generally provoked by reading the newspaper and at other times extraordinarily acute. Although occasionally overwhelming, most of the time such feelings are insufficiently strong for external manifestations to be appropriate.

So far I have argued that the absence of manifestation of feeling in an audience does not entail that no feelings are being

experienced. Neither does it, of course, entail the opposite. So what grounds are there for thinking that expressive music *does* arouse feelings in the right listener in the right circumstances? This takes us back to the beginning of my discussion where I presented my claim that it is a common experience that it does. Furthermore, contrary to Kivy's claim, I would claim that its *manifestation* is a common experience as well: feeling is manifested as much in the concert hall as it is among people reading the paper. Kivy is wrong in denying that people cannot be moved by music to the point of tears or even loss of appetite. Indeed, this denial is sufficiently counter-intuitive to have provoked protests even from other cognitive theorists (Davies 1990). It simply is not credible to hold that the experience of expressive music is not, in some measure, an emotional one and the argument just considered certainly gives us no reason to support such a view.

An analogue of Kivy's claim that feelings are not aroused in concert audiences could be produced against the argument concerning expressive representational art produced in Chapter 5. There I argued that what grounds the belief that a representation is expressive is the feelings which it arouses. The analogue of Kivy's argument would be that the feelings of a reader (or spectator) are not aroused. My counter-argument (that Kivy has no grounds for his claim and that is independently implausible) applies with equal force to this argument. It does not follow from the fact that we do not weep at *La Belle Dame Sans Merci* that we are not emotionally moved by it.

4. This particular argument of Kivy's is, however, only the first of three; the second argument is, Kivy claims, 'the most commonly cited' reason for rejecting the arousal theory. Common though the argument may be, no one has presented it more clearly than Kivy himself.

If music is expressive of emotions in virtue of arousing them, then it would seem that listeners would shun, for example, music expressive of anguish, or melancholy, or any other of the unpleasant ones. For why should we voluntarily submit to being made melancholy or anguished— in short, unhappy? Yet, clearly, listeners do not shun music expressive of the unpleasant emotions. Therefore, is seems highly implausible to think music is expressive of these emotions in virtue of arousing them. (Kivy 1989: 155)

It helps to clarify the intuition being appealed to here to distinguish between the unpleasantness of a feeling, and the unpleasantness of what an emotion is about. 'Negative emotions' (as they have come to be called) usually take as their object propositions about things or situations which are cause for regret. In the case of an audience for a tragedy, there are problems both in virtue of the unpleasant feelings that are caused, and in virtue of the fact that the audience is asked to dwell upon the fates of people in appalling circumstances (cf. Radford 1989, Kivy 1989: ch. 13). As expressive works of art arouse not emotions but objectless feelings, the problem is only why people should willingly submit to the arousal of intrinsically unpleasant feelings, even though provoked by no regrettable circumstance.[4]

What about Kivy's argument itself? Central to the argument is the claim that the arousal theory entails that the experience of some expressive art would be unpleasant. The first point to make is that this claim is false. The arousal theory entails that part of the experience of some expressive art will be feelings which are inherently unpleasant. It leaves it open as to whether or not there may be (as indeed there are) other aspects of the experience which, taken altogether, explain our enjoying the experience as a whole. It would be a mistake, however, to rest the defence of the arousal theory on the claim that we enjoy expressive art in spite of, rather than because of, the feelings it arouses. The expressive properties of art are amongst its valuable properties; they are not irritants which we have to bear for other reasons. The problem with Kivy's argument is deeper than the falsity of his central claim. It lies in his relying on a model of human motivation which, once articulated, is difficult to take seriously.

The argument relies on the assumption that voluntarily submitting to unpleasant feelings is, if not straightforwardly absurd, something which requires justification. No justification is needed for activities which arouse pleasant feelings, as these could be indulged in for this reason alone. Surprising as seems at first, neither of these claims is true in folk psychology—at least for people sophisticated enough to be potential audiences for

[4] The unpleasantness of an emotion and the unpleasantness of the object of an emotion are related in various interesting ways which it would take me too far afield to explore.

expressive art. A member of the philosophy faculty who spent his Saturdays playing video games rather than submitting to his exacting discipline might be thought mildly eccentric; if he spent every day doing it, he might be thought to need a holiday. The claim that pleasure is the overarching justification for all our voluntary activities has been repeatedly and successfully criticized by those philosophers who are opposed to utilitarianism in ethics (e.g. Williams 1973) and is not now accepted even by those sympathetic to that tradition. If there is an overarching consequence that justifies our activity, it is something nebulous such as 'contributes to a worthwhile life' (of which pleasure will of course be a part). Once this is conceded, the force of Kivy's objection evaporates, for there is every reason to think that negative feelings and emotions will play some part in this. Within literature, exposing the life of pleasure as a hollow sham is a time-honoured endeavour; Dorothea Brooke in *Middlemarch* is obviously a much better person than Rosamond Vincy. A philosophical account of the role of such feelings and emotions is beyond the reaches of this discussion depending, as it does, on an understanding of our deepest moral commitments.[5] The point to be made here is that Kivy's argument has no force for the simple reason that all except the spiritually desolate *do* have reason to explore the negative feelings and emotions.

Once again, an analogue of Kivy's argument applies to the account of expressive judgements about representational art given in Chapter 5. Certainly, some representational art arouses some negative feelings in us: the final scene of *King Lear* should cause feelings of utter desolation in the audience. This could not be so on Kivy's argument, because if it were, people would not go to see the tragedy, which plainly they do. The negative feelings aroused by tragedy do not render seeing it incomprehensible for the reasons given above; the fact that an activity does not give pleasure is not a sufficient ground for the claim that people have no reason to pursue it.

5. So far, I have discussed two of the six arguments mentioned in the first section. The third criticizes the arousal theory for

[5] The bones of such an account can be found in Levinson 1982. See also Davies 1994: ch. 6 and Ridley 1995b: ch. 7.

holding that music arouses a 'full-blooded' emotion, including a cognitive content. Kivy rightly holds that, as music is not representational, to maintain this would be problematic. However, as I claim that music arouses feelings rather than emotions this criticism does not apply. Neither does the criticism apply to the arousal theory of expressive judgements made about representational art. In this case the mental state which is aroused could either have a cognitive content or not. If it does, the cognitive content will be some proposition expressed in the content of the work. If it does not, the case is parallel to that of music. In neither case is there anything left to be explained. Kivy's fourth argument will, as I said, be discussed in the next chapter.

There are two more arguments against the arousal theory of expressive judgments to be considered in the remainder of this chapter. The first can be found in Kivy's later book on musical experience, *Music Alone*.

If, as the emotivist claims, music is moving in virtue of arousing such emotions as sadness, joy, anger and the like, it seems absolutely extraordinary to me that there should be no obvious, commonsensical explanation, of the Uncle Charlie kind, to explain how the arousal takes place. If I had no other reason to be suspicious of the claim that to be moving, music must make me sad and angry and yearning, than that there is no ordinary, non-technical explanation for why these emotions are aroused in me, or how, I would consider the absence of such an explanation enough to put me off that claim. (Kivy 1991: 151)

An explanation of 'the Uncle Charlie kind' is one in which it is explained *why* an emotion is felt, *how* it was aroused, and *against whom* it is directed (Kivy 1991: 146–7).

Kivy claims that an 'essential condition' of feeling an emotion is that the person experiencing it has an explanation of 'the Uncle Charlie kind' to hand. It is therefore a sufficient condition to reject the arousal theory that, in the aesthetic case, it follows from the theory that no explanation of this kind is available. This argument is deficient in two respects. Firstly, Kivy is wrong in thinking that people who feel emotions in the central case have an explanation of 'the Uncle Charlie kind' to hand. Secondly, even if they did, there is no reason (according to the arousal theory) for thinking such an explanation will be available in the aesthetic case.

The third part of Kivy's claim (that when one feels an emotion,

one knows against whom it is directed) may be put to one side because, as we have seen, the arousal theory claims that music arouses a mental state which does not have an object. There is therefore nothing for a person in this state to know, as the state is not directed against anything or anybody.[6] We are left with the claim that it is essential to having a feeling or emotion that it is known *why* and *how* the state was aroused. As this is not true for feelings aroused by expressive art, there are no feelings which are aroused in this manner.

Although usual, it is (contrary to Kivy's claim) by no means necessary that we know *why* we feel the emotions we do. We might be wrong about the cause—it is the drink and not my friend which is making me feel sorry for myself—or I might not have any beliefs about what the cause is—I simply hate someone without knowing why. Perhaps what Kivy means is that if we do not know why we are feeling an emotion we cannot *justify* it. To justify an emotion is to show that it is an appropriate response to some cause, which is something we cannot do if the cause is not known.[7] The complaint against the arousal theory would therefore be that the feeling it postulates as being caused by expressive art is not justified, because expressive art is not an appropriate cause of such a feeling. To return to a familiar example, the second movement of the *Eroica* is not an appropriate cause of sadness in the way that a death is an appropriate cause of sadness.

Kivy's second claim, that to feel an emotion it is necessary to know *how* it is caused, is difficult to interpret. Either it is the same as the question of *why* we feel an emotion, or it is straightforwardly false. I have no idea how emotions are caused—in either the central or the aesthetic cases—if what is required is some detailed scientific account.

The objection, therefore, amounts to the claim that music does not justify the feelings it arouses. Kivy is not the only philosopher to make this complaint. Stephen Davies, in a searching criticism of the arousal theory, writes: 'According to the arousal theory,

[6] Although, contrary to what Kivy says, it does not follow from our having an emotion that we can identify its object. There is nothing self-contradictory in saying 'I thought I was in love with her, but in fact I was in love with her sister'.

[7] Again, this seems an implausibly strong claim. We ought sometimes to trust our emotions, even if we do not know why we have them.

music's expressiveness just is its power to produce an affective response. In equating the two, the theory denies to us the possibility of *justifying* the response by reference to the expressive character of the work' (Davies 1994: 199). This objection shows how deeply these critics misunderstand the arousal theory. The theory is an attempt to justify our beliefs that certain works of art express sadness with the claim that those works arouse a feeling in a qualified observer in relevantly normal conditions. This aroused feeling is not, however, appropriate in a way that would *justify* our response to the work. The whole point is that the second movement of the *Eroica* is not an appropriate cause of sadness in the way that a death is an appropriate cause of sadness. It is a virtue of the arousal theory that it does *not* require a causal intermediary between the music and the feeling which will justify the latter. The basis of the theory is that expressive music *just is* that which arouses the feelings. Although the aroused feeling is not justified, it justifies the belief it causes. It is the fact that the work arouses (in the right person in the right circumstances) a feeling of a particular sort that justifies the belief that it expresses an emotion of that (or a related) sort.

The request for explanation, that is, the question of *how* music arouses feelings is (as was true in the central case) not for philosophy to answer. Whilst being conscious of the danger of armchair theorizing on psychology and evolutionary biology, one can speculate on possible ways in which such a question might be answered. The following three approaches have some prima facie plausibility. The first, which fits in with some work currently being done producing an account of how and why art evolved (Gear 1990), is that art is the effect of some prior complex psychological need at some stage of man's evolution, part of this need being for something to arouse feeling. The basic thesis is, therefore, that it is simply a fact that art arouses feelings and it is because of this that we have it. To explain how art arouses feelings would, therefore, require resources from psychology and evolutionary biology, perhaps resulting in the kind of evolutionary account which Kivy sketches in *Sound Sentiment*. The second is that art includes a conventionalized representation of the expression of emotion by people. Both in *Sound Sentiment* and elsewhere Kivy has marshalled some impressive evidence that various groups in the history of music (in particular, the

Florentine *Camerata*) have deliberately represented the ebb and flow of human utterance in music. This might effect our disposition to respond to the expression of emotion, and thereby arouse our feelings. Thirdly, art might be a conventionalized representation of the expression of emotion by people. It cannot be an accident, for instance, that sad music is generally slow and low whilst joyful music is generally sprightly. Of course, these three accounts are unlikely to be exhaustive of the field or exclusive of each other. The point is that the arousal theory has no commitments here. It is compatible with each of these accounts of the way our feelings are aroused; it claims only *that* expressive music arouses our feelings.

6. In this final section I will comment on one further aspect of the experience of expressive art, and show how the arousal theory provides a natural explanation for its occurrence. The discussion is best approached through a criticism of the theory. The following is from an article by Robert Stecker. (He follows John Hospers (Hospers 1954) in referring to all theories which essentially involve an aroused experience as 'emotionalism'):

> It is often the case that we are moved by a work in virtue of an emotion the work expresses yet we do not feel that emotion but another. Thus if a work expresses grief we may not feel grief but something more akin to pity or compassion. According to emotionalism, the work expresses pity or compassion and this is wrong. (Stecker 1983: 237)

This objection obviously does not touch the version of the arousal theory I am putting forward, in which the appropriate reaction to expressive music just is the feeling component of the appropriate reaction to the expression of that emotion in the central case. It simply follows from this that 'if a work expresses grief we may not feel grief but something more akin to pity or compassion'.

The difference between reacting to a piece of music with pity and reacting to it with sadness will not be a difference in cognitive content, as what expressive music arouses is a feeling and not an emotion. The difference will be in the nature of the feelings aroused. Given the links established in the central case, both the feeling aspect of pity and the feeling aspect of sadness will

cause the belief that the music expresses grief.[8] However, not only will their phenomenology differ, they will also differ in the beliefs they cause as to the experience of the listener. Pity and sadness are perhaps not the best illustration of this, as their feeling components are so similar. (Recall that the example is not mine but Stecker's. If the difference cannot be demonstrated, that is one fewer problem for me to deal with, not one more.) A better example might be found in the emotions expressed in the final movement of Shostakovitch's Fifth Symphony, some of which seems to be an expression of anger. One way to react therefore is with a feeling almost of awe—a feeling very different to that being expressed. In this case the difference in phenomenology is more evident.

Other philosophers have argued that we can react to the emotion expressed in a work either with that emotion or with another related emotion (Budd 1989: 136–7, Elliott 1967: 146). Elliott's discussion introduces some useful terminology. He claims that we can imaginatively conceive of a work of art as an expression of emotion from one of two viewpoints; that of the persona giving 'voice' to the work, or that of the person to whom the persona's feelings are directed. He distinguishes between these two viewpoints, which he calls experiencing works 'from within' and 'from without':

experiencing a work from within is, roughly speaking, experiencing it as if one were the poet, composer or artist. If a work is experienced as expression, experiencing it from within involves experiencing this expression after a certain imaginative manner as one's own. Experiencing it from without is experiencing it as expression, but not experiencing this expression as if it were one's own. (Elliott 1967: 146)

It is a strength of the arousal theory that it explains why this should be so. The two viewpoints are not exclusive to art; they can also be found in our reaction to the expression of emotion by people. We can either imaginatively identify with the person and experience something like the emotion they are expressing,

[8] I am not, as my critics sometimes seem to think, committed to their being a non-cognitive state properly described as pity (Ridley 1992, Davies 1994: 197). Davies's second point, that Stecker is wrong in thinking a reaction akin to pity is ever appropriate, is dealt with below.

or we can react sympathetically with a different but related emotion.

Let us return to the example of the sadness expressed in the second movement of the *Eroica*. We may react to it with unease and sadness: that is, we may identify with the emotion expressed. Then, in Elliott's terms, we would be experiencing it from within. Alternatively, we may react to it with the feeling component of pity—that would be to experience it from without. Each reaction is possible, and each throws the music into slightly different relief. But if we react with the feeling component of pity, that fact no more entails that the work itself expresses pity than our reacting with pity to a sad person entails that they too are feeling pity. Pity is a natural response to manifestations not of pity but of sadness. In other words, part of feeling pity is being disposed to make assertions such as 'that person is sad' and being aroused to the feeling component of pity is to make assertions such as 'That work expresses sadness'. Another assertion we might be disposed to make is the self-avowal: 'I feel pity'.

The objections considered in this chapter have provided no reason for rejecting the arousal theory, which should further increase our confidence in it. Furthermore, unlike other theories which attempt to explain expression, it both stems from a natural characterization of our experience of expressive works of art and is able to answer the questions that arise from such experiences. Before embracing the theory, however, there is one more objection to consider: an objection so important that it deserves a chapter to itself.

9

The Musical Experience

1. Sophisticated opposition to the arousal theory begins with
the thought that a causal characterization of the sort it provides
could never be sufficient to analyse expression. In this chapter I
will consider two different arguments to this conclusion. The
first argues directly that the relation between an expressive work
of art and the mental state of a listener is not causal but inten-
tional. Asking what it is about a work of art that is expressive
is—it claims—not a request for a psychological explanation, but
a request for the work to be redescribed in a way which matches
the listener's mental state. Hence, a causal theory such as the
arousal theory is irrelevant to the analysis of expression. The
second argument concedes that causality might be necessary for
the analysis of expression, but claims it is not sufficient. To
achieve sufficiency one would need, once again, to construe the
relation as intentional.

The first argument is a special case of a general argument put
forward by Wittgenstein against psychological explanations in
aesthetics (Wittgenstein 1966: 13–15). The argument concerns the
criterion which determines the ground for a listener's reaction
to expressive music. If the relation between the music's expres-
sive properties and the listener is causal, finding the ground will
be finding the cause; the method for doing this will be the same
as that employed in any other causal relation.[1] For example, if
we accept the conditional analysis of causation, the criterion
which determines the ground for a listener's reaction to expres-
sive music would be the truth of the relevant subjunctive condi-
tional. So if x is some property or properties of the music, and
α is the feeling aroused by the music, x causes α if, were x not
to have existed, α would not be aroused. Although the listener

[1] The problems and ramifications of this kind of enquiry are explored in detail in
Chapter 11.

is in a good position to hypothesize on the specific cause of his feelings, his hypothesis does not *determine* the truth of the conditional. The hypothesis might be true or false, depending on whether it picks out the property which actually causes the feeling.

On the other hand, if the relation between the music's expressive properties and the listener is intentional, which properties of the music are expressive will be a function of which properties of the music the listener claims are expressive. The example Wittgenstein uses—aesthetic discontent—is reasonably plausible in this respect. If I feel discontent at some work of art, I need to authorize suggestions as to the grounds of this discontent before the suggestion can be considered correct. For example, I might feel uneasy about Albert Camus's *L'Étranger*. Various reasons might be suggested as to why this should be so; I shake my head until it is suggested that the fact that somebody has been murdered is not given a proper place in the reader's sympathies. I recognize this as a description of my discontent and my puzzlement vanishes. Because of this nobody can gainsay my avowal that what I claim to be the ground of my discontent really is the ground of my discontent.

The objection to the arousal theory only arises if Wittgenstein's conclusion can be generalized from *puzzlement* about a work of art to *expression* by a work of art. But can it be so generalized? In other words, are the criteria which determine the properties of expressive music which are grounds for the feeling aroused in a listener characteristic of an intentional relation? It is compatible with the arousal theory that the listener is in a *good position* to hypothesize about the cause of his feelings. The link between the music and the feeling is (as we shall see) sufficiently close to make it likely that the self-conscious listener will be able to identify the feeling's cause, which makes the listener the ideal candidate to adjudicate on the grounds for his reaction. But if Wittgenstein's argument can be generalized, something stronger would obtain: misidentification by the listener of the grounds for his reaction would be impossible.

It is I think obvious that Wittgenstein's example of aesthetic puzzlement cannot be generalized to cover expressive judgements. The puzzlement I feel over my dissatisfaction about a work of art vanishes when its object is distinctly identified; the

puzzlement and its object are not logically distinct. By contrast, in the case of expression, it is difficult even to understand how the aroused mental state of a listener and its ground could be construed as anything other than distinct; the feeling is not a mental state which can be clarified by further description. Furthermore, the causal account provides a better explanation of the relation between expressive art and our reaction to it, as can be seen by comparing the consequences of construing the relation as intentional with those of construing it as causal. The former would entail the impossibility of a listener's *wondering* whether he had correctly identified the musical ground for his reaction. Of course, this not only is possible but is a familiar experience when forming a view as to why a piece of music is expressive.

Furthermore, contrary to the intentional thesis, the listener's avowal can be falsified in the usual manner for causal claims. That is, if a listener claims that it is x that is causing his reaction, he can be exposed to the music with x filtered out to see if the same reaction is caused. Because—as we shall see—the different parts of music interact with each other, such 'falsifications' will be difficult; x might be a necessary part of the cause without being particularly prominent. Despite this difficulty, people do conduct such 'falsifications', if only in their imaginations. An effective and simple way to gauge the effect of a certain event in a piece of music (a brass entry or drum roll, for instance) is to imagine the piece without it. This is an instance of counterfactual reasoning which is customarily employed when we are attempting to pin down the cause of something.

2. A stronger case can be made for expression not being a causal matter if it is conceded that expression has a causal aspect, but that this is not what is characteristic and therefore interesting about it. The arousal theory has been thought to be the apogee of philistinism: as doing no justice to the complexity of music and, in particular, to musical expression. It is even doubted whether it can make the distinction between appreciating music as expressive and being driven mad by a persistent noise. To take a famous example, the 'music' produced by a student practising on a piano in the room below distracted Wittgenstein from his work and aroused strong feelings in him, but the music was not in virtue of that fact expressive. It was, however, the music which

aroused his feelings. What needs to be shown, therefore, is that the arousal theory is able to rule out cases such as this (which I shall call 'Wittgenstein cases').

To explain how the arousal theory is able to do this, it is helpful, once more, to return to the underlying analogy between reacting to expressive art and reacting to expressive people. An analogy to the distinction between cases of genuine expression and Wittgenstein cases can be found in the central case: being confronted by a person expressing sadness might cause us to feel pity, but it might also cause us to feel irritation at the fact that he or she is so doleful. If this is true of our reaction to expressive people, there is no reason why it should not be true of our reaction to art. The problem is that in the former case, unlike the latter, what is being expressed is independent of our reaction to it. In the case of the arts, the distinction will need to be made solely in terms of our reactions.

Consider, once more, the arousal theory's definition of expressive works of art: art expressive of e will (in the right person in the right circumstances) arouse a feeling of the same type as that which is the component of the emotion characteristically aroused by the expression of e in the central case. In Chapter 2 I argued that the characteristic reaction to an emotion in the central case is defined against an idealized background: the aroused emotion α which is the characteristic reaction to e is that emotion which would be aroused in a normally sympathetic person were the expression of e the only cause of α. In the absence of any other cause, normally sympathetic people react to the expression of emotion rather than (as we can put it) the fact that an emotion is being expressed. It would be wrong to maintain (for example) that the characteristic reaction to sadness is irritation, as opposed to pity. Hence, the arousal theory needs only to consider those feelings which are components of emotions which are characteristic reactions to expression, not those feelings which are components of emotions which are characteristic reactions to the fact that an emotion is being expressed. The range of feelings covered by the definition would include the feeling aspect of pity characteristic of the reaction to someone's sadness, but not the feeling aspect of irritation at the fact that someone is sad.

The arousal theory, therefore, will exclude from consideration many reactions characteristic of Wittgenstein cases, such as

irritation (at the student's bad playing), envy (at someone's good playing), and pride (at one's daughter's good playing). However, some feelings, characteristic of Wittgenstein cases, *are* amongst those characteristically aroused by the expression of emotion in the central case: sadness (the music reminds us of a sad event) and joy (they are playing our tune) are obvious examples. On the occasions on which these feelings *are* aroused in Wittgenstein cases, it seems that they should, according to the arousal theory, lead to the belief that the work involved is expressive. This is obviously unsatisfactory and the theory needs to find some way of dealing with these apparent counter-examples.

There are some cases in which music arouses feelings characteristically aroused by the expression of emotion which are not counter-examples to the arousal theory. These are cases in which the feeling is part of an emotion. For example, if you have paid money to see a concert and the musicians are obviously drunk or incompetent you might be caused to feel sad. It may even be true that it is the music that is doing this rather than the situation; every late entry or wrong note plunges you deeper into despair. In circumstances of this type, the aroused mental state will have a cognitive component: that you have to sit through another two hours, that you have wasted your money. Such circumstances are among the characteristic causes of sadness and, therefore, the feeling will not cause the belief that the music expresses sadness. The arousal theory is not committed to the obviously absurd view that feelings which are components of emotions cause the belief that their cause expresses the relevant emotion. If it did, it would be committed to holding that urchins express sadness (because they arouse pity) and weddings express joy (because they arouse joy). It is only feelings which are not simply components of an emotion that cause the belief that their apparent cause is expressive.

There remain, however, those cases in which although the right sort of feeling is aroused, they do not go on to become components of an emotion. The possibility of such counter-examples stems directly from the arousal theory's causal analysis of expression. Because the feeling aroused by expressive music is only causally connected to the music and is thus independent of it, it follows that the feeling could be aroused by other means. The point may be dramatized by considering the implications of

a 'feeling drug': a drug which arouses a feeling of a kind which is amongst those characteristically aroused by music on the basis of which it is judged to be expressive. The drug itself would then appear to satisfy the arousal theory's definition of expressive art given in Chapter 8: it arouses in its user a feeling which would be an aspect of the appropriate reaction to the expression of e by a person, or to a representation the content of which was the expression of e by a person (Ridley 1986, 1993).

Clearly, anyone who takes the drug will not be caused to believe it is expressive; expression is a different matter altogether. The conclusion would seem to be that the causal aspect of expression which the arousal theory captures, true as far as it goes, is not what is distinctive and interesting about expression, for it applies to circumstances in which our feelings are aroused (by a drug) and which are not cases of expression. This encourages the thought, encountered earlier, that the arousal theory could be an account of how we come to make expressive judgements but not an analysis of such judgements. Against this, I will argue that it is characteristic of expression, but not characteristic of cases such as that of the 'feeling drug', that the feelings aroused are intimately bound up with what arouses them.

In addition to the above, I shall consider two further objections which stem from the thought that, unlike the drug, expression is not so much about the feeling aroused as about the thing that arouses it. The first, already encountered in Chapter 7, is Bouwsma's point that 'the sadness is to the music rather like the redness to the apple, than it is like the burp to cider' (Bouwsma 1950: 98). The claim is phenomenological: we hear music *as* sad, or we hear sadness *in* the music. The arousal theory claims that music arouses certain feelings in the listener, characterizable independently of the music. Having rendered those feelings independent of the music, the theory needs to account for the experience of the feelings *in* the music. How, for example, does hearing music as sad differ from hearing music and feeling sad?

The second problem is that of showing the arousal theory to be compatible with understanding music. Understanding music is a topic which has its own problems and a large literature devoted to solving them. The arousal theory's emphasis on aroused feelings appears to threaten such understanding. Simply being affected by music seems too passive a way of construing

the experience of listening to it: listening to music is not a matter of letting the music wash over us and finding, without effort, feelings aroused by it. Somebody who can use technical musical vocabulary and who follows what he is listening to in the score, characteristically has a greater understanding of, deeper appreciation of, and finer reactions to, the music to which he is listening. The arousal theory needs to find room for such an appreciation of music and to show how such appreciation can influence the state of mind the music causes and the consequent emotional characterization it receives.

Before considering the arousal theorist's response to these problems, I want to show, once again, why there are no analogous problems with our reactions to the plights of characters in fiction. Such reactions embody propositional attitudes: namely, imagining propositions concerning those characters. Hence, our appreciation of them is cognitive at least to this extent. I argued in Chapter 5 that such propositions might not be the whole cause of the reaction; properties of the representation might influence our feelings directly, so as to influence the emotion we feel. To take an earlier example, the fact that Count Dracula wears black, is lit from below, and is frequently heralded by eerie music acts directly on our feelings to accentuate the fear (or disgust) that we feel towards him. The problems that arise for expression do not arise in our reaction to Dracula because the feeling caused becomes part of the emotion we feel *towards him*. Hence this mental state has an object, and there is no further need to explain how the feeling and the cause of the feeling appear to be in a closer relation than simple cause and effect.

To solve the problem for non-representational arts, therefore, would seem to require one of two things. The first would be to discover or invent an object to explain the apparently intimate connection between the feeling and its cause. Such an object would also provide the content for cognitive appreciation. The second would be to show how this connection can be explained within the causal picture without invoking an object. As we saw in the previous chapter, the first option is untenable. The task then is to work within the causal picture: to explain what it is about art (in particular, about music) that distinguishes its arousing feelings from the feelings aroused by taking an appropriate drug.

3. The arousal of our feelings in the aesthetic case differs in two ways from their arousal by a 'feeling drug': in the sorts of properties that are doing the arousing and in the way in which they are doing it. The second of these is more fundamental so I shall begin by looking at that. Let us start with a simple case. When I stub my toe on a tree-root, my foot collides with the root; I am aware of a pain and I become irritated. I am able, either by memory or inference, to ascertain why I am feeling pain and thus why I am feeling irritated. The tree-root is the cause of my irritation, but in order for it to be that cause it is not necessary that a representation of it should appear before my mind. This is similar to what happens following my taking a 'feeling drug'. For a drug to make me feel sad, what must happen is that I take the drug which arouses certain feelings in me. These feelings may remain objectless, or I may fix upon an object and thus have an artificially induced emotional attitude towards that object. At no time need a representation of the drug itself appear before my mind (otherwise spiking drinks would be a conceptual impossibility).

In this respect, there is a significant contrast with music. Commenting on a proposed analogy between aesthetic and colour appreciation, Frank Sibley claims that aesthetic properties 'contrast sharply with those perceptual qualities like red and green which do not depend for their character upon other perceptual qualities of things' (Sibley 1965: 140). Music is (at one fundamental level) comprised of sound, which is a secondary property. That is, the experience of music is the experience of sound, which, to labour the obvious, is something which happens within consciousness. This is an important point, for it is apparently sometimes assumed that the arousal theory claims that our experience of music is *replaced* by our experience of the feelings it arouses. Of course this is absurd. It is the perceptual qualities of music which cause the feelings and, being perceptual, they are part of the experience. Listening to music is having present to consciousness an ordered structure of sound. It is no part of the arousal theory to deny that this can itself be the subject of interest and attention.

This point forms at least part of the reply to the critic who maintains that the arousal theory finds no place for understanding music. The theory does *not* claim that listening to music is simply a matter of being passively affected by it. Part of the

experience of music—the most significant part—is actually lis-tening and appreciating the music, experiences which might be facilitated by following the score. Furthermore, there are plenty of philosophical questions concerning this experience. Exactly *what* is interesting about it? To what extent is our appreciation of it cognitive? What is it to respond to the *beauty* of it? These are interesting questions about which much has been written. But the arousal theory, even if it is incompatible with some answers which might be given to these questions, need not wait upon their satisfactory solution. Questions about the under-standing of music and questions about the nature of expression are in some measure independent, as I hope my discussion will show.

There is something amiss in the analogy given above between music and the tree-root and the 'feeling drug'. For the tree-root and the drug were supposed to be analogous to the music itself. However, they are things which initiate a causal chain which leads to the arousal of feelings, but which need not themselves figure in consciousness at all. In this respect, they are not analo-gous to the music, but rather to the physical scrapings of the strings by the bow or the air vibrating in the clarinet. Nobody would claim that *those* things have the sort of expressive prop-erties I am investigating. Of course, showing that music arouses emotion by appearing in consciousness, whilst the tree-root and the drug do not, does not in itself show that the account I have given of expression is in the clear; it still remains to be shown how the fact that music is represented in consciousness is rele-vant to the analysis of expression. It is, however, enough to show that the analogies do not by themselves sink the arousal theory.

4. One account which would explain the relevance of music's being represented in consciousness is that given by Patricia Greenspan, which I discussed in Chapter 2. Greenspan claims that it is a 'brute fact' about the affective components of an emo-tion that they are 'object-directed'. In the central case the object in question is the emotion's propositional component. If, along with Greenspan, we accept the intentionality of feelings as a brute fact, the problem which the arousal theory faces would admit of a simple solution. The difference between expressive works of art and the 'feeling drug' would be that in the former

case the feelings aroused are directed towards their cause, while in the latter case they are not. This difference could be explained by the fact that the music, like the propositional component of an emotion, is present within consciousness whilst there is no representation of the drug towards which the feelings could be directed. This solution would also provide a direct and succinct answer to the phenomenological problem. Bouwsma claimed that the experience of hearing music as sad cannot be construed as the experience of music in addition to the feeling of sadness. Greenspan's description of the experience, that the feelings are directed at the music, seems, on the other hand, absolutely accurate.

Looked at through the lens of Greenspan's account, the arousal theory is simpler and more obviously true. However, as I said in Chapter 2, I do not feel able to use it to solve the difficult problem the theory faces here. I see no motive for accepting the intentionality of purely affective states except to solve this kind of problem. Moreover, it is not necessary to accept the intentionality of such states, for, as I will go on to demonstrate, the problem can be solved within the causal picture.

Another unnecessarily quietist account of this problem is given by Roger Scruton in his book *Art and Imagination*. I have no quarrel with Scruton's central thesis: namely, that the similarity between an expressive work of art and an expressive person lies in the effect each has on an observer. His argument for this conclusion, however, deviates from my own at several crucial points. Scruton's solution to the problem of the apparent phenomenological unity of our experience of expressive art is one such point.

I shall first place this in the context of Scruton's overall argument, which claims that the experience of emotion in art is an instance of 'aspect perception'; a claim I argued against in Chapter 7. Scruton claims that an expressive judgement is to be understood in terms of the experience of an expressive work, which is to be understood in a similar way to the experience of seeing an aspect in a certain figure ('seeing as'). Two points in this account are relevant here. First, Scruton maintains that the mental states involved in both normal perception and aspect perception embody a cognitive content (in Scruton's terminology, a thought). In the case of normal perception, this thought is a

belief. Whether beliefs or not, these thoughts are not specifiable independently of the experience. 'The quest for a total and independent specification of the thought involved in "seeing as" is as out of place as the request for a total and independent specification of the belief involved in a visual experience' (Scruton 1974: 119). The experience of a sad piece of music embodies a thought which is not specifiable independently of the experience. This constraint makes description of the experience impossible in terms other than the unilluminating 'the experience of music as sad'. Analogously, our experience of a person expressing sadness cannot be described except as 'the experience of a sad person'. Because no further descriptions are available, no justification of expressive judgements is available in terms of a full comparison between the two experiences. Instead, Scruton claims the experience of an expressive work of art is 'irreducibly analogous' to the experience of an expressive person.

Scruton's second point follows from the claim that the perception of expression in art is an instance of aspect perception (Scruton 1974: 120). Recall the duck/rabbit figure: a drawing which can either be seen as representing a duck or as representing a rabbit. When one sees the lines as a representation of a duck one does not see lines in addition to the representation of the duck, one has a single experience of a drawing of a duck. Because the experience of an expressive work of art is a matter of aspect perception, 'there is something like an experience which accompanies the hearing or seeing of the work of art, and which is indeed not truly separable from that seeing or hearing' (Scruton 1974: 120). The problem with which I am concerned—that of finding the link between the work being experienced and the aroused feeling—is, for Scruton, not a problem. The link is the same as that which exists between a drawing or object and an aspect which can be seen in it.

I cannot, in this brief discussion, do justice to Scruton's elaborate account. I shall instead focus on the particular point of contrast between his theory and my own. Our experience of a person expressing sadness conforms (roughly) to the following pattern. We notice certain facets of a person's behaviour and know those to be characteristic effects of the felt emotion of sadness. Thus we are caused to believe that the person is sad. Scruton is quite wrong in his claim that the thoughts embodied

in this experience cannot be specified independently of it. Why cannot we say: 'I noticed that . . .' and then specify what it was about his appearance or behaviour that we noticed (cf. Budd 1985*a*: 147)? Of course, this proposition will not *be* the experience of noticing—it will be the proposition describing the experience. Furthermore, the proposition expressing the resultant belief (that the person is sad) is also independently specifiable. Similarly, the proposition expressing an expressive judgement is independently specifiable. As the cognitive components of the experience of a person expressing an emotion and the experience of expressive music can be specified, Scruton has no grounds for postulating an irreducible analogy. Why could not something be said about the relation between the propositions in each kind of case?

Scruton deserves credit for avoiding the sterile cognitivist route of searching for a way to fill out the dots after 'I noticed that . . .' in a way common both to the experience of a person expressing an emotion and that of expressive music. But if it is not the cognitive content which is common, it must be some other aspect of the two experiences. Again, I fail to understand Scruton's quietism; there seems no reason not to attempt to specify the link between the two experiences in terms of their non-cognitive elements.

Scruton's reply to the question of why, when we listen to expressive music, we have a single experience rather than two experiences is couched, as I have said, in terms of aspect perception: the emotion is perceived as an aspect of the music, and perceiving an aspect in an object is a unified experience. It is difficult to take this seriously for reasons given in Chapter 7. Certainly, when I experience lines on a page as a representation of a duck, my experience does not divide into two: that of a set of lines and that of a representation of a duck. (This has nothing in particular to do with aspect perception; it is true of any pictorial representation.) However, if we are to avoid the problems discussed earlier, the problem of expressive judgements cannot be considered a special case of aspect perception. It is not clear which elements are supposed to be analogous, let alone that the structure of the two problems is identical. There is simply no solution here. Thus the problem of reconciling the arousal

theory with the apparent unity of our experience of expressive works of art remains to be solved.

5. What, then, is the relevance of the fact that, unlike the tree-root and the 'feeling drug', to experience music one must experience it consciously? Consciousness alone is not, of course, sufficient to distinguish expression from the drug case. It would be possible to administer a drug to a person listening to music, such that he was conscious of the music and the feeling simultaneously. But, as this would obviously not be a case of hearing an emotion *in* the music, the fact that a listener is experiencing music and a feeling simultaneously does not entail that the music is expressive. Rather, the music must *cause* the feeling. It is the way in which it does this that explains the intimate link between music and feeling, and therefore explains why it is we hear music as expressive rather than simply hearing the music and experiencing a feeling.

The account of the relation between the music and the aroused feeling parallels the account of the relation between the reader's experience of a representation and his aroused emotion towards a fictional character presented in Chapter 5. The experience of expressive music is the experience of an organized structure of sound and the corresponding feelings it arouses. The feelings are aroused by paying attention to the sound, and sustained by continued attention. The feelings being those usually aroused by the expression of a certain emotion in the central case is (for a qualified listener) sufficient to cause the belief that the music is expressive of that emotion. This is simply a contingent fact about us and the world.

I shall begin my defence of this answer with a truism about listening to music: that to listen to a worthwhile piece of music requires concentration. In one sense this is analytic, for to listen to (as opposed to hear) music requires that the sound is before the mind and the way we get things before the mind is by paying attention to them. The point is identical to that made in Chapter 5 in respect of representations. There I argued that in order to engage with a representation it is necessary for the reader to pay attention to it. Similarly, in order to engage with a piece of music it is necessary for the listener to pay attention to

it. There are further requirements. To experience the music in any depth the listener must have some grasp of something analogous to narrative in fiction: he must have some idea of where the music has 'come from' and where it is 'going'. This requires listening for and recognizing themes, being aware of the structure of the piece, and so on. This is summed up in Jerrold Levinson's definition of music as a 'humanly organized sound for the purpose (arguably) of enriching experience . . . through requiring a person's *attention* to the sounds as such' (Levinson 1990: 273).

Until now the dynamic properties of music, which are claimed by cognitivists as essential to the analysis of expression, have not been touched on by the arousal theory. It is, however, likely to be significant that the property of music most often seized upon to explain the expression of emotions in music is that of musical movement. The arousal theory does not deny this significance: although music's relational properties do not have the role assigned to them by the cognitive theory, they *are* important to an understanding of expression in music. For it seems, as a matter of fact, to be the dynamic properties that are most efficacious in arousing the listener's feelings. To understand this, we need first to understand what musical movement is.

The experience of music is the experience of something which happens over a period of time, where what happens at one time is related to what happens at another.[2] This 'something', according to Malcolm Budd, 'consists of phenomena grouped into units that are more or less complete in themselves, but which are combined with other units to form higher-level groupings with a more inclusive sense of completeness, thus making the work a composition of elements on different hierarchical levels' (Budd 1985*b*: 243). These phenomena are *tones*, where a tone is distinct from a sound in that a tone (to put matters crudely) seems to contain within it the promise of other tones to come, related to the first tone in some relevant fashion. A piece of music, then, is a structure, the identity and value of which will not reside in any particular part, but rather in the relations between its parts. The truistic consequence of this is that the value of a piece of music

² On the vexed question of what music is, a preliminary reading list of recent literature would include Scruton 1983, Budd 1985*b* (esp. p. 243), Tanner 1985, Levinson 1990 (esp. p. 273), Maconie 1990, and Davies 1994.

emerges over time, as it takes time, when listening to a piece of music, for these relations to emerge.

Of course, all this prompts almost as many questions as it provokes, particularly about the philosophical implications of the perceived relations between tones.[3] I simply want to borrow from this debate the claim that among the most important properties of music are relational properties which are revealed to a careful listener over time. Relations underlie much of the vocabulary used to talk about music, as the following brief survey by Roger Scruton illustrates:

> our perception of harmony is dependent upon our musical understanding as a whole. It cannot be separated from the understanding of movement, tension, and release. Moreover, what we experience in hearing harmony is something that has to be described in metaphorical terms. Chords are heard as 'spaced', 'open', 'filled', 'hollow' (to use the basic metaphors of musical experience): harmony is described in terms of geometrical relations between parts, in terms of the coming together and separating of movements, in terms of oppositions and agreements. Just as melody involves the metaphorical transference of ideas of 'movement', 'space', 'height' and 'depth', so does harmony involve the metaphorical transference of ideas of 'tension', 'relaxation', 'conflict' and 'resolution'. (Scruton 1983: 94)

What it is to hear music, then, is to experience these relations between tones.

As already indicated, it is the dynamic properties of music which are commonly attested to carry the burden of musical expression. There is thought to be an isomorphism between the dynamics of music and the dynamics of our emotions. Levinson puts the point as follows: 'The idea is that a musical passage expresses an emotion whose structure . . . closely mirrors or resembles the structure of the passage' (Levinson 1981*b*: 283). As we have seen, the problem lies in showing how music can 'closely mirror or resemble' the emotions. The arousal theory provides the simple and obvious answer. Consider some simple harmonious piece of music which, according to Scruton above, would be characterized in terms of tension, relaxation, conflict, and resolution. At some stages of the piece, the music might sound

[3] The best such investigation is in Budd 1985*b*.

restless and unsatisfied. Then, as it finishes with a perfect cadence, this impression vanishes to be replaced by a feeling of satisfaction and total completion. These musical stresses and strains are an important aspect of the piece, since someone who did not hear them would not be hearing the piece as music.

It does not *follow* from a piece of expressive music which exhibits such relations as tension, relaxation, conflict, and resolution that the feelings aroused will themselves stand in such relations. Although it does not follow, however, the aroused feelings of the listener do, commonly, stand in such an isomorphic relation.[4] As the music moves from dissonance to resolution, so the feelings move from doubt to satisfaction. Consider the following example from a discussion by Anthony Hopkins of the adagio of Mozart's Piano Concerto in A Major (K 488). He is talking about the second piano entry.

For five bars the solo piano holds the stage alone; then we arrive at a moment of melting beauty as the piano turns positively towards a major key for the first time in the movement. This significant change is marked by a hushed chord in the strings; it is not quite powerful enough to shake off the wistful quality that has so far prevailed, and we find ourselves in a sort of limbo half-way between A minor and A major. It is the orchestra that resolves the dilemma, opting firmly for A major with yet another theme given out by the woodwind. (Hopkins 1977: 179)

As the music moves towards A major, it moves from wistfulness, through a state of slightly more resolute expression before the theme commences and the music achieves, for the moment at least, a sense of emotional satisfaction. As the music resolves itself, so does the feeling it expresses. Hence the structure of the music is mirrored in the structure of the feelings it arouses.

This is an important element in the relation between the music and the feelings. It is not that one listens to a sound and this simply causes a feeling. The connection is far closer than that. At any time during the experience of a piece of expressive music, the feeling at that time will be caused by the accompanying sound, plus the relations which that sound has to others in the piece.[5]

[4] The point I make here is related to Monroe C. Beardsley's claims about the 'unity' of aesthetic experience (Beardsley 1970).

[5] To borrow a useful piece of terminology, the feelings are 'directly causally dependent' on the music (Lowe 1992: 82).

The connections are both intricate and intimate, and the feelings themselves will reflect this complexity. There is an enormous phenomenological difference between the experience of expressive music and the experience of having one's mood altered by a drug; a difference which is more than sufficient to account for the fact that the first causes the belief that the music is expressive and the second does not cause the belief that the drug is expressive. Furthermore, Bouwsma is quite right: the intimate connection between the music and the feeling is closer to the impression of the apple as red, than it is to burping some time after gulping a pint of cider.

The claim is that attention must be paid to music in order to keep it 'in front of the mind' so that the listener notices the dynamic properties of the music; properties which unfold over time. In order to perceive these properties, therefore, the listener's attention must be *sustained*. This distinguishes the arousal of a feeling relevant to expression from those cases in which the listener's initial attention to the music wanders: the music is used as a springboard for indulging in feelings which it does not directly cause. The intimate connection between the music and the aroused feeling needs to be sustained as it is only feelings caused by the music that are relevant to expression, not feelings released by the music but which have some other source.

In Chapters 6 and 7 I criticized cognitive theories of expression on the grounds that, unlike expression, having a belief is not an experience with duration. It is difficult, therefore, to see how expression may be analysed in terms of it. The fact that the arousal theory has as a consequence that listening to music requires sustained attention and the constant causation of feeling (provided, of course, the work remains expressive) ensures that, for the arousal theory, this problem does not arise. The theory explains why it does not make sense to ask *when* during the performance of an expressive piece of music the emotion was expressed. It was expressed for as long as the feelings were aroused by the music. This important aspect of expression which posed such problems for the cognitive theory—the fact that it has duration—is a natural consequence of the arousal theory.

The problem for the arousal theory is to give a causal account of those aspects of the experience of expressive music which appear to require an intentional explanation. I have argued that

the theory is able to do this with a causal account which reflects the complexity of the phenomenon to be explained. It remains true, however, that no matter how complicated such an account becomes, it still describes a relation between distinct particulars. The arousal theory must accept the consequence of this: namely, that as music and the feelings aroused are distinct, the latter could be caused by some means other than the former. A 'Beethoven's Fifth drug' could, in theory, provide all the feelings one would get on listening to the music with all the attention one could muster (Budd 1985a: 124–5). Such a drug would provide about half an hour of tightly-packed feelings without apparent cause. It does not follow from this that a listener would be indifferent to taking the drug or listening to the music: the former experience, lacking the sound to which the feelings are intimately tied, would be altogether different. It is only if one believes that the feelings *alone* are what is valuable about music that such a conclusion would follow. That, however, is a very strong and completely implausible premiss.

The arousal theorist is able to account for the experience of the listener without introducing anything that is *ad hoc* or of doubtful philosophical pedigree. The effects of the 'feeling drug' and the effects of expressive music are both explicated causally, but there the similarity ends. What is going on in the consciousness of the drug-taker is different from what is going on in the consciousness of the listener; a difference which, I claim, is sufficient to explain why we take the latter to be a matter of expression but not the former. What the arousal theory takes to be the facts of the case—the simultaneous presence in consciousness of two things in intimate causal connection—provides a plausible explication for the phenomenological claim that the listener hears the music as expressive without recourse to the non-explanatory notions of irreducible analogies, aspect perceptions, *sui generis* modes of expression, or animation.

What, then, is the arousal theory's answer to the question of the meaning of the judgement 'the music is sad'? The first answer is that the music is sad if it has the capacity to be experienced as sad, and if that experience is not rendered aesthetically irrelevant by other considerations. This is not, on its own, informative. The relevance of the arousal theory is that it is able to say what the experience is; not how it is caused, but rather how it is

constituted. Hence, it is an account both of the experience of the listener and of what is meant by expressive judgements. The scope of the semantic claim is one theme that will be further developed in the next chapter.

6. So far I have discussed two ways in which music can arouse feelings: the first, in which we react to it simply as music, rather than reacting to it as expressive, and the second, in which our reaction is caused and sustained by attending to its properties. In accusing the arousal theory of philistinism, its detractors have in mind that it confuses these two kinds of reaction. The arousal theory is accused of elevating any emotional reverie provoked by hearing a piece of music to the aesthetically valuable. This is Kivy's fourth objection, left over from the discussion in the previous chapter. But this accusation is unjust; the feelings which constitute the experience of musical expression are those which are aroused by close attention to the music, and which *track* the music in virtue of this.

Implicit in this claim is that expression is a complicated matter which cannot be tied to any simple cause. At its simplest (and this is still not very simple), a minor chord played in isolation expresses the darker emotions; doubt in need of resolution. The properties of a piece of music which are relevant to expression are just those which arouse the listener's feelings when the music is listened to in the manner described above. Because these properties are defined dispositionally, the range of properties cannot be specified, independently of their effects, in advance. It is certain, however, that a number of different sorts of properties will be relevant; although the dynamic properties will be important, other properties of the music will also be causally efficacious. We saw in Chapter 7 that one implausible aspect of some cognitivist accounts is that movement is thought to be the sole determining factor of expression, but this is to ignore such factors as the *sound* of the music—for example, whether the piece is in a major or minor key.

Although the arousal theory captures the primary sense in which music is expressive, there are other ways in which music can be expressive which are not *directly* tied to the arousal of feelings in a listener. These are forms of 'second-order' expression in which the emotion expressed by a work emerges from the

relation which its expressive parts bear to one another. This is best illustrated by example. In Chapter 5, I quoted from Gerhart von Westerman's description of Beethoven's Fifth Symphony. Quoting the discussion at greater length, it is clear that von Westerman's view is that the symphony expresses hope and optimism not in virtue of any particular aroused feeling, but as a result of the relation between the different feelings which are aroused as the piece progresses.

The threatening strokes of fate at the beginning of the symphony intimate a passionate struggle that is to draw all the energies of life into its fateful wake. The whole long movement evolves out of this one theme which stands like a cipher at the beginning of the work: life storms along, hard and inexorable; softer ideas attempt to make their mark, but none succeed: fate proceeds ruthlessly along her chosen path.

The second movement, 'andante con moto', takes place in a totally different world. The lower strings open with a wonderful melody, and this is complemented by a march-like theme in the woodwind. The latter takes a victorious, radiant turn; both themes, artfully altered, recur several times in the course of the movement. Emotionally, the movement has its ups and downs—the weather is changeable—but there is no lapse in confidence; the movement is full of faith in happiness and beauty.

The third movement returns to the world of ideas manifested in the first allegro. A theme that seems to wish to escape from the low region where it started leads to a derivative of the fate motif. As it feels its way ahead with gliding limbs, the strokes of fate recur, now hard and threatening, and then later, softly reverberating in the basses; a game that is an attempt at gaiety. This pales and flies off into nothingness. The dark lines start their climb as at the beginning, and the fate theme recurs again but with less life than before. An uncanny, heavy mood starts to spread, a mood of scary suspense, and it is from this that the victorious last movement breaks out, in all it elemental strength. (von Westerman 1968: 138–9)

We recognize in this emotional progression the same changes we find in life when, struggling through sadness and trouble, we emerge into a state of optimistic strength. The symphony *is* optimistic; it expresses a particular progression of emotions which are characteristic of hope. Although the belief that the symphony is optimistic is not caused by any single feeling, it is none the

less controlled by—and dependent on—beliefs caused by feelings aroused by particular passages within the work.[6]

It would be unwise to claim that the addition of this consideration exhausts the ways in which a piece of music can be expressive. There might be other means by which a relation of a passage of the music to another passage, to the piece as a whole, or even to passages outside the piece might produce beliefs concerning a work's expressive nature (cf. Levinson 1990: 356). This does not effect the arousal theory's claim to have captured the central notion of musical expressiveness, upon which these other ways in which music is expressive ultimately rely.

7. In responding to the argument that causation is irrelevant to the analysis of expression, I have, thus far, considered only music. I have concluded that the properties which distinguish being caused to be sad (by the 'feeling drug', for example) from the experience of the musical expression of emotion are that for music to arouse the feelings, the listener needs to pay sustained attention to its properties, in particular its relational properties. Implicit in this claim are rationalizations of two vague but appealing thoughts we have about music's relationship to the other arts. The first is that, amongst the arts, music is pre-eminent; the second is that talk of 'the music' of prose and poetry is more than a metaphor.

Why is it, then, that 'all art constantly aspires to the condition of music'? Expression is explained by the arousal of feeling through close attention to the work of art—in particular to certain sorts of relational properties. These properties are more constitutive of music than of the other arts, from which it follows that music is potentially more expressive than the other arts. With the addition of the premiss that the more expressive art is the better, it follows that music is potentially better than the other arts. There is not, it seems to me, any very good reason to accept the additional premiss. Expression *is* an important value of art but, as I pointed out in section 4, there is no reason to think it is the only, or even an overriding, value.

[6] The same point is made—although obviously with reference to his own theory—in Davies 1980.

Such relational properties, if not actually dynamic properties, are important in all the arts. Monroe C. Beardsley christened these 'regional properties', defining them as perceivable properties that belong to a complex but not to any of its parts (Beardsley 1958: 82–8). Disregarding Beardsley's excellent advice 'to be on guard for over-facile transfers from one art to another', we can see that talk of the music of prose and poetry can be justified by looking at the role that relational properties play in the experience of the reader of prose or poetry. In Chapter 5 I argued that feelings aroused by fiction are aesthetically relevant only if aroused by attention to the work itself, and not by some other cause. The feelings for a reader could be aroused either via a cognitive intermediary (a proposition imagined) or directly by the work. In the light of the importance which philosophers of literature, particularly Beardsley, have placed on regional properties, there is no reason to exclude from among the latter relational properties which emerge as reading progresses.

As these properties are most prominently associated with music, the comparison with music springs naturally to mind, as, for example, in this description of reading Tolstoy's *War and Peace* by E. M. Forster: 'it has extended over space as well as over time, and the sense of space until it terrifies us is exhilarating, and leaves behind it an effect like music. After one has read *War and Peace* for a bit, great chords begin to sound, and we cannot say exactly what struck them' (Forster 1974: 26). Although we cannot always specify *which particular* properties of *War and Peace* struck the chords, we can say *that* they struck them. There are relational properties of the novel which are revealed as the novel is read which, if close attention is paid to them, cause feelings in the reader which are similar in complexity to those aroused by expressive music. As with music, the effect of these relations could be cumulative: we might, as Forster says, need to read the book 'for a bit'.

So far, my primary task has been to defend the arousal theory from criticism; a strategy forced on me by the low standing the theory enjoys, at least among professional philosophers. We have seen that in being able to provide an account of expression the arousal theory steals a march on its rivals which alone should make it worthy of notice. In the next two chapters I will consider some further objections, before showing that the consequences

of the account provide unforced explanations of several puzzling aspects of expression. By the end I hope to have shown that the arousal theory is not merely the only account of expression we have, it is also the only one we need.

IO

Belief and Experience

1. In Chapter 8 I gave the following formulation of the arousal theory:

> A work of art x expresses the emotion e if, for a qualified observer p experiencing x in normal conditions, x arouses in p a feeling which would be an aspect of the appropriate reaction to the expression of e by a person, or to a representation the content of which was the expression of e by a person.

This was deliberately modelled on the familiar 'basic equation' for colour (in this case, red):

> x is red iff for any observer p: if p were perceptually normal and were to encounter x in perceptually normal conditions, p would experience x as red.

As we have seen, the analogy between the two cases is not direct. Part of the analysis of red is the claim that the observer 'experiences x as red'; the analogue in the aesthetic case is that the work 'arouses a feeling' in the observer. In the previous chapter this apparent difference was explained away; despite the differences in formulation, the analogy holds firm.

I am not the first philosopher to pursue the analogy between expression and colour (cf. Sibley 1978). Not only is the analogy interesting for the light which it throws on expression, the enquiry is also interesting for its own sake—colour and aesthetic properties fall within that interesting class of properties defined in terms of an observer's experience. My primary concern in pursuing the analogy, however, is to diminish the appeal of two remaining objections to the arousal theory. My strategy will be to show that the considerations underlying these objections apply to arousal (that is, dispositional) theories as such. As the dispositional account of colour is widely accepted despite these

considerations, I shall argue that the considerations do not jus-
tify the rejection of the arousal theory of expression. The two
problems I shall consider are firstly that it is simply not true that
an expressive work of art provokes the relevant response in
everyone whenever it is witnessed, and secondly that the arousal
theory defines the content of the belief that a work of art is
expressive in terms of a 'private' mental state.

The fundamental analogy between colour and expressive
judgements lies in the process by which the content of the judge-
ments is caused. Both involve a non-cognitive mental state which
is caused by perception and which causes the belief expressed
by the judgement. Perceiving a cricket ball causes a certain visual
sensation which causes the belief that the ball is red, and listen-
ing to a piece of sad music causes certain feelings which cause the
belief that the piece is sad. Moreover, the relevant experience,
despite its role in defining the content of the belief it normally
causes, is itself quite distinct from that belief (which will, for
example, persist when the experience has ceased). I need not be
experiencing the redness of a ball to believe that it is red, and
similarly for the other cases. My beliefs about the secondary
qualities of things, and the emotional qualities expressed by
works of art, are not to be identified with the experiences which
normally cause them. Moreover, whereas anyone can have these
beliefs, only someone who possesses a certain capacity or set of
capacities can have the corresponding experiences. I shall call
someone capable of having the relevant experience a 'qualified
observer' of the property in question. I discuss the criteria for
being a qualified observer in the next section.

There is another aspect of the independence of belief and
experience which provides further support for the analogy. It is
quite possible for someone who is not a qualified observer of a
given secondary quality to believe truly that a certain object pos-
sesses that quality since the relevant experience is clearly not the
only way of acquiring the belief. The belief may be acquired by
other means: for example, someone who lacks the capacity to
experience an object as having a certain secondary quality may
simply be told that it has such a property. A blind person may,
for example, be told that a ball is red and thus acquire a true
belief about its colour. This belief, which has not been caused by
any visual experience, will have exactly the same content as a

belief caused by a visual experience of a red ball. We can see that this is so if we consider that someone capable of the visual experience could also acquire the same belief non-perceptually: for example, if a normally-sighted person is told, of a ball that is out of sight, that it is red. The content of the acquired belief—that the ball is red—will clearly be the same in all these cases.

As we have seen, someone who lacks the capacity to experience a work of art as sad could still acquire the belief that it is sad. So, rather than form the belief that the second movement of the *Eroica* expresses grief through an experience of the piece, the belief could arise from reading a programme note or from listening to informed conversation. Conversely, just as someone can acquire beliefs of this sort without having the corresponding experience, so someone can have the experience without that experience causing the corresponding belief. Thus, someone can have the visual experience of an object as red, yet fail to form the belief that the object is red. The individual concerned may, for example, not know what red is: that is, he may lack the concept red. I shall have more to say about concepts and rationalizing experience shortly.

However, whilst in all these cases the corresponding beliefs and experiences can occur quite independently of each other, this in no way prevents the content of the beliefs from being defined by the experiences which normally cause them. It remains the case that what makes the belief that an object instantiates some secondary quality true is the fact that the object would cause the appropriate experience in a qualified observer. The belief that an object is red will be true if and only if a suitably qualified observer in normal conditions would experience it as red. Similarly, the belief that a work of art is sad will be true if and only if a suitably qualified observer in normal conditions would experience it as sad.

2. I remarked in the previous section that someone who is not a qualified observer may react to a work of art or other object with an experience which does in fact define a secondary quality without the observer realizing that it does so. Thus someone may experience the colour of an object without realizing what it is they are experiencing. Hence, the experience would not cause

the corresponding belief that the object is the colour that it is—red, for instance.

In order to recognize specific colours, a qualified observer needs to be able to recognize colours in general. This ability is more complicated than one might think, involving as it does a number of constituent abilities, which are acquired by almost all of us early in life (Hardin 1988: 82–91). An observer who has these abilities, together with the other relevant constituent abilities that enable one to recognize colours, will generally be in a position to acquire specific colour concepts. Through experience and teaching, such a person will be able to recognize a colour as, for instance, the colour red. In other words, his experience of a red object will (in normal circumstances) cause the belief that the object is red. It might even be that coming to possess the concept red not only enables the observer to form such beliefs, but actually alters the nature of his visual experiences. If this were true, then the experience of seeing red objects by someone who possessed the concept would differ qualitatively from that of someone who did not. But whether or not that is so, the significance of the experience will certainly differ in the two cases. For someone who is not a qualified observer the experience will simply be something that happens to them; it will not be something of which they can make sense—unlike those of us who do possess the concept red.

The same is true in the aesthetic case. Somebody who is not a qualified observer of emotion in art might well be emotionally affected by art, yet lack the concepts needed to make sense of the reaction: namely, emotional concepts. This fact—that in order to be a qualified observer one has to possess the relevant concepts—gives us part of the answer to the second of the two objections to the arousal theory mentioned above: namely, that the arousal theory places undue stress on a person's inner experiences. If there were a problem here, it would be as much a problem for the standard theory of colour and other secondary qualities as it is for the arousal theory in aesthetics. For colour and other secondary quality concepts are standardly defined in terms of the experience of the observer in just the way that I am claiming is the expression of emotion in art. Yet this does not entail that our concepts of colour are objectionably 'private'. On the contrary; for as we have just seen, I need more than good eyesight

to see what colours objects are. I need colour concepts to turn my visual experiences into experiences of the colours of objects— and it is no part of our standard 'arousal' theory of colours that I am able to derive these concepts from my 'private' visual experiences. In short, the standard definition of colours in terms of the experience of a qualified observer does not entail any objectionable reduction of the colours of objects to the 'private' visual experiences of people. Nor, analogously, does the arousal theory entail any such reduction of the emotional qualities of works of art to the 'private' feelings of those who experience them.

The other objection to the arousal theory is that it is not true that a work of art which expresses an emotional quality will make anyone who confronts it undergo the appropriate emotional experience. Nor will it: but the arousal theory does not entail that it will, any more than the analogous theory of colour entails that red objects must always give everybody who confronts them the same visual experience. Our theory of colours defines them in terms of the reactions of qualified observers in normal conditions and the arousal theory of the emotional qualities of works of art can—and should—do the same. The question is whether we can define the qualified observer of the emotional qualities of works of art analogously to the qualified observer of secondary qualities.

There have been several attempts to do this, although none of which I am aware goes much beyond Hume's attempt in his essay 'Of the Standard of Taste':

A man in a fever would not insist on his palate as able to decide concerning flavours; nor would one, affected with jaundice, pretend to give a verdict with regard to colours. In each creature, there is a sound and a defective state; and the former alone can be supposed to afford us a true standard of taste and sentiment. (Hume 1757: 140)

Let us start by asking, as Hume does, what *dis*qualifies observers of secondary qualities. What are the sorts of things that prevent us from reacting appropriately to them? The most obvious thing is a defect in the sense by which we detect the secondary quality concerned. For example, a blind person cannot experience red— or indeed any colours at all. Similarly, someone who is colour-blind in a particular way may be unable to experience red; that

is, their range of visual experience would be insufficient to enable them to discriminate red objects from (for instance) green ones, even if they were to possess the concept red. The same is true of sounds. A completely deaf person cannot experience particular sounds because they cannot experience sounds at all. Someone who is unable to discriminate between certain sounds, such as someone who is tone deaf, is in an analogous position to someone who is colour-blind. The experience of something as notes strung together in a tune may be beyond them. In short, the capacity to experience a particular secondary quality depends upon the possession of some more general capacities (to be able see, hear and so on) to an adequate degree.

These defects may also prevent our reacting appropriately to the expression of emotion in art. It is obvious that, in order to appreciate a certain work of art, the sense which a person would need to experience it at all would have to be functioning correctly. There is, for example, no sense in taking a blind person to a gallery of paintings or in reading poetry to someone who is deaf.[1] The same is true of those people who possess the relevant senses, but to an inadequate degree. Thus a picture whose effect depends on contrasting patches of red and green would be lost on someone who was red/green colour-blind. Similarly, tonal modulations essential to the emotional qualities of a piece of music would be lost on a person who did not have the capacity to hear them.

There are, however, conditions besides these which prevent the appropriate emotional experience when faced with art. These are the aesthetic analogues of such things as blindness and colour-blindness. Some people are acutely sensitive to the expression of emotion in art and others utterly 'blind' to it. Many, perhaps most, fall somewhere between. Indeed, it is an advantage of the arousal theory that it can easily accommodate this fact. If the appreciation of emotion in a piece of writing, for instance, is simply a matter of recognizing something about the writing, it is difficult to see how, given the relevant concepts and the proper

[1] Except, of course, if what they are going to appreciate can be detected through the other senses. For example, a blind person can appreciate the tactile qualities of a work of art, and a deaf person might appreciate the rhythm through the vibrations caused by the sound.

working of the senses, this could be a matter of degree: either you recognize it or you do not. By contrast, it is easy to see how writing can arouse people to different degrees of an emotion, as well as to different emotions, and consequently provide them with a different understanding of the work. The analogues of the colour-blind, then, are those who miss out on certain aspects of the normal emotional experience of a work of art.

The aesthetic analogue of a completely blind person is therefore someone who does not possess the capacity to experience the expression of emotion in art, or in some kind of works of art, at all. That is—to use Hume's term—those who do not have 'delicacy of taste' (Hume 1757: 140). According to Hume, delicacy of taste is an acquired human capacity to react to works of art appropriately. This compares, he claims, to capacities in other fields where appreciation is required. For example, not everyone is able to detect subtle flavours in food or wine. Delicacy of taste is not, however, simply the ability to react to a stimulus with the appropriate sensation. As Hume says, we need to 'mingle some light of the understanding with the feelings of sentiment' (Hume 1757: 140–1). As we saw in the previous chapter, the arousal theory does not contradict the plausible claim that the appreciation of art, including the appreciation of a work's expressive properties, requires understanding. Failure to understand a work might mean that its expressive properties—those which have the capacity to arouse feelings in a qualified observer—would be missed.

Taste constitutes a complicated family of related capacities which produce an aesthetic response from a perception. Some of these capacities may be specific to aesthetic appreciation, such as the capacity to have our feelings aroused by instrumental music. There will also be those whose primary function is to get us through life unscathed. As we have seen, these include capacities which almost all of us have from birth, such as the ability to hear, as well as more complicated ones, such as the ability to discriminate a grin from a smile. We all possess some if not all of these capacities to a greater or lesser degree. The fact that almost all of us can discriminate colours, whilst not many of us are able to appreciate the expressive qualities of art, is not, therefore, a problem for the analogy. Colour discrimination requires capacities most of us acquire early in life, whilst appreciating the

expressive qualities of art requires capacities some of us never acquire at all.

3. So far we have looked at what it takes to be a qualified observer of secondary qualities and of emotional qualities of works of art. Another part of the basic equation in both cases is 'perceptually normal conditions', and again we must consider what non-question-begging sense the arousal theory can make of that concept. Once again, an analogy may be developed with normal perceptual conditions for colour. This seems to depend upon the fulfilment of three criteria.

The first criterion concerns the kind of light which is illuminating the object. (That is, for reflected colours. The normal conditions for perceiving the colours transmitted or emitted by objects, or of light itself, will obviously be different, but the differences raise no relevant point of principle.) As a rough approximation, our criterion could be that if we are to judge the reflected colours of objects correctly, we must look at them in the light under which they were intended to be viewed (which will typically be daylight). The second criterion which our perceptually normal conditions must satisfy concerns what happens after the light has been reflected from the object in question. A rough approximation of this might be that once the light has been reflected from the object, it should undergo no further interference which would change the nature of the colour experience it would cause on being 'received' by a normal subject.

Rough analogues for these two criteria are easily found. I will not go into detail, since these analogues are obvious and uncontroversial and do not advance us much in our enquiry. It is obvious that we will only be in a good position to experience all of a work's emotional qualities if we are able to experience the properties which are causally relevant to the arousal of our feelings. It is equally obvious, to take an example, that pictures should not be placed behind coloured glass or viewed through a filter (unless such presentation is part of the work). Perfect conditions are not required in order for us to experience paintings and other works of art properly, but there is a certain minimum standard of presentation below which our experience—including our emotional experience—of almost any work will be rendered inaccurate.

The second criterion deals with obvious ways in which our experience might be relevantly altered; that is, with interference from immediate surroundings. The surroundings can add to or distract from our experience of art. Some works, for example, some religious music and painting, were produced to be experienced in a certain setting and are, in a way, incomplete outside the setting. Other works were created to be experienced without reference to their surroundings. It is, presumably, to facilitate the second case that galleries and concert halls tend to have the aura of religious buildings: quiet, spacious interiors with a minimum of distractions, which encourage attention and allow the observer to be affected exclusively by the work being experienced.

Apart from the perceptual circumstances controlled by these two criteria, however, our experience of colour also depends to a large extent on the context in which the coloured object is viewed. We need a third criterion, therefore, which is that the object should be viewed in a 'normal' context, where what counts as normal seems to be governed partly by contingency and partly by convention. The most obvious influence of context on our colour experience is the background against which the object is viewed. Not only can a background change the shade of an object's colour; but, as painters know, there are also occasions on which it can change the colour altogether. Hence, we need to add to our criteria that the colour should be viewed against a relevantly neutral background.

It is not only the immediate spatial context which can affect our experience however, but also the temporal context. If we consider other secondary qualities we can see that what the observer has been doing previously can affect the quality of his experience. Take, for example, our sense of touch, and the experiment made famous by Locke. A person who has been resting one hand in cold water and the other in hot plunges both hands into a bowl of luke-warm water. The felt temperature of the water will differ for each hand, thus showing how a perceptual experience can depend on the state a perceiver has been put into by a prior experience (Locke 1689: II. vii. 21). As for feeling, so for taste; a gourmet might insist on eating a sorbet between two courses in order to restore his palate to a relevantly normal

state to prepare it for the accurate experience of flavours to come.

The aesthetic analogue of this third criterion is difficult to state precisely, because the effect of context on our appreciation of the expression of emotion in art is rather complicated. Hume sums up the general problem thus:

> But though all the general rules of art are founded only on experience and on the observation of the common sentiments of human nature, we must not imagine, that, on every occasion, the feelings of men will be conformable to these rules. Those finer emotions of the mind are of a very tender and delicate nature, and require the concurrence of many favourable circumstances to make them play with facility and exactness, according to their general and established principles. The least exterior hindrance to such small springs, or the least internal disorder, disturbs their motion, and confounds the operation of the whole machine. (Hume 1757: 138–9)

The 'exterior hindrance' has already been discussed above, which leaves us with the 'internal disorder'. Consider, for instance, an analogy with the example from Locke. It is certainly true that recent or distant experiences can change the state of mind of an observer in ways which affect his appreciation of emotion in art. Such a change might be unfortunate and idiosyncratic; Mary Mothersill, for example, relates that she is now unable to listen to the final movement of the sixth Brandenburg concerto without feelings of nausea, after being forced to listen to it thirty or forty times at a bad party (Mothersill 1984: 403). Not all such changes, of course, are as unpleasant as this and some are changes for the better. An individual might, for example, find that in the course of arriving at a better appreciation of Cézanne, they are forced to re-evaluate the work of some of the Impressionists. Later, perhaps, they might re-evaluate Cézanne in the light of their newly acquired appreciation of Braque and Picasso. Thus, it might become, for them, a condition of being able to appreciate Manet properly that they have not recently been looking at a Cézanne; and a condition of appreciating Cézanne properly that they have not just been looking at the Cubists. Thus, as the observer changes, so might the conditions he has to place on the context of his experience of works of art if he is to experience them accurately. We need not go to such

debatable examples to illustrate the point. Anyone who hangs pictures, compiles anthologies, or arranges concert programmes knows that an audience's experience of a work will be affected by other works they have recently encountered. This is why it is seldom that we encounter works of art thrown together at random.

4. Another, and more significant, 'internal disorder' arises out of a disanalogy between the aesthetic and the colour case. As has already been discussed, the mental processing involved in colour perception is best explained in purely causal terms. It is not conscious and not under our control. By contrast, it is possible for an observer deliberately to inhibit the effect of a work of art, demonstrating that these processes are—at least in part—under conscious control. That is, an observer can either suppress or make himself susceptible to the effect of expressive art, or even alter the way in which he is moved.[2] By what means, then, is an observer able to intervene?

First, a viewer or listener must be *willing* to pay attention to a work in the manner identified in the last chapter as necessary to appreciating expression. This is because, as we saw in that chapter, a work arouses our feelings by 'filling our consciousness'. Art which we choose to ignore will not arouse our feelings, no matter how expressive it is, because it is not available in our consciousness to do so. Secondly, it is possible simply to stop one's feelings being aroused by a work. The ability to do this is not specific to art: we are able to inhibit our emotional reactions in central cases. A doctor, for example, might deliberately inhibit his emotional reaction to a patient's suffering in order that his mind should be kept clear for the sake of a more efficient diagnosis. Such an attitude is compatible with the doctor's believing that the circumstance is such that pity would be an appropriate reaction and (of greater significance for the aesthetic case) believing that it is the feeling of pity which he is inhibiting.

The doctor's case has a bearing on a vexed question for the arousal theory. There is, to adopt some terminology from

[2] We have already seen an example of such control in the discussion in Chapter 8 of responding to art 'from within' or 'from without'.

Bouwsma, such a thing as 'dry-eyed criticism': namely, cases in which we believe a work of art expresses a certain emotion without actually being aroused by the work (Bouwsma 1950: 92). It is not the separation of belief and experience which is a problem for the theory; in section 1 I argued that experiencing a work as expressive of emotion is different from believing that it expresses emotion, and that the belief can be acquired in ways other than the experience. The problematic claim is that there are cases in which the belief *does* arise from the experience; but the experience only of the work, not an aroused feeling. If this is true then, contrary to the arousal theory, the feeling cannot be a necessary part of the experience of the work which causes the belief that it is expressive.

Could the content of the dry-eyed critic's belief be, as in the case of the doctor, that it would be *appropriate* if a certain feeling were aroused in the circumstances? That is, the experience of the work causes the critic to believe that it would be appropriate to react with (for instance) sadness even if, at that time, the critic has other reasons not to react in that manner. But it does not look as if the analogy with the doctor can help the arousal theory here. The doctor believes that the patient is in pain, and that pity is an appropriate reaction to pain. These two beliefs could lead him to the conclusion that pity would be the appropriate reaction in the circumstances (even if he has other reasons not to feel that emotion himself). An analogous argument is not possible in the aesthetic case because the arousal theory is premissed on the claim that there is no analogy to the first of the doctor's two beliefs in the aesthetic case. That is, the critic does not believe that the music is in pain or recognize the music as the expression of pain.

What about the doctor's belief that he is inhibiting a feeling of pity? This need not be based on what he believes about the situation; it might simply be based upon his beliefs about his current (or potential) mental state. But how would such a belief be caused? I have, throughout, been assuming a version of the functionalist account of mental states. According to functionalism, mental states are analysed, at least in part, in terms of dispositions to behaviour. It is commonly agreed that there is an asymmetry between the way in which we acquire beliefs about our mental states and the way in which we acquire beliefs about

others' mental states. We acquire beliefs about others' mental states largely by noticing their behaviour. For example, I come to believe that you believe it is raining because I see you putting up your umbrella. However, I do not need to put up an umbrella myself to believe that *I* believe it is raining. I believe I have this belief whether or not it is manifested in action. To account for this, functionalism postulates internal causal links which facilitate the reliable acquisition of beliefs about our own beliefs. That is, there is a reliable connection between the belief that *p* and the belief that one has the belief that *p*.

Let us return to the doctor. Does the doctor have any grounds, apart from those inferred from the situation, for believing he is inhibiting a feeling of pity? Such grounds would have to stem from the feeling itself. That would appear to be impossible as, by hypothesis, the doctor has no such feeling. Could the grounds not stem from an internal link, not to pity, but to doctor's disposition to feel pity? This too would appear to be impossible. Unless the disposition had identifying characteristics of pity, the internal causal link could not identify it as a disposition to feel pity (as opposed to some other emotion). However, it would only have such characteristics if pity had actually been aroused, which, we are assuming, it has not. The conclusion seems to be that only beliefs about the situation can provide grounds for a dry-eyed judgement. As expressive judgements are not made on the basis of such beliefs, the arousal theory would seem—implausibly—to make dry-eyed criticism impossible.

I do not think the arousal theorist should accept this argument. The crucial assumption, that a disposition to feel pity can only be identified as such if it actually *is* pity, should be rejected. What should be postulated, both in the case of the doctor and in the case of the dry-eyed critic, is an incipient feeling of the requisite sort. This will be an insignificant enough part of conscious experience to explain why the doctor and critic claim not to be experiencing a feeling, but possess enough of an identity to cause their belief that, were they to indulge themselves, they would experience a feeling of that sort.

This reply is counter to the thesis that first-person claims about the nature of mental states are not open to question but are logically tied to such states (Wittgenstein 1956). If this were the case the argument against the arousal theory would be irre-

futable. The functionalist account of mental states which I am presupposing construes the relation between our mental states and our beliefs about them as causal rather than logical. That is, it is possible for the critic's belief that he is not experiencing a feeling to be false. The arousal theorist needs to show that what is logically possible is psychologically actual. Can all the facts be accommodated within a plausible picture of the observer's psychology which is compatible with the arousal theory?

What is the evidence for the incipient mental state that is being postulated? Consider first the case of the doctor. It is unlikely that the patient's plight will not affect the doctor's feelings in any respect whatsoever. If, as we can suppose, he is disposed to feel pity for people who are in pain when circumstances are normal, it is unlikely that he will be able to disable this disposition altogether. To suppress a feeling seems to be doing something with it; a state which is distinct from not having a feeling at all. This suggests that the doctor experiences something which he subsequently suppresses so that it does not interfere with his proper mental and physical functioning. If this suppression is successful, he will be in a position in which he could have experienced a feeling but did not in fact do so. The natural way to report this would be with the claim that he is not experiencing the feeling.

Dry-eyed criticism may be explained in the same way. The expressive music causes an incipient feeling which is sufficient to cause the belief as to what the feeling would be were one to engage with the music at the level at which an emotion would be caused. This solution to the problem rests on two premisses: that an incipient feeling is caused and that it causes the relevant belief. I will consider each in turn.

To show that the critic has the incipient feeling, I need to show first, that there is good reason to believe in such a state; and second, that its existence is not incompatible with the critic's claim not to be experiencing the feeling. The first claim, however, does not go beyond anything claimed in Chapter 8. There, I claimed that, in common with the central cases, we do not respond to expression with the simple formation of a belief. This is true to experience, an established psychological fact and is supported by descriptions of the experience of expressive art throughout the literature. It is no part of this claim that the feeling has to be of

a strong 'consciousness-filling' form; like the central case, it varies from the incipient to the unbearable.

What does make 'dry-eyed' criticism a problem, however, is the critic's denial that he is experiencing a feeling. As with the doctor, the case is not clear-cut. The critic's claim need amount to no more than that he is not experiencing what he would feel were he to give himself over to the music, which is compatible with his being in an incipient mental state. There is no overriding reason to equate the claim 'I am not feeling sad' with the claim 'my mental state has no feeling component whatsoever'. Furthermore, the claim that the existence of an incipient feeling is compatible with a denial that one has that feeling receives support from empirical psychology. There are several ways of testing for a person's mood or feelings, from simply asking them to observing the way they perform certain tasks. The two measures do not have identical results; some subjects deny that they have the feelings which their performances show they have. A plausible explanation for this is that the mood is not prominent enough in consciousness for the subject to be comfortable in saying they are experiencing it. That does not mean they are not experiencing it; it is affecting their behaviour, and is therefore, of course, available to affect their beliefs.

The second premiss, namely, the claim that the incipient state can cause the critic to believe he is in that state, makes use of a general point in the philosophy of mind which we have encountered before. We have mechanisms which give us beliefs about our mental states. The expressive music causes in the critic an incipient feeling which tracks the music in the manner described in the previous chapter. The mechanisms which the critic uses to monitor his mental states pick up on the feeling, and cause the belief that the music expresses the corresponding emotion. There remains the suspicion that this is an epistemological 'second-best' for detecting expression in music; namely, that the incipient feeling will not be discriminating a detector of emotion in music. This is a suspicion I share and which prompts me to wonder how common dry-eyed criticism actually is.

Common or not, it is possible and its existence may be accounted for by the arousal theory. This is not the last we will hear of this problem however; in the next chapter, I will argue that not all dry-eyed criticism is explained by the existence of an

incipient mental state; there exist cases in which a critic simply recognizes a work as being of a sort that would arouse a certain reaction.

There are many different aspects of the experience of expressive works of art which may be clarified using the analogy with secondary qualities. So far in this chapter I have looked at the relation between experience and belief, the role of concepts, and the notions of the qualified observer and perceptually normal conditions. I will conclude by using the analogy to sort out the different senses of that difficult term, 'subjective'. Colours and aesthetic properties are both subjective if what is meant is that their definition makes essential reference to the mental states of an observer. But this does not entail that the application of colour terms is subjective if what is meant is that their use is idiosyncratic. The correct use of colour terms is not 'up to me' or 'simply a matter of taste'. Similarly, it would require a separate argument to show that the use of emotion terms in expressive judgements was idiosyncratic in this way; it is certainly not entailed by the application being dependent on the observer in the way I have claimed. Hence, the arousal theory does not render the truth of expressive judgements relative; or rather, only as relative as the concepts involved in their formation.[3] 'Mind dependence' may be necessary for idiosyncrasy of judgement, but it is not sufficient.

I have looked at the analogy between the experience aroused in us by a coloured object and that aroused in us by a sad work of art. But that is only half the story, even of our experience of colour. The other half deals with the causes of these experiences, and I believe the analogy to be additionally instructive in this respect. The development of this aspect of the analogy will be the task of the next chapter.

[3] Which would seem to make them relative to a culture.

Creation and Criticism

1. Although judgements attributing secondary qualities to objects are normally made on the basis of an experience of a kind which defines the quality in question, these judgements are not, as I have pointed out, about the experience. The experience causes a belief *about the object*. We believe the object in question to be (for example) red. A qualified observer is able to make a judgement of this kind solely on the basis of a suitable observation which gives the relevant experience. So, a qualified observer of colour can correctly judge a ball to be red simply by looking at it, a qualified observer of the pitch of sounds can correctly judge a piano to be emitting a middle C simply by hearing it, and a qualified observer of emotions in art can correctly judge an expressive work to be sad simply by experiencing it.

What makes these judgements about objects true in each case is that something about the object is causing the relevant experience in a qualified observer under perceptually normal conditions. So, the judgement that a ball is red is true if something about the ball was, in such circumstances, the cause of the experience which formed the basis of that judgement. In other words, the fact that some property or properties of the ball caused the suitably-placed and qualified observer to experience it as red, is what makes his subsequent belief—that it is red—true.

The following is a brief sketch of the causation which is presumably involved in the account of colour with which we have been working. It does not do full justice to the complexity of the process, but it will do for our purposes. Qualified observers of colour are those who, given normal conditions, will experience a certain colour when their eyes pick up light within a certain range of frequencies. Light of different frequencies affects their eyes in different ways and thereby causes different colour experiences. The surfaces of reflecting objects generally reflect light of

some frequencies more than others and this is what gives them their colour. For example, some objects are red because they reflect light in the range of frequencies which cause us to experience red.

In other words, if we correctly call an object red then, *ceteris paribus*, that object will possess a certain *primary* property, usually a property of its surface, which causes the corresponding colour experience in us in something like the way described above. This is what makes red and the other colours paradigm cases of *secondary* qualities. An object's colour is not part of the object in the same way as is its shape, for example. Furthermore, if we consider a variety of red things, we can see that there need not be, and in fact is not, any single primary property which corresponds to 'looking red'. Different objects can be made to look red by very different properties: the surfaces of red balls and red roses, for example, need not share the same mechanism for reflecting predominantly red light (Hardin 1988: 62). Moreover, some red objects do not *reflect* light at all. The property of a red-hot poker that makes it emit red light—a high temperature—has nothing to do with what makes it reflect red light. Again, a red sunset is rendered red not by the atmosphere's reflecting predominantly red light, but by the transmission of it—something that does not depend on surface properties at all.

What this shows is that 'red' is not co-extensive with any of the physical predicates that pick out the properties which make objects look—and therefore be—red (Mellor 1991). It does not follow from the fact that something is red that the object has any particular primary property; merely that it has some property (or combination of properties) which in perceptually normal conditions causes a qualified observer to experience it as red. Redness is therefore a special kind of dispositional property; an object is red if it has any primary property which disposes it to cause a certain kind of visual experience. Other dispositional properties, such as solubility, share the same feature. Whether or not something is soluble is determined by its molecular structure, but there is no single molecular structure which is possessed by everything soluble. Hence, if something is soluble, it does not follow that it has a particular molecular structure. All that follows is that it has some or other molecular structure which causes it to dissolve in the appropriate circumstances.

Except in exceptional circumstances, moreover, the judgement that an object is red is no more based upon our *recognizing* that the object possesses some primary property than the judgement that it is soluble is based upon our recognizing that it has some molecular structure. For one thing, if it were, we would also have to recognize the primary property as the very property which causes the experience of red in us. However, if we did that—and we satisfied the relevant normality constraints—then we would already be experiencing red. Hence, provided the conditions were normal, we would neither need nor have the opportunity to *infer* from the primary property in question that the object was red.

Furthermore, when I make a correct colour attribution I do not *mean* or *imply* that the object of my judgement possesses a specific primary property, or indeed any primary property at all. There is nothing intrinsic to the language of colour attribution which implies that colour has a causal underpinning. It is no part of the meaning of 'the ball is red' that the ball has a surface of a particular sort, that it reflects light of a certain frequency, or that the physiology of our vision works in any specific way. Similarly, I do not mean or imply that sugar has a particular molecular structure when I say that it will dissolve in my tea. I would know what I was talking about even if I had not heard of molecular structures. One can, therefore, perfectly well make and understand these dispositional assertions without knowing anything about the properties which underlie them. My judgement that an object has a certain colour is not a judgement *about* the primary property of the object which underlies my experience of that colour, any more than it is a judgement about the experience itself. It is a judgement about the colour of the object. When I see that an object is red, I simply *experience* it as red, and, unless I am engaging in scientific study, the thought of the colour's causal basis will probably not enter my mind.

Now compare this with the properties which cause emotional reactions to works of art (I will call these the work's 'basic properties'). There is an obvious and important difference between these properties and the primary properties which cause our colour experiences. Except in exceptional circumstances, the only role of the latter is that they cause these experiences: when I notice the colour of a ball, I do not notice the relevant primary

property (or properties) of the ball which caused me to notice its colour. By contrast, as I argued in Chapter 9, the basic properties of a work of art are all perceptible—and are generally perceived—by any qualified observer of the emotional qualities of the work. Many of the perceptible properties of works of art are themselves secondary qualities. For example, paintings are made up of colours which we see when we look at them and music is made up of sounds which we hear when we listen to it. Many of the basic properties which cause us to react emotionally to works of art will, therefore, themselves be secondary qualities. This need neither surprise nor trouble us: most of the basic properties of works of art are perceptible; and a good many of the perceptible properties of works of art are secondary qualities.

This difference between basic properties and primary properties does not preclude their being very similar in other important respects. One is the great variety of basic properties underlying a given emotional quality. We have already noted that an indefinitely large number of primary properties can cause our experiences of a certain colour. Analogously, no one basic property of a work of art need be shared by every work expressing a certain emotion in order to have its emotional effect. One could see this if one looked at a representative selection of the works of Mark Rothko, Yves Tanguy, Max Ernst, and Marc Chagall. Each has produced paintings which express sadness or melancholy, yet their styles are sufficiently different to ensure that the effect is achieved by different means. Rothko deals in planes of colour, Tanguy paints organic shapes in empty landscapes, Ernst violently juxtaposes images and abstraction, and Chagall paints wistful imaginative scenes which combine representations with bright patches of colour.

The point may be further reinforced by considering works from different media. Contrast the above examples with the following, also expressive of sadness: various of Jean Arp's *Constructions*, *Fête in the Park* by Watteau, and a characteristically wistful piano piece by Eric Satie. What basic property could these works possibly have in common which would explain their emotional effect? It could not be any single basic property, since works in different media give us qualitatively different experiences. It might be that the 'organic' shapes of Arp's sculptures are among the basic properties that make them expressive of sadness.

Such a property can obviously not be found in sad music, as shapes are not properties of sounds, being perceptible to touch and vision but not to hearing.

The fact that the relevant basic property (or combination of properties) *may* differ in different works with the same emotional qualities does not mean that it *must* differ; any more than different primary properties must underlie every appearance of red. One can discern relevant similarities between otherwise very different works of art, or even between works of different artists, in the way a particular emotional effect is achieved (cf. Levinson 1980). An interesting example of this may be found among the examples cited above. It is, for example, enlightening to compare the ways in which Arp and Tanguy developed the expressive potential of their abstract 'organic' shapes. This kind of analytic enquiry plays an important role in art criticism, a role we shall need to consider in later sections.

The two other points made above about the primary qualities which cause colour experiences also have analogues in the aesthetic case. Here too, for example, we do not usually recognize a certain configuration of basic properties as ones which would cause us to experience a certain emotion, and infer from this the presence of the relevant emotion in the work. The reasons are parallel to those given in the colour case: provided we satisfy the normality constraints, these basic properties will cause us to experience the emotion, whether or not we recognize them for what they are, let alone as causes of our emotional experience.[1] Furthermore, as in the colour case, when I make a true aesthetic judgement I do not *mean* that the object of my judgement possesses a specific basic property. My judgement may be made solely on the basis of my experience without my worrying, except in the most general way, about the basic properties of the work of art that are causing my experience. The fact that these basic properties, unlike primary properties, are generally both perceptible and perceived, does not entail that they must be recognized and identified as such in order to have their emotional effect. So, for example, we can judge the first adagio of Mozart's *Gran Partita* to be sad without knowing (unlike Salieri

[1] I will discuss those occasions in which we do infer that a work expresses a given emotional property from knowledge of its basic properties in a later section.

in Peter Shaffer's play *Amadeus*) that the experience of it as such is caused by the tension set up between the melody and the unnerving base. Our emotional reaction to the work may be correct without being self-conscious: it may be purely sensuous, either because we are unable to respond on a more critical level, or because we simply do not want to respond at such a level. I may simply recognize and enjoy the emotional effect the work has upon me, without wishing to find out what it is about the work which gives it such an effect.

2. What makes a work of art sad is that part of the experience it causes is an experience similar to that which we would have were we to be confronted with a sad person. It does this in virtue of its possession of some basic property (or combination of such properties). We saw in the previous section that one can make a judgement based on this experience without knowing what property of the work it was that caused the experience; it is not necessary to know which are the efficacious basic properties. However, while such knowledge is not necessary, there are good reasons why we should seek it. Knowing which basic properties cause which emotional reaction is useful both to the artist and the critic. Before we discuss why, however, let us once more compare this facet of the theory with colours. The relation between our experience of an object and its colour is not contingent, by virtue of the role our experience plays in the definition of colour. The relation between our experience and the properties of the object which cause our experience, however, *is* contingent; it could not be discovered by analysing the concepts involved. It is discovered, rather, by empirical investigation.

It is possible in the case of, for instance, red paint, to discover the primary property of the paint which causes us to experience it as red. Such knowledge has an obvious use; if you want to manufacture red paint you need to find out what primary property or properties will cause a paint to be experienced (by qualified observers in perceptually normal conditions) as—and therefore be—red. In the course of such a investigation, it will obviously be helpful if the chemists engaged in the task have the capacity to experience colour. It is not, however, strictly necessary for paint chemists themselves to be sighted, because one cannot normally see the relevant primary properties with the

unaided eye and that sense need not be the one used to detect their presence or absence. A chemist may indeed be able to calculate, purely from what is known about the primary properties of chemical substances, which substance or mixture of substances would best reflect light of certain frequencies—and in particular, therefore, light of the frequencies which are known to cause normally-sighted people to see red. There is no special problem about doing this calculation even when one is blind. So even though colours are secondary qualities defined by our experience, substances can be made (and known) to have them in advance by being made (and known) to have the relevant primary properties.

The analogous relation between a given basic property (or combination of properties) of a work of art and its consequent emotional qualities is of course also contingent. It cannot be discovered simply by analysing our emotional or aesthetic concepts. The discovery of the basic properties of a work of art is, rather, a matter of discovering empirically what it is about them which arouses emotions in people. Whether or not such an undertaking could result in a body of knowledge that was even relatively systematic is a controversial question. Mary Mothersill has argued that not only would such an enquiry be fruitless, but even to think it possible is to make a grave theoretical error (Mothersill 1984: chs. 3–5). It is important to show that Mothersill is wrong about this, not only because she contradicts a consequence of my position, but because she appears to undermine the possibility of interesting critical generalizations, including the comparison of the work of Arp and Tanguy given above.

Let us schematize a critical judgement on the expressive properties of a work of art as 'the work expresses e because of x' where e is some feeling or emotion and x is some basic property or combination of basic properties. If this judgement is true, if x really is the cause of the work expressing e, then anything which has x should express e. This plausible piece of reasoning has—according to Mothersill—led almost everyone, whether they admit it or not, to believe in 'principles of taste'. A principle of taste is defined by Mothersill as: 'a generalization that, if valid, would provide deductive support for a verdict' (Mothersill 1984: 87). I am not concerned (except indirectly) to defend principles of taste against Mothersill's subsequent attacks, but rather to

examine the way Mothersill attempts to undermine them. For she claims that what gives credence to principles of taste is the belief in laws of taste and these, she argues, do not exist. A law of taste, she says, 'would tell us what features of items in a specified class will be *pro tanto* a cause of pleasure to subjects suitably qualified and under standard conditions' (Mothersill 1984: 92). Although Mothersill frames her definitions exclusively in terms of pleasure, there is no reason to think that she would not also apply them to the kind of feelings with which I am concerned. Whether she would or not, however, is irrelevant; her position (or a position derived from hers) is a well-entrenched view which is incompatible with the theory I have put forward, which, or course, claims that there *are* laws linking basic properties with aesthetic experience which could be the subject of empirical investigation.

The first thing to notice is the strength of the claim Mothersill is advancing: namely, that the aesthetic realm is outside natural law. The argument she provides, however, does not support this claim. Instead of arguing directly that there are no laws of taste, she argues for the much weaker thesis that nobody *believes* there are laws of taste; and she does this by arguing for the even weaker thesis that nobody can *state* a law of taste for the purpose of making true predictions about future actualizations of the antecedent (Mothersill 1984: 100): 'The test for my general hypothesis is as follows: try to come up with a lawlike generalization about your own preferences and ask yourself (a) whether it is interesting, and (b) if it is, whether you actually believe it' (Mothersill 1984: 105). Applied to the problem of expressive judgements, Mothersill's challenge is to state some law connecting some specified basic property with specified expressive property that is both interesting and true. To be interesting, the law must at least be falsifiable. We need not speculate as to whether or not we can state such a law for, as Eddy Zemach has pointed out, the challenge is irrelevant (Zemach 1987). I cannot come up with a law concerning the way in which the piece of paper I drop will travel to the floor that is both interesting and true; I simply do not know the relevant physics. However, this shows neither that I do not believe the laws of physics nor that the laws of physics do not exist.

Even if Mothersill's argument is hopeless, the spirit of her

challenge must be taken seriously. If, as I claim, there are laws linking the basic properties of a work of art with the mental states of an observer, what can be said about them? Are they sufficiently complex to be always beyond our grasp? Let us compare their case with that of colour. Few of us can state the laws linking primary properties with visual experience. *Pace* Mothersill, this does not lead us to believe there are no such laws; which is just as well, because of course there are. There is, however, a disanalogy here between the colour and aesthetic cases which I think explains Mothersill's confusion.

Recall that there is no single primary property which causes sensations of red. Rather, there is a set containing at least four laws each with the same consequent—the production of a visual sensation of an object as red—but different antecedents, involving four properties of light and of reflecting, transmitting, and emitting objects respectively (cf. Mellor 1991: 180). This is the root of the disanalogy. For, given the set of laws connecting primary properties and the visual sensation of red, one can say, of any primary property, whether or not it will be experienced (by qualified observers in perceptually normal conditions) as red. The intuitions Mothersill musters are directed against the view that the same is possible in the aesthetic case. That is, she thinks that there is no set of laws from which, given a certain basic property, we could predict the effect it would have on a qualified observer. Mothersill is right to the extent that there is a disanalogy, but wrong in the conclusion she draws from it. It is not that there is no set of laws governing expressive properties, but rather that it is seldom a single basic property which arouses a feeling. As we saw in Chapter 9, it is primarily the relations in which basic properties stand to each other that is significant. This means that the relevant aesthetic laws do not connect single basic properties with expressive properties, but rather *groups* of such properties with expressive properties.

On the assumption that each non-identical group of basic properties instantiates a different set of relations, each will fall under a different set of laws. The reason that we cannot formulate the laws underlying expression is not because they do not exist, but rather because there are too many of them. It is rather as if the universe kept providing new types of primary property which caused sensations of colour. This would not mean that

there were no laws linking primary properties with colour experiences, but that the number of such laws was large and growing all the time.

I have assumed that each non-identical group of basic properties instantiates a different set of relations, and thus that each will fall under a different set of laws. To put this in a less abstract way, the laws underlying expression will be different for every work of art which contains a non-identical group of basic properties. As it is unlikely that there are different works of art with the same basic properties,[2] it follows that every distinct work of art instantiates different laws of expression. If this were so, it would undermine the possibility of generalizations concerning basic properties which appear in different groups, for the individual contributions made in each group would appear not to be assessable. This is, in fact, the truth in Mothersill's conclusion (Mothersill 1984: ch. 11).

3. However, it is a very strong assumption that the contribution made by individual basic properties to the works in which they appear is not systematic. There are a number of considerations which cast doubt upon it. The most important of these considerations is empirical: several more or less successful attempts have been made to trace the contribution a particular basic property makes to various works of art. It is a further merit of the arousal theory that it makes a place for such enquiries. In the past—partly because nobody knows quite what to do with these findings—they have been dismissed as irrelevant. A notorious attempt at systematization is that of Ernst Gombrich (Gombrich 1951, 1962, 1977: ch. 11), who cites the psychologist C. E. Osgood's attempts to map the links which people draw between secondary qualities and feelings (Gombrich 1951: 58). Other notable attempts at finding correlations include Kandinsky's *Concerning the Spiritual in Art* (Kandinsky 1977) and Deryck Cooke's *The Language of Music* (Cooke 1960). Kandinsky's book is concerned mainly with the psychological effects of colour, to which the author attributes an almost mystical significance. In *The Language of Music* Cooke argues that all

[2] Impossible if contextual basic properties are taken into account; cf. Currie 1990*a*.

composers of tonal music have used the same, or closely similar, melodic phrases, harmonies, and rhythms to affect the listener in the same ways. In an impressive display of scholarship he provides hundreds of examples of correlations between emotions and certain musical patterns to support his case. The result is the essentials of a musical lexicon, which, as Cooke would describe it, specifies the emotive meaning of the basic terms of the musical vocabulary.

The task of providing a 'dictionary' linking basic properties with emotions will only be partially successful. This is because— as I have argued—the emotional effect of any one basic property is liable to be altered when it is experienced as part of a group. However, even partial success suggests that there is something systematic in what a basic property will contribute to the groups in which it figures. Is there anything which may be said on a general level about this? Gombrich has argued that the effect of specific colours can be known with greater precision when we take certain other facts into account. The full account of emotional expression not only includes the fact that certain properties of a work affect us as they do (what Gombrich calls 'natural sympathy'), but also a great deal of background knowledge about what Gombrich calls 'the language' of these properties.

Gombrich claims that a property will only be affective if it is seen against a structure in which it is contrasted with possible alternatives. The point is best explained by example:

> Granted that colours, shapes or harmonies can be experienced as expressive, the artist can only use these qualities with some confidence within a limited choice situation. The critics who worry how a chord can possibly be described as 'sad' are justified in one respect: it is not the chord, but the choice of the chord within one organized medium to which we so respond. The artist who wants to express or convey an emotion does not simply find its God-given natural equivalent in terms of tones or shapes. Rather, he proceeds as he proceeds in the portrayal of reality—he will select from his palette the pigment from among those available that to his mind is most like the emotion he wishes to represent. The more we know of his palette, the more likely we are to appreciate his choice. (Gombrich 1951: 62–3)

The effect of a basic property will often depend not simply on the presence or absence of other relevant basic properties but also upon what we know—whether or not we are consciously aware

of this knowledge at the time—about the potentialities of the medium.

Tracing further dependencies adequately would take us much too far afield, so I will restrict myself to one much-remarked-upon way that a basic property can make an effect. As we have seen in earlier chapters, one prominent and obvious way in which a work arouses our emotions is by depicting or describing something which would, in the normal course of life, arouse our emotions. We react to works which describe a sad situation in much the same way as we would react to the situation itself. We also saw that it is not only what a work represents that affects us, but how it represents it. In other words, the emotional effect is a combination of the content of the work and of the way that content is presented. It is obviously and significantly (though, again, of course, contingently) true that in such cases the emotional effect of a set of basic properties can change dramatically according to what they are used to represent.

It is easy to imagine, for example, that a spot of red paint would cause one reaction were it used to represent a ruby, and quite another if it were used to represent a drop of blood. Another example of this is words which are set to music. The words may describe a sad situation and this, when combined with the effect of the music, makes the work sad.[3] The same music, however, can have very different emotional effects when put to different words. As is well known, several choruses in Handel's *Messiah* (including 'For unto us' and 'Hallelujah') were remodelled secular works. In the *Messiah*, however, they seem to express emotions which match the content of the words. The representational content of the work—the story of Christ—is reinforced by the emotional effect of the music. More contemporary examples include Elgar's *Pomp and Circumstance March No. 1* ('Land of Hope and Glory'), in which the emotional effect of the words has completely appropriated the emotional effect of the music, and a theme from the 'Jupiter' suite of Holst's *Planets*, which was also the setting for a hymn.[4]

[3] I am not forgetting my earlier point that the judgement we make on the work does not necessarily match the judgement we would make on the content. Jolly music might undermine the effect of the sad tale.

[4] In both cases the composer expressed disapproval at the appropriation of the music; a testimony, perhaps, to the power the words have in influencing our aesthetic experience.

I have discussed two ways in which basic properties might interact with each other. These do not, of course, exhaust the field; the ways in which basic properties combine into complexes are too varied to group under easily comprehended headings. The efficacy of a basic property may be undermined by another basic property, or may, together with another, be changed altogether. The most we can claim is that basic properties have a *tendency* to cause certain emotional effects.

4. So far I have concentrated on the role of the spectator, rather than on those of the artist and the critic. By persevering with the analogy with colour, I will show how the arousal theory can also provide a natural account of both the creation and the criticism of expressive works of art. In this section I will consider the artist, while the critic will be the subject of the remaining sections of the chapter. The artist presents a prima facie problem for the arousal theory which we are now in a position to solve. The problem is that if the basic properties which make a work of art express an emotion can only be defined by the fact that they cause certain emotional experiences, how can anybody know what those properties are in advance of their causing those experiences? In other words, how would it be possible for an artist to know in advance what properties to put into a picture in order to make it express a certain emotion, if knowing that it did so depended on its being experienced?

The analogy with secondary qualities shows why this is not a problem in principle for the arousal theory, merely a problem in practice for the artist. For we saw, when considering colour, how it is possible for someone to know that a primary property causes (or primary properties cause) a particular secondary quality, and then to use that knowledge to produce something with that quality. That is, a colour chemist is someone who knows how to produce an object which will cause a particular colour experience by reflecting, emitting, or transmitting light of the right frequency; and there is nothing mysterious about the inductive processes by which paint manufacturers and others come by such knowledge. A colour chemist is, in this respect, analogous to someone who is able to create an emotionally expressive work of art. Part of being a skilled artist is knowing how to manipulate the medium in which you are working so as to cause the right kind of emo-

tional experiences in a qualified observer in perceptually normal conditions. This is not, of course, to deny that this process will differ significantly from the much simpler process of producing red paint. In particular, artists may not need to be self-consciously aware of what they are doing in creating a certain work: it is no part of my claim that the artist's knowledge must be propositional—'knowledge that' as opposed to 'knowledge how'. There is a great deal more to be said about artistic creativity and the value of emotionally expressive works of art. However, the problems that such things present are not problems for the arousal theory; the fact that the expression of emotion in art is defined via the emotional experiences of qualified observers does not make the process of creating works of art any more mysterious than it is on any other account.

There is, however, a related objection to the position I have been putting forward which I do need to consider: namely, that it seems to make the production of emotionally expressive art formulaic. If all that is needed to make a joyful or a sad work is the inclusion of some basic properties known to be correlated with these emotions, what is to prevent someone simply reading Gombrich and Kandinsky and producing such works at will? Furthermore, to continue the analogy with the chemist, it would seem that such a person would not even need to be able to experience the emotions expressed in the resultant work himself. It would be possible for someone to be in a position analogous to that of the blind chemist, possessing the ability to produce emotionally-charged works that he cannot himself experience.

In reply it seems to me that it would indeed be possible for someone to do just this. However, while it is a consequence of the position I have put forward, it is not a refutation of it. To see this, let us look at some examples of works in which our emotional reaction occurs as a result of the work's representational properties. It is not difficult to find the sorts of properties which will be linked with a given emotional reaction and so set up correlations between them. Because we are reacting in this case to the content of the work, we are reacting to facts about it which we know to be appropriate causes of the emotion involved. Hence, the properties of the work to which we are reacting are those which represent causes of that emotion in the central cases: we

react with sadness to death, disappointment, and so on. Someone 'blind' to the emotional effect of art could still exploit this knowledge of our emotional reactions to sad people and sad situations in order to anticipate the effects of representations of such people and situations. It takes no special aesthetic insight to predict that a painting of a young urchin holding a broken doll and rubbing her tear-filled eyes will pass as a sad painting, and there is no problem in explaining how a painter may be aware in advance that a reasonably good representation of such a scene will inherit its emotional quality.

Even in cases in which we are reacting to the non-representational basic properties of objects, there are many examples of the employment of formulae in the arousal of feeling. For example, colour schemes in houses and hotels are designed to affect the feelings and emotions of the people who experience them: their designers rely on well-known correlations between certain combinations of colours and widespread emotional reactions to them. Evelyn Waugh's description of a hotel room in his novel *Scoop* is a just parody of a real phenomenon: 'The room was large and faultless. A psychologist, hired from Cambridge, had planned the decorations—magenta and gamboge; colours which—it had been demonstrated by experiments on poultry and mice—conduce to a mood of dignified gaiety.' Incidental music from films provides more examples. A repeated note in a certain pitch, for instance, will contribute to a rising level of anxiety. It is even possible to buy records which contain music and sounds designed to give the amateur film-maker just such devices for arousing the right emotional responses in an audience.

Such examples are in the main too trite to count as works of art; which is, surely, what we would expect. We saw in the previous section that it is groups of, rather than particular, basic properties which arouse feelings with the result that correlations between particular basic properties and particular emotional reactions are bound to remain sparse and general. Works produced according to explicit formulae are consequently bound to be uninteresting because their 'creator' will not be able to risk mixing too many basic properties for fear of undermining their individual efficacy. The only practical way to check the total effect of combining many basic properties is by experiencing— or imagining experiencing—the combination. In short, only

someone who is both a creator and a spectator will be able to anticipate the effects of all the basic properties involved in any interestingly complex or original work of art.[5] Only very simple and dull works can in practice be produced by adherence to formulae. This conclusion does not entail the falsity of the arousal theory; it shows, rather, that there is no serious aesthetic analogue of the blind colour-chemist.

5. The arousal theory not only finds a natural place for the artist but also for the critic. An artist knows what to do to create a work which expresses a certain emotion, and a critic knows how it has been done. Part of the task of criticism, at least with respect to a work's emotional properties, is to reveal the way in which such effects have been achieved. In other words, according to the arousal theory, the critic must be able to pick out the basic property or properties that are causing the relevant emotional experiences in the audience.

But do critics in fact investigate the basic properties of a work that cause the experiences upon which, in turn, their expressive judgements are based? Indeed they do; as we can see by borrowing from the detailed description of art criticism given in Sibley's 'Aesthetic Concepts':

We may simply mention or point out non-aesthetic features: 'Notice these flecks of colour, that dark mass there, those lines.' By merely drawing attention to those easily discernible features which make the painting luminous or warm or dynamic, we often succeed in bringing someone to see these aesthetic qualities. We get him to see B by mentioning something different, A . . . In mentioning features which may be discerned by anyone with normal eyes, ears, and intelligence, we are singling out what may serve as a kind of key to grasping or seeing something else (and the key may not be the same for each person). (Sibley 1959: 832)

The arousal theory can easily provide a rationale for what the critic is doing here (something Sibley himself is notoriously unable to do). The critic is drawing the attention of his audience to the properties that provoke the relevant emotional reaction in a qualified observer of the work in question. Indeed what else could the critic be doing in such cases? There is surely nothing

[5] It is interesting to compare this with similar points made in Wollheim 1964.

else for him to indicate except the relevant basic properties of the work: that is, those properties that provoke our reaction to it.

Sibley lists a number of other methods to which a critic has recourse, including drawing the observer's attention to certain non-aesthetic properties they might not otherwise believe are salient; linking aesthetic and non-aesthetic remarks; using similes and metaphors; drawing contrasts and comparisons with other works of art and finally, by using bodily movements (one can easily imagine attempting to persuade a novice of the emotional import of the Rachmaninov's Piano Concerto No. 2 by waving one's arms around in sympathy with the gushing tunes and arpeggios). Each of these techniques fits plausibly into the causal picture. The critic is attempting to ensure that the appropriate mental state is aroused by focusing the spectator's attention on the appropriate cause.

Sibley is interested specifically in the visual arts although, as we have seen, examples of the same critical technique can be found in other media. Music critics repeatedly point out the basic properties of pieces of music and link them to their emotional and other aesthetic effects. This technique can be found in virtually every programme note:

The main theme is a gloomy march melody, played first by the strings, *pianissimo*, and then by the woodwind. After the appearance of a con-ciliatory counter-melody, the plaintive main theme recurs. Then there is a new, luminous idea in a light C major that seems like a vision, an apotheosis of the hero. Rising out of the most delicate colours, this vision is elevated to the heights of victory. But torn and painful rhythms of mourning are muttering again, and the development continues with an energetic fugato. This too is interrupted by the lament of the main theme. A wonderfully delicate melody in the violins seems temporarily to mitigate the general gloom, but it fails to penetrate. The straining rhythms of the opening reappear, and the movement ends as they die away, melancholy and lamenting. (von Westerman 1968: 135)

In this example—a description of the second movement of the *Eroica*—the author clearly describes the interaction of some basic properties of the music: the main theme, a subsidiary theme, melody, and rhythm. These are given a station in the over-all development of the piece, and associated—in some cases quite explicitly—with feelings and emotions. What these two examples demonstrate is that critics look for basic properties in order to

justify their judgements. This particular function of the critic is compatible with a number of different theories of expression; indeed, I would hope it would not rule any of them out. I am not attempting to claim that compatibility with critical practice is a *proof* of the arousal theory, but rather to show that it is what we would expect were the arousal theory true.

In the last chapter I discussed a problem for the arousal theory not provided by criticism as such, but by a particular sort of criticism: namely, dry-eyed criticism, in which expressive judgements are made by someone who has not had a feeling aroused by the work of art in question. I argued that the dry-eyed critic could have an incipient mental state which causes him to believe that he would have experienced a certain feeling had he indulged his appreciation of the work more fully. Following that discussion, I claimed that the explanation does not cover all instances of dry-eyed criticism. There are occasions when a dry-eyed expressive judgement is made and on which an incipient mental state is not felt. Such a judgement is easily explained using the analogy between primary and basic properties. As we have seen, a chemist studying an object to discover which primary property causes us to see it as red need not himself see it as red. He simply needs to know that a qualified observer—himself or someone else—would see it as red, and be able to tell which of its primary properties is causally responsible for this fact. Analogously, the fact that we need not undergo the appropriate reaction when we perceive an expressive work of art does not refute the arousal theory. The possibility remains that we are able to predict the expressive properties of a work from knowledge of its basic properties and their relations. If we know which feelings basic properties have a tendency to cause and are aware that a work has a plethora of such properties, we can hypothesize as to the expressive properties which the work will exhibit. Familiarity with a particular idiom is likely to breed the capacity to predict the effect of the basic properties of works in that idiom. Once more, I am not suggesting that this is necessarily a matter of conscious inference; it is more likely to be a capacity to recognize a work's potentialities without inference.

6. According to the arousal theory, at least part of what a critic does is trace the causes of the emotional experiences aroused by

works of art. The critic therefore needs, first, to possess the ability to undergo such experiences, and secondly, to be able to pinpoint their causes. So the arousal theory gives a clear sense and rationale for an old idea: first, that a critic must be open to aesthetic experience, and secondly, that he should be able to explain this experience. The critic's position is a privileged one because he has abilities which go beyond those of a normally qualified observer who must indeed be capable of having the appropriate emotional responses to works of art, but need not match the ability of the critic when it comes to responding appropriately to a wide range of works or to explaining his responses.

What sort of extra abilities does a good critic require? To answer this question it is best once more to return to Hume's 'Of the Standard of Taste', where he asks himself the same question: 'where are such critics to be found? By what marks are they to be known? How distinguish them from pretenders?' (Hume 1757: 147–8). The 'rare character' qualified to judge art has, according to Hume, the following 'marks': 'Strong sense, united to delicate sentiment, improved by practice, perfected by comparison and cleared of all prejudice' (Hume 1757: 147). The first two of these 'marks' are concerned, in the main, with the critic's superior sensibility, while the remaining three relate to his ability to reveal the cause of his experience. If we adopt Hume's word, 'marks', it will remind us that we are not looking for necessary and sufficient conditions, but simply at the kind of abilities a person must possess to an unusual degree in order to perform the kind of criticism which we are discussing.

Let us take each of Hume's suggestions in turn. It is unclear why 'strong sense' should be counted a virtue, since nowadays the natural meaning of the phrase is a sense that does not waver, one that is both forthright and consistent. However, if one's sense is awry, it is surely worse to be forthrightly and consistently wrong than to waver a little. In Hume's time, however, 'strong' also meant 'eminently able' (a sense which survives in 'one's strong point'), and this is an obvious virtue. In particular, it is obviously a virtue in a critic to be eminently able to perceive whatever an artist is using to produce his emotional effects. There is, as we have seen, no reason why artists should confine themselves to basic properties which are easy for qualified observers to identify. The emotional qualities of a work of art

often depend upon very subtle basic properties: in painting, subtle changes in shade; in music, subtle changes in tone; in poetry, subtle changes in rhythm, and so on. Having a 'strong sense'—in other words, having an unusual ability to detect subtle features of one's sensory experience and identify their emotional effects—will, therefore, certainly be of advantage to the critic.

To have 'delicate sentiment' was to be sensitive to emotional changes and able to discriminate finely between them. This too is a virtue in a critic; and not only in a critic. Like the ability to make fine discriminations among secondary qualities, a delicate sentiment is also useful in other ways. It is difficult to conceal one's emotions from people with a delicate sentiment: they are too sensitive to all the slight behavioural nuances which give the game away, whereas people without any delicacy of sentiment seem blind to any communication short of direct speech. Similarly, to identify the emotion expressed by a work of art, one must be *sensitive* to it. This emotional sense has to be delicate because not all artists are expressionists; it is not easy to tell which emotions, if any, some works of art are expressing. Few could miss the expression of emotion in van Gogh's *L'Église d'Auvers-sur-Oise* (1890, Musée d'Orsay), but it would take someone with a very delicate sentiment indeed to make a comparative study of the emotions expressed in the paintings of interiors produced by Vermeer and Chardin. And the same is true of literature; some of the 'impressionistic' writing of Virginia Woolf seems to rely for its effect on our being able to discriminate between more varieties of sadness than are immediately apparent except to readers of exceptionally delicate sentiment.

This thought—that it is part of the skill of being a critic that one is able to make fine discriminations—has of course been remarked upon by philosophers since Hume. For example, Frank Sibley, in 'Objectivity in Aesthetics', writes:

There is the sophistication that consists in making finer distinctions and employing a precise vocabulary. Where the many lump certain things together under a common and generic term ('lovely' or 'pretty'), the few may agree in differentiating them more specifically as, say, beautiful, dainty, elegant, graceful or charming . . . (Sibley 1968: 46)

It is a virtue of the arousal theory that it provides such a good explanation of why a critic needs the skills which are tradi-

tionally ascribed to him. In order to have the best chance of producing the appropriate emotional reaction to a work of art, a critic must indeed be able to make fine discriminations among the relevant perceptible properties of the work and be sensitive to its emotional nuances. And having had the appropriate reaction, the critic should then be in a position to identify the basic properties which caused it.

Of course, it is possible that such an identification could go awry. As was made clear in Chapter 9, what is claimed by the observer does not determine the correct answer here. However, as is also clear from that chapter, the possibility of misidentification is very small, because the emotional reaction is caused by attention to properties within a critic's consciousness. Pinpointing *exactly which* property it is that is significant is not always a simple matter; the observer has to test them in his own experience. In principle, however, this criticism is no different from all other investigations into the causes of things. A critic, like a paint chemist, may be a reliable judge of which basic properties are affecting him without his being a demonstrably infallible one. In short, the critic uses methods similar to those used in any other investigation into the causes of things; principally, comparison of the work of art under scrutiny with other works of art which are similar in some relevant respect. The method is summed up neatly in Hume's claim that critical acumen is 'improved by practice, perfected by comparison'.

In both this and the previous chapter I have employed the analogy with colour to show that issues believed to be problems for expressive judgements would also be problems in a more familiar area of enquiry. I do not claim to have provided a complete account of aesthetic enjoyment, creativity, and criticism, but rather to have shown that the price of the arousal theory is not to render these dark and mysterious. On the contrary, the theory provides natural explanations for a range of phenomena; something which should increase rather than lessen our confidence in it. There the case for the theory rests. Any writer in this area would have to be profoundly insensitive to the history of thought to believe their work to be the last word on the subject. I hope, however, that this book may provoke a discriminating reassessment of the arousal theory.

12

Afterword

The problem of expression has seemed more difficult than in fact it is because philosophers have construed it in terms of intentional objects and necessary connections, when really the explanation is causal and there are only contingent connections. The problem has been to show that we can get all we want from our theory from within the causal picture. This I have attempted to do. However, the obstacles that need to be overcome are not solely philosophical ones. When we listen to music, walk around an art gallery, or read about the thoughts and experiences of composers and artists, it is difficult to believe that expression can be explained in a relatively clear way using familiar philosophical concepts. The experience of expression seems almost to require a complicated and mysterious analysis.

This train of thought, although tempting, rests on a fallacy: namely, that the explanation of a phenomenon must match that phenomenon in *gravitas*, importance, and so on. The same mistake is made by some writers on ethics: anti-realist accounts of ethical judgement are castigated for not paying sufficient attention to the realist nature of our moral discourse and the importance it has in our lives. How, it is asked, can a philosopher claim that truth and falsity are inappropriate for ethical judgements when it is just those judgements that are so important to us? How can ethics be a matter not of fact, but of approval or disapproval?

Whatever the virtues of the anti-realist's view, the reply he is able to give will also serve our purpose here. Regardless of the importance ethical or aesthetic judgements have in our lives, they raise problems which it is proper for philosophy to look at. To provide an explanation of how those judgements fit into the picture we have of the world, to explain how they come to be made from within our view of the mind, is a worthwhile endeavour. It

is a virtue rather than a vice that such an explanation is clear, leaves no mysteries, and makes no use of concepts invented for convenience.

BIBLIOGRAPHY

ARISTOTLE. *Rhetoric*, transl. W. R. Roberts, in *The Basic Works of Aristotle*, ed. R. McKeon, pp. 1317–1451. New York: Random House, 1941.

ARMSTRONG, D. M. (1968). *A Materialist Theory of the Mind*. London: Routledge & Kegan Paul.

ATKINSON, R. F. (1978). *Knowledge and Explanation in History*. London: Macmillan.

BARWELL, I. (1986). 'How Does Art Express Emotions?' *Journal of Aesthetics and Art Criticism* 45: 175–81.

BEARDSLEY, M. (1958). *Aesthetics*. Indianapolis, Ind.: Hackett.

—— (1970). 'The Aesthetic Point of View', repr. in *The Aesthetic Point of View*, 1982, pp. 15–34. Ithaca, NY: Cornell University Press.

—— (1982). 'The Aesthetic Experience', repr. in *The Aesthetic Point of View*, 1982, pp. 285–98. Ithaca, NY: Cornell University Press.

BEDFORD, E. (1956). 'Emotions', repr. in D. F. Gustafson, ed., *Essays in Philosophical Psychology*, 1967, pp. 77–98. London: Macmillan.

BLACKBURN, S. (1984). *Spreading the Word*. Oxford: Clarendon Press.

BOOTH, W. C. (1991). *The Rhetoric of Fiction*. London: Penguin.

BORUAH, B. (1988). *Emotion and Fiction*. Oxford: Clarendon Press.

BOUWSMA, O. K. (1950). 'The Expression Theory of Art', repr. in W. Elton, ed., *Aesthetics and Language*, 1954, pp. 73–99.Oxford: Blackwell.

BUDD, M. (1985*a*). *Music and the Emotions*. London: Routledge & Kegan Paul.

—— (1985*b*). 'Understanding Music', *Proceedings of the Aristotelian Society* supp. vol. 59: 233–48.

—— (1989). 'Music and the Communication of Emotion', *Journal of Aesthetics and Art Criticism* 47: 129–37.

—— (1991). Review of Peter Kivy, *Sound Sentiment*, *British Journal of Aesthetics* 31: 191–2.

CALHOUN, C. (1984). 'Cognitive Emotions?', in C. Calhoun and R. Solomon, eds., *What is an Emotion?* New York: Oxford University Press, 327–42.

CARROLL, N. (1990). *The Philosophy of Horror*. London: Routledge.

COLLINGWOOD, R. G. (1936). 'Human Nature and Human History', *Proceedings of the British Academy* 22: 97–127.

—— (1938). *The Principles of Art*. Oxford: Clarendon Press.

CONTER, D. (1991). 'Fictional Names and Narrating Characters', *Australasian Journal of Philosophy* 69: 319–28.

COOKE, D. (1960). *The Language of Music*. Oxford: Oxford University Press.

COOPER, D. E. (1986). *Metaphor*. Oxford: Blackwell.

CURRIE, G. (1990a). 'Supervenience, Essentialism and Aesthetic Properties', *Philosophical Studies* 58: 243–57.

—— (1990b). *The Nature of Fiction*. Cambridge: Cambridge University Press.

—— (1991). 'Visual Fictions', *Philosophical Quarterly*, 41: 129–43.

DAMMAN, R. (1992). 'Emotion and Fiction', *British Journal of Aesthetics* 32: 13–20.

DAVIES, S. (1980). 'The Expression of Emotion in Music', *Mind* 89: 67–86.

—— (1990). 'Violins or Viols?—A Reason to Fret', *Journal of Aesthetics and Art Criticism* 48: 147–51.

—— (1994). *Musical Meaning and Expression*. Ithaca, NY: Cornell University Press.

DE SOUSA, R. (1979). 'The Rationality of the Emotions', repr. in A. O. Rorty, ed., *Explaining the Emotions*, 1980, pp. 127–52. Berkeley and Los Angeles: University of California Press.

—— (1987). *The Rationality of Emotion*. Cambridge, Mass.: MIT Press.

ELLIOTT, R. (1967). 'Aesthetic Theory and the Experience of Art',repr. in H. Osborne, ed., *Aesthetics*, 1972, pp. 145–57. Oxford: Oxford University Press.

FORSTER, E. M. (1974). *Aspects of the Novel*. Cambridge: Cambridge University Press.

GEAR, J. (1990). *Perception and the Evolution of Style*. London: Routledge.

GOMBRICH, E. H. (1951). 'Meditations on a Hobby-horse', repr. in *Meditations on a Hobby-Horse*, 1985, pp. 1–11. Oxford: Phaidon.

—— (1962). 'Expression and Communication', repr. in *Meditations on a Hobby-Horse*, 1985, pp. 56–69. Oxford: Phaidon.

—— (1977). *Art and Illusion*. Oxford: Phaidon.

—— (1978). *The Story of Art*, 13th edn. Oxford: Phaidon.

GOODMAN, N. (1972). *Problems and Prospects*. New York: Bobbs-Merrill.

—— (1976). *Languages of Art*, 2nd edn. New York: Bobbs-Merrill.

GORDON, R. M. (1990). *The Structure of Emotions*. Cambridge: Cambridge University Press.

GREENSPAN, P. (1988). *Emotion and Reason*. London: Routledge.

GRICE, H. P. (1957). 'Meaning', repr. in P. Strawson, ed., *Philosophical Logic*, 1967, pp. 39–48. Oxford: Oxford University Press.

HARDIN, C. L. (1988). *Color for Philosophers*. Indianapolis, Ind.: Hackett.

HEAL, J. (1988). 'The Disinterested Search for Truth', *Proceedings of the Aristotelian Society* 88: 97–108.

HOPKINS, A. (1977). *Talking About Music*. London: Pan.

HOSPERS, J. (1954). 'The Concept of Expression', *Proceedings of the Aristotelian Society* 55: 313–44.

HUME, D. (1757). 'Of the Standard of Taste', repr. in *Selected Essays*, 1993, pp. 133-54. Oxford: Oxford University Press.

KANDINSKY, W. (1977). *Concerning the Spiritual in Art*. New York: Dover.

KARL, G. and ROBINSON, J. (1995). 'Levinson on Hope in *The Hebrides*', *Journal of Aesthetics and Art Criticism* 53: 195–9.

KIVY, P. (1981). 'Secondary Senses and Aesthetic Concepts: a Reply to Professor Tilghman', *Philosophical Investigations* 4: 35–8.

—— (1989). *Sound Sentiment: An Essay on Musical Emotions Including the Complete Text of* The Corded Shell. Philadelphia, Pa.: Temple University Press.

—— (1991). *Music Alone: Philosophical Reflections on the Purely Musical Experience*. Ithaca, NY: Cornell University Press.

KRIPKE, S. (1980). *Naming and Necessity*. Oxford: Basil Blackwell.

LAMARQUE, P. (1981). 'How can we Fear and Pity Fictions?', *British Journal of Aesthetics* 21: 291–304.

LEIGHTON, S. (1984). 'Feelings and Emotions', *Review of Metaphysics* 38: 395–403.

LEVINSON, J. (1980). 'Aesthetic Supervenience', repr. in *Music, Art and Metaphysics*, 1990, pp. 107–33. Ithaca: Cornell University Press.

—— (1981*a*). Review of Peter Kivy, *The Corded Shell*, *Canadian Philosophical Reviews*, 1: 148–52.

—— (1981*b*). 'Truth in Music', repr. in *Music, Art and Metaphysics*, 1990, 279-305. Ithaca, NY: Cornell University Press.

—— (1982). 'Music and Negative Emotion', repr. in *Music, Art and Metaphysics*, 1990, pp. 306–35. Ithaca, NY: Cornell University Press.

—— (1990). 'Hope in *The Hebrides*', repr. in *Music, Art and Metaphysics*, 1990, pp. 336–75. Ithaca, NY: Cornell University Press.

—— (1993*a*). 'Making Believe', repr. in *The Pleasures of Aesthetics*, 1996, pp. 287–305. Ithaca, NY: Cornell University Press.

—— (1993*b*). 'Seeing, Imaginarily, at the Movies', *Philosophical Quarterly* 43: 70–8.

—— (1995). 'Still Hopeful: Reply to Karl and Robinson', *Journal of Aesthetics and Art Criticism* 53: 199–201.

—— (1996). 'Musical Expressiveness', in *The Pleasures of Aesthetics*, 1996, pp. 90–125. Ithaca, NY: Cornell University Press.

230 *Bibliography*

LEWIS, D. (1978). 'Truth in Fiction', repr. in *Philosophical Papers* vol. 1, 1983. New York: Oxford University Press.

LOCKE, J. (1689). *An Essay Concerning Human Understanding*, ed. P. H. Nidditch, 1975. Oxford: Oxford University Press.

LOWE, E. J. (1992). 'Experience and its Objects', in T. Crane, ed., *The Contents of Experience*, pp. 79–104. Cambridge: Cambridge University Press.

LYONS, W. (1980). *The Emotions.* Cambridge: Cambridge University Press.

MACONIE, R. (1990). *The Concept of Music.* Oxford: Oxford University Press.

MARGOLIS, J. (1989). Foreword to Kivy 1989.

MATRAVERS, D. (1991*a*). Review of Noël Carroll, *The Philosophy of Horror*, *British Journal of Aesthetics* 31: 174–6.

—— (1991*b*). 'Who's Afraid of Virginia Woolf?', *Ratio* (n.s.) 4: 25–37.

—— (1995). 'Beliefs and Fictional Narrators', *Analysis*, 55: 121–2.

—— (1997). 'Truth in Fiction: A Reply to New', *Journal of Aesthetics and Art Criticism*, 55: 423–5.

MELLOR, D. H. (1990). 'Telling the Truth', in *Ways of Communicating.* Cambridge: Cambridge University Press.

—— (1991). 'Properties and Predicates', in *Matters of Metaphysics.* Cambridge: Cambridge University Press.

MOTHERSILL, M. (1984). *Beauty Restored.* Oxford: Clarendon Press.

—— (1986). Review of Malcolm Budd, *Music and the Emotions*, *Mind* 95: 513–21.

NEILL, A. (1991). 'Fiction and Make-Believe', *Journal of Aesthetics and Art Criticism* 49: 47–56.

—— (1992). 'Who's *Afraid* of Virginia Woolf?', *Ratio* (n.s.) 5: 94–7.

—— (1993). 'Fiction and the Emotions', *American Philosophical Quarterly* 30: 1–14.

NOVITZ, D. (1987). *Knowledge, Fiction and Imagination.* Philadelphia, Pa.: Temple University Press.

PETTIT, P. (1983). 'The Possibility of Aesthetic Realism', in E. Schaper, ed., *Pleasure, Preference and Value*, pp. 17–38. Cambridge: Cambridge University Press.

PUTNAM, H. (1975). *Mind, Language and Reality.* Cambridge: Cambridge University Press.

RADFORD, C. (1975). 'How Can we be Moved by the Fate of Anna Karenina?', *Proceedings of the Aristotelian Society* supp. vol. 49: 67–80.

—— (1989). 'Emotions and Music: A Reply to the Cognitivists', *Journal of Aesthetics and Art Criticism*, 47: 69–76.

REY, G. (1980). 'Functionalism and the Emotions', in Rorty (1980).

RIDLEY, A. (1986). 'Mr. Mew on Music', *British Journal of Aesthetics* 26: 67–70.

—— (1993). 'Pitiful Responses to Music', *British Journal of Aesthetics* 31: 72–4.

—— (1995*a*). 'Musical Sympathies: The Experience of Expressive Music', *Journal of Aesthetics and Art Criticism* 53: 49–57.

—— (1995*b*). *Music, Value and the Passions*. Ithaca, NY: Cornell University Press.

ROBERTS, R. C. (1988). 'What an Emotion is: A Sketch', *Philosophical Review* 97: 183–209.

ROBINSON, J. (1995). 'Startle', *Journal of Philosophy* 92: 53–74.

RORTY, A. O., ed. (1980). *Explaining the Emotions*. Berkeley and Los Angeles: University of California Press.

ROSEBURY, B. J. (1979). 'Fiction, Emotion and Belief', *British Journal of Aesthetics* 19: 120–30.

RYLE, G. (1963). *The Concept of Mind*. Harmondsworth: Penguin Books.

SAVILE, A. (1969). 'The Place of Intention in the Concept of Art', repr. in H. Osborne, ed., *Aesthetics*, 1972, pp. 158–76. Oxford: Oxford University Press.

SCRUTON, R. (1974). *Art and Imagination*. London: Routledge & Kegan Paul.

—— (1976). 'Representation in Music', repr. in *The Aesthetic Understanding*, 1983, pp. 62–76. London: Methuen.

—— (1983). 'Understanding Music', repr. in *The Aesthetic Understanding*, 1983, pp. 77–100. London: Methuen.

SIBLEY, F. (1959). 'Aesthetic Concepts', repr. in G. Dickie and R. Sclafani, eds., *Aesthetics*, 1977, pp. 815–37. New York: St. Martin's Press.

—— (1965). 'Aesthetic and Non-Aesthetic', *Philosophical Review* 74: 135–59.

—— (1978). 'Objectivity and Aesthetics', *Proceedings of the Aristotelian Society* supp. vol. 42: 31–54.

SMITH, P. and JONES, O. R. (1986). *The Philosophy of Mind*. Cambridge: Cambridge University Press.

SOLOMON, R. C. (1976). *The Passions*. New York: Doubleday/Anchor.

STECKER, R. (1983). 'Nolt and the Expression of Emotion', *British Journal of Aesthetics* 23: 234–9.

TANNER, M. K. (1985). 'Understanding Music', *Proceedings of the Aristotelian Society* supp. vol. 59: 215–32.

TORMEY, A. (1971). *The Concept of Expression*. Princeton, NJ: Princeton University Press.

VERMAZEN, B. (1986). 'Expression as Expression', *Pacific Philosophical Quarterly* 67: 196–234.

VON WESTERMAN, G. (1968). *Concert Guide*. London: Sphere Books.

WALTON, K. (1973). 'Pictures and Make-Believe', *Philosophical Review* 82: 283–319.

—— (1975). 'Fearing Fictions', *Journal of Philosophy* 75: 5–27.

—— (1988). 'What is Abstract About the Art of Music?', *Journal of Aesthetics and Art Criticism*, 46: 351–64.

—— (1990). *Mimesis as Make-Believe*. Cambridge, Mass.: Harvard University Press.

—— (1994). 'Listening With Imagination: Is Music Representational?', *Journal of Aesthetics and Art Criticism*, 52: 47-61.

WESTON, M. (1975). 'How can we be Moved by the Fate of Anna Karenina?', *Proceedings of the Aristotelian Society* supp. vol. 49: 81–93.

WILLIAMS, B. (1973). *Utilitarianism: For and Against* , ed. J. Smart and B. Williams. Cambridge: Cambridge University Press.

—— (1985). *Ethics and the Limits of Philosophy*. London: Fontana.

—— (1993). *Shame and Necessity*. Berkeley and Los Angeles: University of California Press.

WITTGENSTEIN, L. (1956). *Philosophical Investigations*, trans. G. E. M. Anscombe. Oxford: Blackwell.

—— (1966). *Lectures and Conversations on Aesthetics, Psychology and Religious Belief*, ed. C. Barrett. Oxford: Blackwell.

WOLLHEIM, R. (1964). 'On Drawing an Object', *On Art and the Mind*, 1974, pp. 3–30, Cambridge, Mass.: Harvard University Press.

—— (1966). 'Expression', repr. in *On Art and the Mind*, 1974, pp. 84–100. Cambridge, Mass.: Harvard University Press.

—— (1969). 'The Mind and the Mind's Image of Itself', repr. in *On Art and the Mind*, 1974, pp. 31–54. Cambridge, Mass.: Harvard University Press.

—— (1980). *Art and its Objects*. Cambridge: Cambridge University Press.

—— (1987). *Painting as an Art*. London: Thames & Hudson.

ZEMACH, E. (1987). 'Aesthetic Properties, Aesthetic Laws and Aesthetic Principles', *Journal of Aesthetics and Art Criticism* 46: 67–73.

INDEX

Amis, Kingsley 81 n
Aristotle 14
Armstrong, D. M. 20 n, 121
arousal theory 4, 8–9, 10, 114, 117,
 132–40, 146–226
 with respect to representations
 85–99, 156, 158, 159, 171, 215
Arp, Jean 207, 208, 210
aspect perception 123–4, 174–7, 182
Atkinson, R. F. 77
Austen, Jane:
 Mansfield Park 40
 Pride and Prejudice 23, 29, 39, 79,
 81, 83

Barwell, I. 119 n
'basic properties' 206–24
Beardsley, M. 102, 180 n, 186
Beck, J.:
 Harvey 74
Bedford, E. 14 n
Bedford, Sybille:
 Jigsaw 80
Beethoven, Ludwig van:
 Third Symphony (Eroica) 160–1,
 164, 190, 220
 Fifth Symphony 100, 145, 182, 184
beliefs 2, 15, 20–5, 66–8, 72, 73, 78, 147,
 150
 about fictions 2, 29–31
 instrumental 22, 64, 69
Blackburn, S. 59 n
Blunden, Edward 84
Booth, W. C. 41
Boruah, B. 32 n
Bouwsma, O. K. 102, 119 n, 139, 170,
 174, 181, 199
Braque, Georges 197
Budd, M. 10, 14 n, 16, 32 n, 105 n, 109,
 116, 118, 120 n, 128, 140–44, 153,
 163, 176, 178, 179 n, 182

Calhoun, C. 22 n
Campbell, Roy 80
Camus, Albert:
 L'Étranger 166

Carroll, N. 30, 32–4, 57, 92–3
Cézanne, Paul 197
Chagall, Marc 207
Chardin, Jean Baptiste Siméon 223
Chaucer, Geoffrey:
 The Merchant's Tale 61
cognitivism:
 concerning expression in literature
 86, 95–9
 concerning expression in music
 9–10, 114–64, 181
 see also emotions
Collingwood, R. G. 78, 102
colour 11–12, 98, 151, 188–213, 216–19,
 224
Conrad, Joseph:
 Lord Jim 96
content (of expressive judgements)
 98–9, 116–17, 128, 146, 182–3
Conter, D. 42 n
Cooke, D.:
 The Language of Music 213–14
Cooper, D. E. 107 n
creativity 216–19
criticism 208, 210, 216, 219–24
Currie, G. 14 n, 36–37, 42 n, 46–51,
 53–4, 59, 61, 82 n, 213 n

Damman, R. 30 n
Davies, S. 27, 105 n, 109, 119 n, 120 n,
 122, 126, 156, 158 n, 160–1, 163 n,
 178 n, 185 n
'definitional problem' 3, 29, 73, 90
Defoe, Daniel:
 Robinson Crusoe 69, 70, 77
Delaroche, Paul:
 The Execution of Lady Jane Grey 6,
 89
De Quincy, Thomas 78
 The Flight of the Kalmucks 65
De Sousa, R. 5–6, 14 n, 15, 16–17, 23–5,
 73
Douglas, Norman:
 South Wind 2, 76
'dry-eyed' criticism 199–203, 221

Elgar, Edward:
 *Pomp and Circumstance March
 No. 1* 215
Eliot, George:
 Middlemarch 58, 158
Elliott, R. 138, 139, 140, 145–6, 151,
 163–4
emotions 2, 4–7, 14–28, 94, 110–16,
 147–65, 168
 broad cognitivist views of 14–18
 concerning fictions 2, 7, 14, 29–99,
 156, 158, 159, 171, 177
 concerning historical events 78
 felt for other people 25–8
 in response to a confrontation 58–9,
 64, 67–8, 78, 87
 in response to a representation 59,
 77–8, 83–99
 narrow cognitivist views of 7, 18–
 25, 29–32, 36, 57, 63, 68, 72, 73
Ernst, Max 207
experience 9, 86–90, 120–1, 143, 145,
 151, 154, 189–98
expression 3, 8, 111–13, 115–16, 118–19,
 168
 in fiction 94–9, 186
 in music 99–187, 215
 varieties of 183–5

family resemblance 4
fear for oneself 14–15, 20, 24–5, 73–6
'feeling drug' 170, 172–3, 177–83, 185
feelings 148–64
 defined 19
 incipient 200–3, 221
 see also arousal theory
fiction 1–2, 8, 38–58, 66
 compared to documentary 69–70,
 77–81
 content of a 61–2
 value of 79
fictional characters:
 ontology of 81–2
fictional narrator 39–52, 61, 96–7
Flaubert, Gustave:
 Madame Bovary 39
Fleming, Anne 81 n
Fleming, Ian 81 n
 Diamonds are Forever 39
Ford, Ford Madox:
 The Good Soldier 61
formulaic creativity 217–19
Forster, E. M. 186

functionalism 20, 58, 65, 67, 147,
 199–201

Gear, J. 161
Gombrich, E. H. 97, 104, 213–14
Goodman, N. 104–8, 112
Gordon, R. M. 14 n
Greenspan, P. 14 n, 17–18, 22–3, 57–8,
 72, 173–4.
Grice, H. P. 59, 61, 62, 66

Handel, George Frederick:
 The Messiah 215
Hardin, C. L. 191, 205
Hardy, Thomas:
 The Return of the Native 91
Heal, J. 63
Hemingway, Ernest 63 n
 Hills Like White Elephants 14, 96
history 7–8, 65, 69, 77–81
Holst, Gustave:
 The Planets 215
Hopkins, A. 180
Hospers, J. 102, 162
Hume, D. 192, 194, 197, 222–4

imagination 37–8, 66–7, 73, 83, 137–40
 see also make-believe
irony 91
Isherwood, Christopher 103

Jones, O. R. 20 n, 150 n

Kandinsky, W.:
 Concerning the Spiritual in Art 213
Karl, G. 150 n
Keats, John:
 La Belle Dame Sans Merci 97–8,
 156
Kivy, P. 4, 10, 13, 114–19, 122–8, 132,
 142, 146, 147, 154–64, 183
Kripke, S. 81

Lamarque, P. 30 n
Lang, Fritz:
 You Only Live Once 48
Leighton, S. 22 n
Levinson, J. 4 n, 10, 53–5, 75 n, 77 n,
 128, 130–2, 150 n, 151–4, 158 n,
 178, 179, 185, 208
Lewis, D. 62
Locke, J. 196–7
Lowe, E. J. 180 n

Lyons, W. 14 n, 21

Maconie, R. 178 n
make-believe 7, 31–58, 61, 65–73, 82,
 140–3
 concerning fiction 38–45
 concerning the visual arts 45–55, 74
 report model of 39–55
 see also imagination
Manet, Édouard 197
Margolis, J. 114
Matravers, D. 32 n, 62 n, 82 n
Mellor, D. H. 62 n, 205, 212
Melville, Herman:
 Moby Dick 70, 81–2
metaphor 9, 102–10.
Monteverdi, Claudio:
 Arianna's Lament 126
Mothersill, M. 12, 19, 197, 210–13
Mozart, Wolfgang Amadeus:
 Gran Partita (K361) 208
 Marriage of Figaro 126
 Piano Concerto in A Major (K488)
 180
 Requiem 128
music 99–101, 172, 177–80, 185–6, 215
 understanding 170–3, 194

Neill, A. 32 n, 34–7, 73–4
normal conditions 195–8
Novitz, D. 32 n

Orwell, George:
 1984 70
Osgood, C. E. 213

'paintball' 71
paradigm scenarios 5–6, 16–17, 23–5, 73
Pettit, P. 104
Picasso, Pablo 197
Plato:
 Phaedo 81
Poe, Edgar Allen:
 Fall of the House of Usher 74–5
Potter, Beatrix:
 The Tale of Peter Rabbit 61
primary properties 11, 205–13, 216–19,
 221
private visual experiences 189, 191–2
Putnam, H. 20 n

qualified observer 60, 189–95

Rachmaninov, Sergei:
 Piano Concerto No. 2 220
Radford, C. 29–30, 68, 82 n, 157
representations 59–81
 being struck by 89–90
 transparent and imaginative 63–8,
 71–2
Rey, G. 14 n
Richardson, Samuel:
 Pamela 39
Ridley, A. 10, 14 n, 132–8, 145, 158 n,
 163 n, 170
Roberts, R. C. 14 n, 18, 22–3
Robinson, J. 74, 150 n
Rosebury, B. J. 30 n
Rothko, Mark 207
Ryle, G. 109

Satie, Eric 207
Savile, A. 52
Scruton, R. 67, 88 n, 89 n, 118 n, 119,
 120 n, 174–6, 178 n, 179
secondary properties 11, 205, 207
 see also colour
'seeing in' 123, 124–5
Selkirk, Alexander 69–70, 77
Shaffer, Peter:
 Amadeus 209
Shakespeare, William:
 Hamlet 2
 King Lear 86
 Othello 90
 Richard III 80
 Romeo and Juliet 49
Shostakovitch, Dmitry:
 Fifth Symphony 163
Sibley, F. 87, 151, 172, 188, 219–20, 223
Smith, P. 20 n, 150 n
Socrates 81
Solomon, R. C. 20
Stecker, R. 147, 162, 163 n
Stoppard, Tom:
 *Rosencrantz and Guildenstern are
 Dead* 51
'subjective' 203
Swift, Jonathan:
 Gulliver's Travels 39, 45

Tanguy, Yves 207, 208, 210
Tanner, M. K. 178 n
taste 194–5
Tolstoy, Leo 30
 War and Peace 186

Tormey, Allen 115
Tourneur, Cyril:
 The Revenger's Tragedy 50
Tovey, D. 120
truth 59, 66

van Gogh, Vincent:
 L'Eglise d'Auvers-sur-Oise 223
Vermazen, B. 10, 110, 128–30
Vermeer, Jan 223
von Westerman, G. 100, 145, 184, 220

Walton, K. 7, 10, 30, 31–52, 55–8, 62,
 65–70, 72, 73–4, 76, 82 n, 109,
 137–40, 142

Watteau, (Jean) Antoine:
 Fete in the Park 97, 207
Waugh, Evelyn:
 Scoop 218
Williams, B. 60, 158
Wittgenstein, L. 11, 108 n, 123, 152,
 165–7, 200
'Wittgenstein cases' 168–83
Wodehouse, P. G. 153
 How Right You Are, Jeeves 50
Wollheim, R. 43, 111, 123, 125, 219 n
Woolf, Virginia 223

Zemach, E. 211